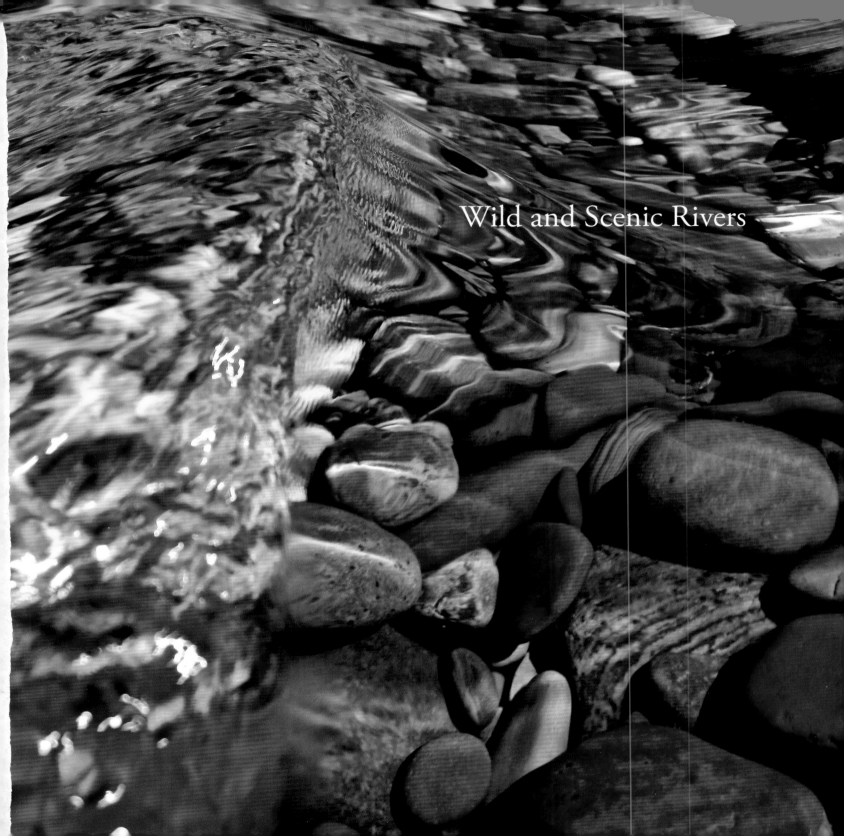

Wild and Scenic Rivers

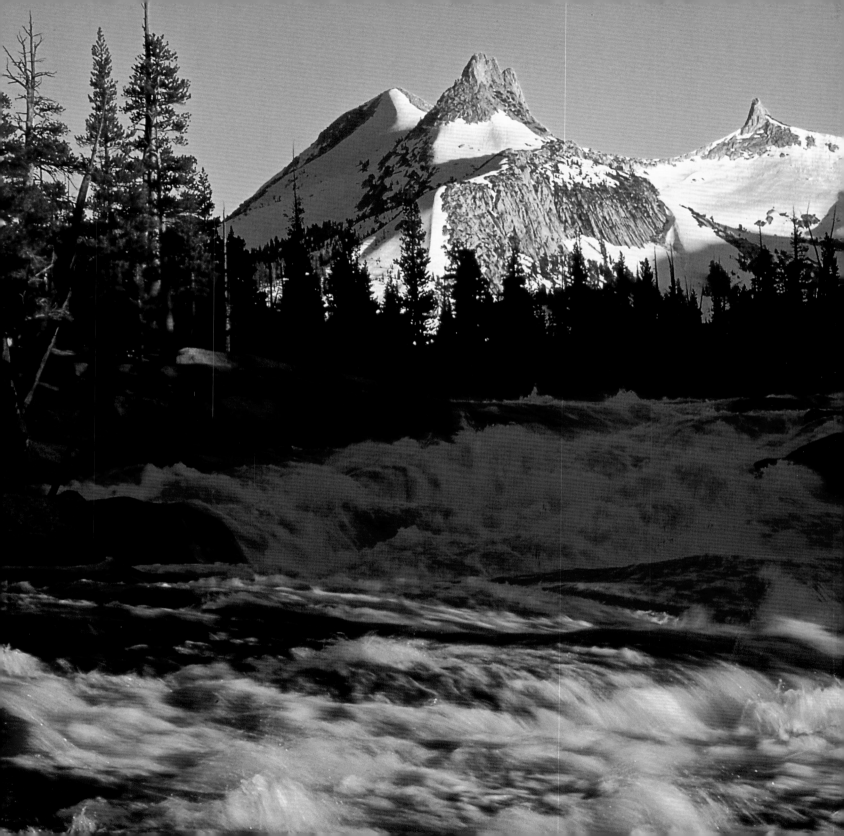

TEXT AND PHOTOGRAPHS BY TIM PALMER

Oregon State University Press Corvallis

Wild and Scenic Rivers

An American Legacy

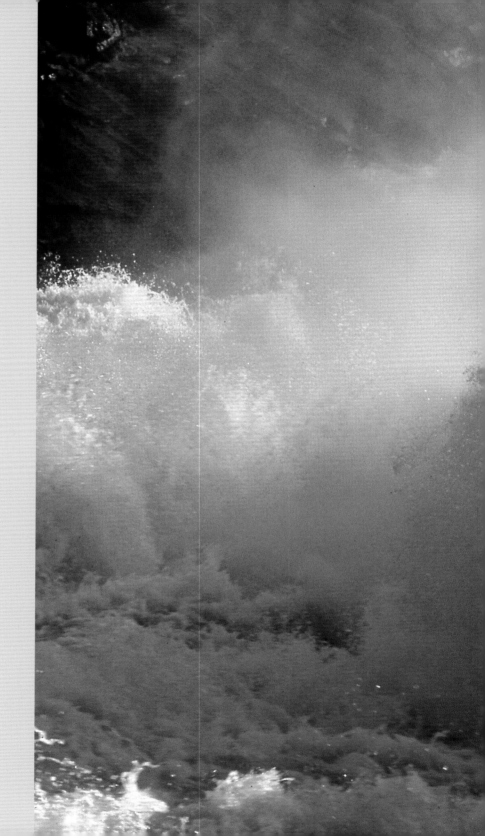

The John and Shirley Byrne Fund for Books on Nature and the Environment provides generous support that helps make publication of this and other Oregon State University Press books possible.

Cataloging-in-publication data is available from the Library of Congress.

ISBN 978-0-87071-897-7

♾ This paper meets the requirements of ANSI/NISO Z39.48-1992
(Permanence of Paper).

First published in 2017 by Oregon State University Press
Printed in China

Oregon State University Press
121 The Valley Library
Corvallis OR 97331-4501
541-737-3166 • fax 541-737-3170
www.osupress.oregonstate.edu

p. i: Brilliant metamorphic cobbles color the bed of the South Fork Flathead River in Montana.

p. ii–iii: Melting snowfields of Yosemite National Park in California tower over the Tuolumne River in its steep descent.

p. iii: The Snake River bubbles through a riffle at Flagg Ranch, Wyoming, south of Yellowstone National Park.

p. iv–v: In the lustrous green of the Northeast, maple limbs arc over the Musconetcong River,

p. vi–vii: Springtime runoff explodes at California Falls of the Tuolumne River.

p. viii–ix: Dawn's first light begins to illumine the Delaware River below the bridge at Frenchtown, Pennsylvania, and New Jersey.

p. xi: The Clarion River of northwestern Pennsylvania splashes through a rocky rapid during a mid-summer thunderstorm.

p xiii: The Owyhee River of eastern Oregon offers one of the West's outstanding river trips through glowing desert canyons

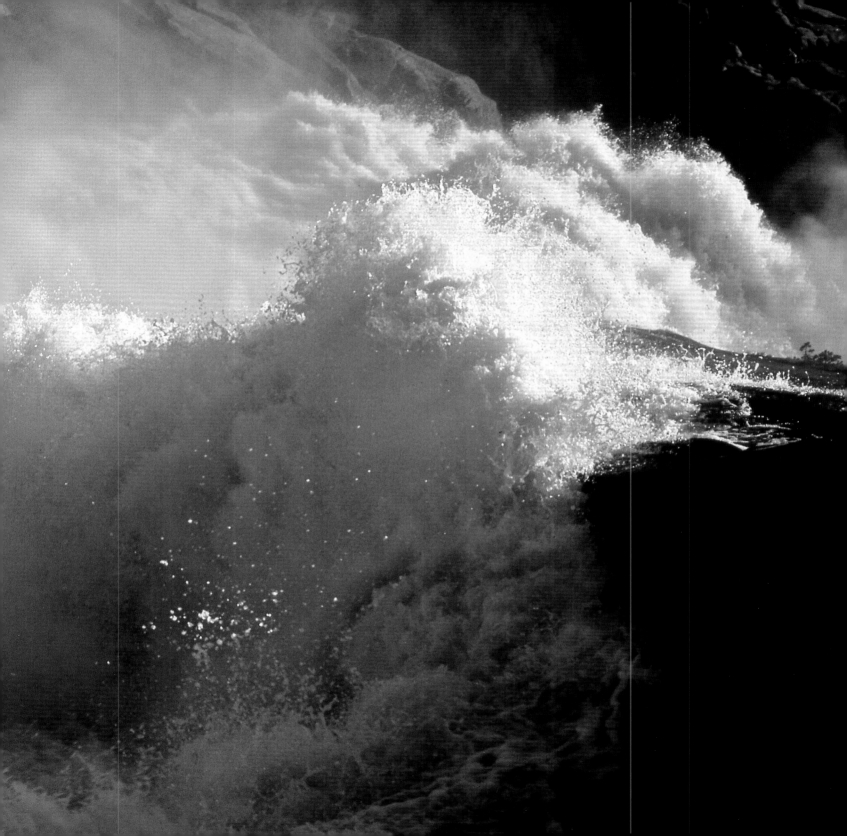

Contents

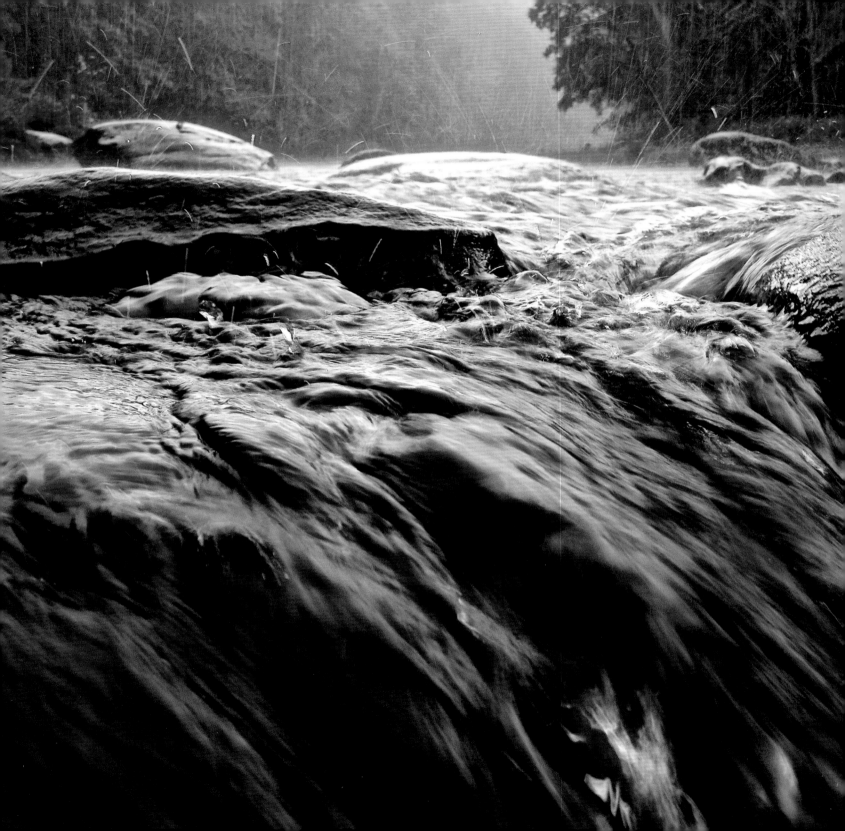

Foreword

Wm. Robert Irvin, President, American Rivers

Writer and historian Wallace Stegner described our national parks as America's "best idea"—one that protected some of our most spectacular public land including Yellowstone, Yosemite, Grand Canyon, and the Great Smoky Mountains. Our care for these iconic landscapes has served as a model for other nations, inspiring the preservation of wildlands around the globe, from Africa's Serengeti to the United Kingdom's Lake District.

In this impressive book, Tim Palmer celebrates and elucidates, in eloquent prose and stunning photographs, another American conservation innovation—designation of many of the nation's best waterways as national wild and scenic rivers. Tim knows his subject well, having spent much of his life studying rivers, chronicling their history, and fighting for their protection. Now, as we mark the fiftieth anniversary of the National Wild and Scenic Rivers Act of 1968, Tim reminds us that our stewardship of these rivers is among America's most important conservation initiatives benefitting all people for all time.

American Rivers, the conservation organization I proudly lead, was founded in 1973 to fight dams and secure more wild and scenic river designations. Working with dedicated grassroots river conservationists around the country, we have helped protect remarkable rivers such as North Carolina's New, California's Tuolumne, and Colorado's Cache la Poudre.

Growing up in Kentucky, one of the battles that inspired me to dedicate my career to environmental conservation was the fight in the early 1970s to protect the Red River and its spectacular gorge from an unnecessary and wasteful dam. In an era when any free-flowing river was viewed by politicians and the US Army Corps of Engineers as an opportunity for dam building and pork barrel largesse, the Red River was ripe fruit waiting to be picked. Thanks to determined opposition from local farmers and residents who did not want their pastures and homes submerged beneath a reservoir; the support of paddlers, hikers, and climbers who valued the Red River Gorge and its recreational opportunities; and the timely appearance of Supreme Court Justice William O. Douglas, who hiked the Gorge to highlight its rugged beauty, the dam proposal was defeated. In 1993, the Red River was permanently protected as Kentucky's only federal wild and scenic river. The story came full circle for me when I became president of American Rivers in 2011 and learned that some of our organization's founders were leaders in the fight for the Red River.

Today, wild and scenic rivers remain a top priority for our organization. That's because taking good care of these rivers benefits us all—from kids in Massachusetts to ranchers in Montana to small business owners in Georgia. Protecting these vital streams ensures sources of clean water for our communities and farms. Protecting wild and scenic rivers and their floodplains provides us with natural insurance against catastrophic floods and devastating droughts—conditions that are becoming disturbingly more frequent as a consequence of climate change. Also, we are guarding economic assets that provide millions of dollars generated by

recreational activities such as fishing, canoeing, and rafting, including all of the spending for hotels, restaurants, and gear that goes with those activities.

Rivers connect us to our past, our future, and each other. When we set aside wild and scenic rivers we carry forward our shared American heritage—from the Concord River in Massachusetts, where the "shot heard 'round the world" started the Revolutionary War, to Lewis and Clark's exploration of the White Cliffs of the Missouri River, to the many storied rivers of explorers, Native Americans, and settlers.

While the benefits of protecting wild and scenic rivers are clear, the job is far from finished. As Tim explains, we have designated only 13,000 miles of the 2.9 million miles of rivers and streams in the United States. Despite a powerful movement over the past twenty years to remove outdated dams and restore rivers, many streams remain under threat from new dam proposals, pollution, unsustainable

water withdrawals, mining, and oil and gas development. National and local conservation groups must work with federal, state, and local governments to ensure strong and effective stewardship of existing wild and scenic rivers. This commitment must be backed up with increased support for the agencies charged with responsibility for these special waters. In addition, Congress should finish the job by protecting many of our remaining free-flowing rivers through additions to the national wild and scenic rivers system.

This beautiful, important, and timely book reminds us be thankful for those whose foresight and courage saved so many of our national river treasures. The photos that Tim shows and the stories he tells together honor our achievements, inspire our efforts, and chart our course forward in a continuing dedication to safeguard the finest of American rivers.

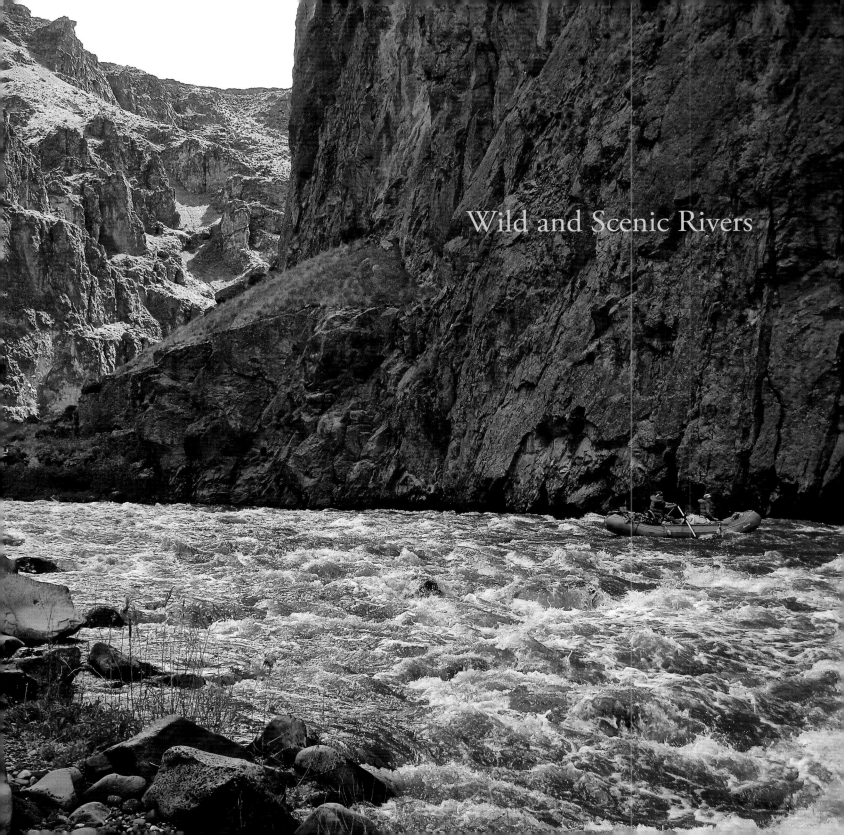

Wild and Scenic Rivers

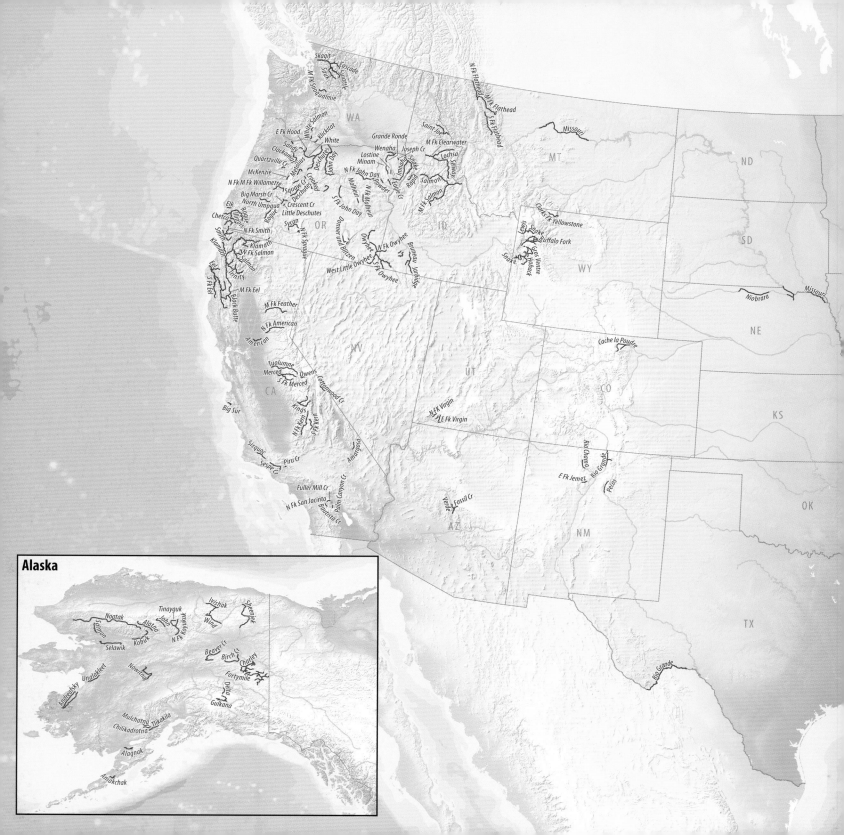

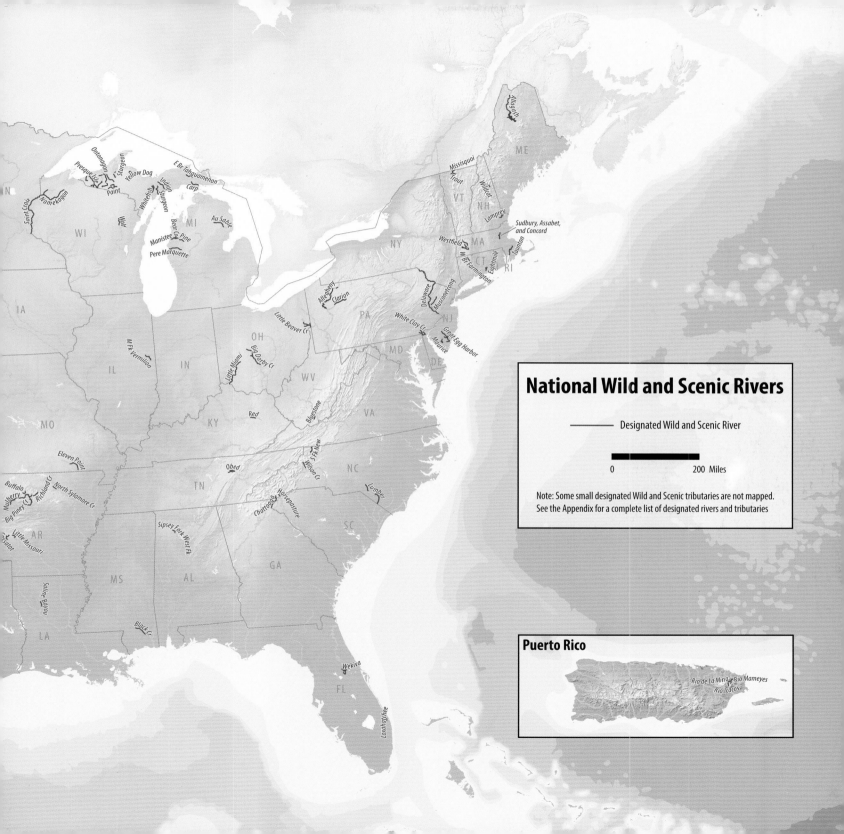

National Wild and Scenic Rivers

——— Designated Wild and Scenic River

0 200 Miles

Note: Some small designated Wild and Scenic tributaries are not mapped.
See the Appendix for a complete list of designated rivers and tributaries

Puerto Rico

Rio de La Mina Rio Mameyes
Rio Icacos

MN

Ontonagon
Presque Isle
Yellow Dog
Sturgeon
Paint
Whitefish
Indian
E. Br. Tahquamenon
Carp
Sturgeon
Wolf
Bear Cr.
Pine
Manistee Cr.
Pere Marquette
Au Sable

Saint Croix
Namekagon

WI
MI
IA
IN
IL
MO

M. Fk. Vermilion
Little Miami
Big Darby Cr.
Little Beaver Cr.
OH
Little Miami
KY
Red
WV

Allegheny
Clarion
PA
White Clay Cr.
Maurice
Delaware
Musconetcong
Great Egg Harbor
NJ
DE
MD
VA

Bluestone
S. Fk. New
Wilson Cr.
NC
Obed
TN
Horsepasture
Chattooga
SC
Lumber

Eleven Point
Buffalo
Mulberry
Big Piney Cr.
Richland Cr.
North Sylamore Cr.
AR
Little Missouri
Cossatot
Sipsey Fork West Fk.

Saline Bayou
LA
MS
AL
Black Cr.
GA

Wekiva
FL
Loxahatchee

ME
Allagash
Missisquoi
Trout
Wild
VT
NH
Lamprey
Westfield
MA
W. Br. Farmington
CT
Eightmile
Taunton
RI
Sudbury, Assabet, and Concord
NY

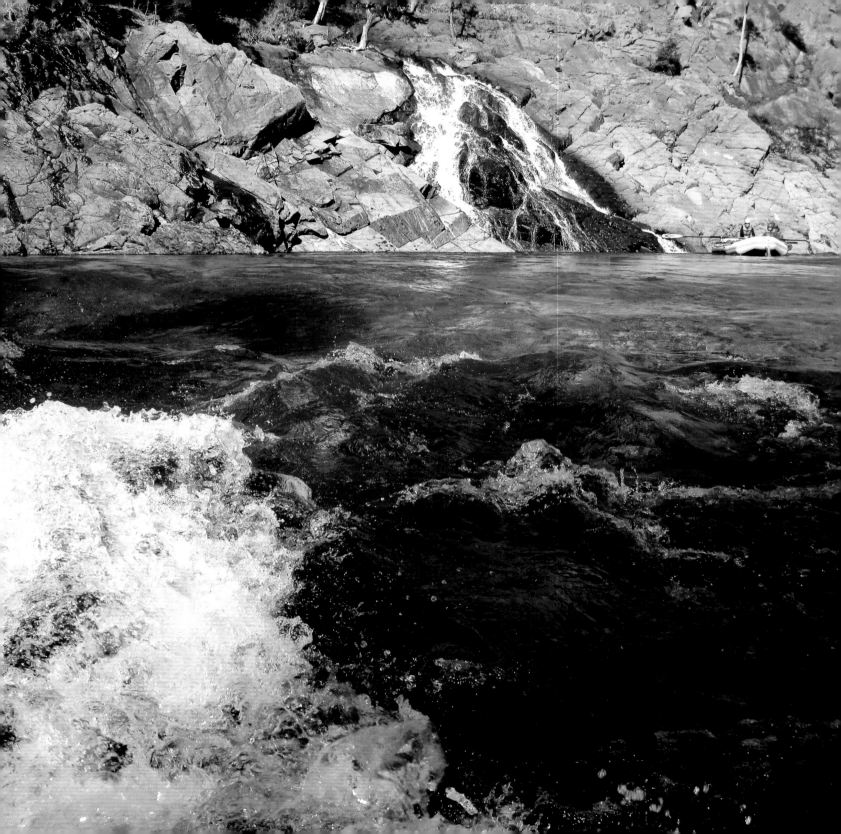

Beauty, Life, and Liveliness

From mountains, forests, and grasslands all across America, rivers flow with astonishing beauty, and their pathways across the land are essential to all life. To safeguard the best of these streams, citizen conservationists, river enthusiasts in federal resource agencies, and congressional members joined forces to pass the National Wild and Scenic Rivers Act in 1968.

Two years later, I had the good fortune to become involved in this creative, ambitious, and unprecedented effort to spare our most outstanding rivers from dams and other developments. While I was studying landscape architecture at Penn State University, forestry professor Peter Fletcher approached me to craft a watershed protection plan for one of twenty-seven rivers named for study under the new Wild and Scenic Rivers Act. He reasoned that my work on landscape analysis and planning could lend support to the proposal. I leapt at the opportunity and soon became rapt with Pine Creek's misty sunrises, scents of springtime, and enchanting rapids.

Little did I know that this twist of fate had introduced me to a passion that would fire my spirit for nearly fifty years, and counting. Quite simply, I fell in love with rivers. My experiences with them—and with the nation's premier program for protecting them—would grow in unexpected ways, culminating with the book in your hands.

In the Wild and Scenic Rivers Act, Congress decreed that America's headlong rush to develop rivers with dams and other developments should be

Opposite: Rafters pause before the next steep drop of the North Fork Smith River, California.

1

Rivers are the lifelines for fish, wildlife, and people. Here pink salmon spawn at the mouth of the Cascade River, a Skagit tributary in Washington.

complemented by saving the best streams. This goal marked a historic turning point in our society's regard for rivers. Instead of believing that every stream should be flooded by dams or otherwise heavily developed, we would begin to respect intrinsic values of these vital, free-flowing, natural features.

Now, as I write, the fiftieth anniversary of the Wild and Scenic Rivers Act is near, and it invites everyone to consider, appreciate, and celebrate our collective determination to save the nation's finest free-flowing waters so that future generations may know them as well. This book was written with the belief that knowing the past can help guide us to the future, and that the beauty of our waters and shorelines, from Alaska's Sheenjek to Florida's Wekiva, can inspire us to care more deeply for these arteries of nature.

River protection at this scale had never occurred in the United States, or for that matter, in the world. The wild and scenic program stands alone in its recognition that a certain category of landscape—rivers with their integral valley or canyon corridors—should be singled out for special care. We've passed no similar nationwide laws specifically to set aside mountains, or forests, or deserts, or lakes. But to protect our finest rivers, we have. This is fitting given the central importance of rivers in our lives.

One way or another, we all drink from rivers. Our bodies are 67 percent water, virtually all of it from rivers or from groundwater that's intimately connected to the surface flow. The fascination that many of us have for rivers is no mystery; they literally flow in our arteries and veins.

Rivers, however, matter to far more than just us. They are lifelines—essential to fish and important to all creatures. Rivers connect headwaters—necessary as spawning habitat for salmon, steelhead, and other fish—with the ocean where anadromous fish spend much of their lives in the sea's greater nutrient pool. Rivers are key corridors for wildlife migration, connecting vital habitats such as high-country salad gardens grazed by deer or elk in

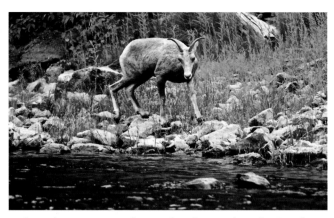

Bighorn sheep venture to the waterline for a sip from the Grande Ronde River in northeast Oregon. Waterfront habitat is the most important for wildlife, and even animals that don't habitually live at riverfronts depend on them for water, food, and connecting corridors that link daily and seasonal ranges.

summer or low-country refuges for those stately ungulates in winter.

We need our rivers, and we also enjoy them. Fleeing the stress of our times, people seek these waterways for both relaxation and excitement, for both discovery of the unusual and escape from the routine, and for exercise in surroundings that nourish us. Perhaps most important, rivers remind us that we are inseparably part of the natural world. The swirling currents appeal to canoeists, rafters, and kayakers, not only for the thrill and challenge of whitewater, but for the rivers' gift of peace and serenity. Paddling on journeys of a day or a week or a month is a captivating way to travel and to experience the finest of nature in extraordinary places seen no other way. Fishing is a favorite American pastime, the source of nourishing food, and an economic backbone of resort economies—from the upper Delaware where shad swim home, to the Snake River in Jackson Hole where cutthroat trout leap, and onward to coastal Oregon where Chinook salmon migrate

in timeless patterns up the Umpqua River from the ocean. Nationwide, twenty-eight million people fished in rivers and streams in 2011 according to the Fish and Wildlife Service. Another twenty million canoed or kayaked.

Riverfront hiking and biking take additional millions of people to watery edges from the Potomac in Washington, DC, to greenways along the Susquehanna in Harrisburg, Chattahoochee in Atlanta, Willamette in Portland, and American in Sacramento. In fact, streams are centerpieces to many towns and cities whether or not local boosters capitalize on this fact. Meanwhile, swimming in rivers is one of the oldest refreshments of all. And who has not enjoyed the solace and pleasure of simply strolling or sitting along a stream?

Rivers seep further into our psyches by symbolizing life. They're used as metaphors for greater journeys. Rivers' emblematic linkages and allusions to nourishment appear in accounts of both struggles and triumphs, from the personal to the cosmic. Rivers stir our emotions and spirits. In practical and imaginative terms, they touch basic truths about the necessities, the pleasures, and the meanings of life.

Rivers are beautiful, drawing us to their flow, their shape, their shine. For the full effect, you have to go and see. But photos are the next best thing, which is why you'll find more than 160 pictures in this book. They represent my modest attempt to make part of our wild and scenic rivers' brilliance available just by turning the next page.

Rivers of all kinds, and in all places, serve many needs, and earnest care is required everywhere that water flows. But the wild and scenic program was established to embrace the *best*, subjective as that term might be. Throwing a big net for this catch, Congress declared that a wild and scenic river must be free-flowing with at least one "outstandingly remarkable" scenic, recreational, geologic, fish and wildlife, historic, cultural, or other value.

Starting with eight rivers plus four tributaries in the original act, the wild and scenic system has grown to 289

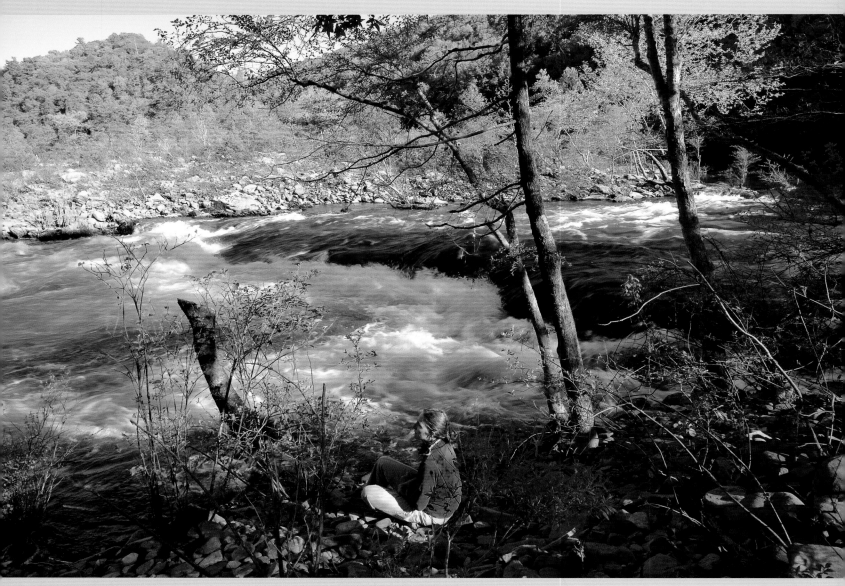

Along the Emory River in Tennessee, Ann Vileisis soaks in
springtime's warm evening light. As drinking water supplies,
community centerpieces, and recreational necessities, rivers
are important in myriad ways.

major rivers and a total of 495 rivers, forks, and tributaries explicitly named (see appendix 1 for mileages and mileage methods, and appendix 2 for numerating methods, which differ slightly here from other sources). The US Geological Survey reports that America has 2.9 million total miles of rivers and streams. The wild and scenic system includes about 13,000 miles—hardly significant in the big picture. More deserve protection. Yet the designated streams include sections of many of our most important natural waterways, and dozens that might be considered American classics.

Gems of national prominence include the Delaware, Missouri, and Klamath. Also the wild Salmon in Idaho, the legendary Rogue in Oregon, the north-woods Allagash in Maine, the Appalachian's Chattooga in Georgia, the historic Concord in Massachusetts, the prairie's Niobrara in Nebraska, the canyon-bound Rio Grande in Texas, the granite-gleaming Tuolumne in California, the rain-shrouded Skagit in Washington, the grizzly bear–haunted Alagnak in Alaska, and the jungle-vined Rio Mameyes in Puerto Rico.

All states but ten have at least one national wild and scenic river. Oregon, California, and Alaska have the most, with 70 percent of the total. Oregon has the largest number of major rivers designated—59. California has 45. Alaska has the most wild and scenic mileage—3,427. The northern and far western states have more protected rivers than the South and Midwest; among other reasons, the political culture is more amenable to conservation in New England, the Northwest, and California.

The longest designated, continuous reach of river (not counting related tributaries) is Alaska's Noatak, 372 miles. The longest reach in the lower forty-eight is the Namekagon and Saint Croix—together a continuous channel of 200 miles. To many people, the most stunning river might be the Merced as it plunges over Yosemite's world-renowned waterfalls. The New is among the oldest rivers on earth.

For most rivers, only portions are designated. A few are less than a mile. But 137 are enrolled for 25 miles or more, and 27 are wild and scenic for 100 miles or more. From source to mouth, the full length of 59 major rivers are designated. At a mega-scale, Oregon and California's adjacent Elk, Rogue, Chetco, Smith, Klamath, and Eel form our largest region of wild and scenic rivers; with back-to-back watersheds these are designated for a 260-mile north-south span.

Specific workings of the Wild and Scenic Act are detailed in the legislation, in the *Federal Register*'s "Guidelines for Eligibility, Classification and Management of River Areas," and in illuminating papers prepared by the Interagency Wild and Scenic Rivers Coordinating Council, available at rivers.gov. But the basics are these: designation by Congress—or by the secretary of the interior when requested by a governor—bans construction of dams that would block a river's flow. It also requires the federal government to protect river values on federal land and to work with property owners and communities to adopt protection strategies for non-federal acreage. Management plans are written by the appointed federal agency and by local communities. The federal government cannot regulate private land use, but the program encourages local governments to establish their own zoning, setbacks, and floodplain regulations. The approach is far different from other protected areas, such as national parks, because wild and scenic corridors are not necessarily managed through federal land ownership. Sensible safeguards, however, are intended to bar the most destructive scenarios and set the stage for protection.

I've had the good fortune to explore these rivers in personal adventures, professional endeavors, and photo odysseys running seamlessly starting the day that Dr. Fletcher led me to open my eyes and heart to Pine Creek. A year later I was hired as a land use planner in the county

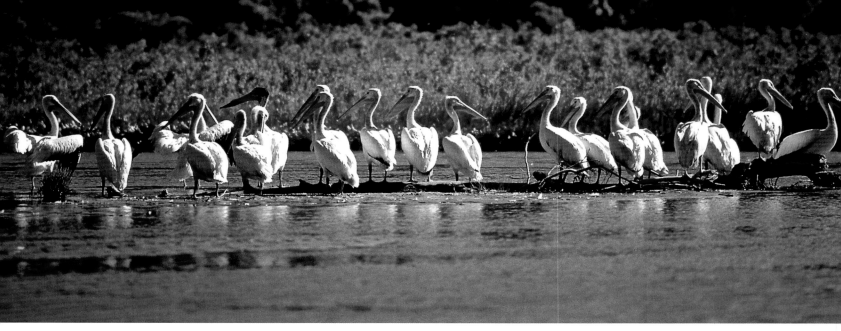

Above, White pelicans rest on sandbars of the Niobrara River, Nebraska, after fishing in early morning. Though underrepresented in the wild and scenic rivers system, rivers of the Great Plains are critical meeting places of plants and wildlife from the East and the West.

Right, A family of mergansers cruises transparent waters of the Middle Fork Flathead at the border of Glacier National Park, Montana.

where my adopted stream flowed, and my river-centric activities multiplied. Taking leave seven years later, I photographed rivers doomed by dam proposals nation-wide, and as a counterpoint on that bittersweet journey, I sought out streams protected as wild and scenic. In 1979 I prepared the first citizen-sponsored Wild and Scenic River Study as part of Friends of the River's campaign seeking to spare California's Stanislaus River from New Melones Dam.

Moving on from my planning job to full-time writing and photography, I drafted a wild and scenic study for the Committee to Save the Kings River in California and led media efforts in the campaign leading to its protection, and I drafted a similar study for the South Yuba River

Citizens League, helping win passage for California State designation there. I authored the history of river protection in *Endangered Rivers and the Conservation Movement*, and then in 1993 *The Wild and Scenic Rivers of America*— until now, the only book thoroughly covering this topic. Meanwhile I explored every stream I could, gravitating especially to long river trips, including Idaho's Salmon, where I launched a forty-two day, 420-mile journey, and Utah's Green, of similar length. Pictures from my expeditions found their way into my photo book, *Rivers of America,* and into photo volumes and guidebooks that I wrote for California and Oregon.

Throughout these sojourns, I never drifted more than a figurative paddle's length from the wild and scenic rivers program, and now, with the act's fiftieth anniversary on the horizon, I've launched a new journey to show and tell the story of America's premier collection of protected rivers.

Following this introduction to that journey, chapters 2, 3, and 4 narrate the history of the program, from its inception in the inquiring minds of two pioneering wildlife biologists, to passage of the Act, and onward through five decades while the system grew to sixteen times its original mileage and twenty-four times its original number of major streams. As I've explored and photographed

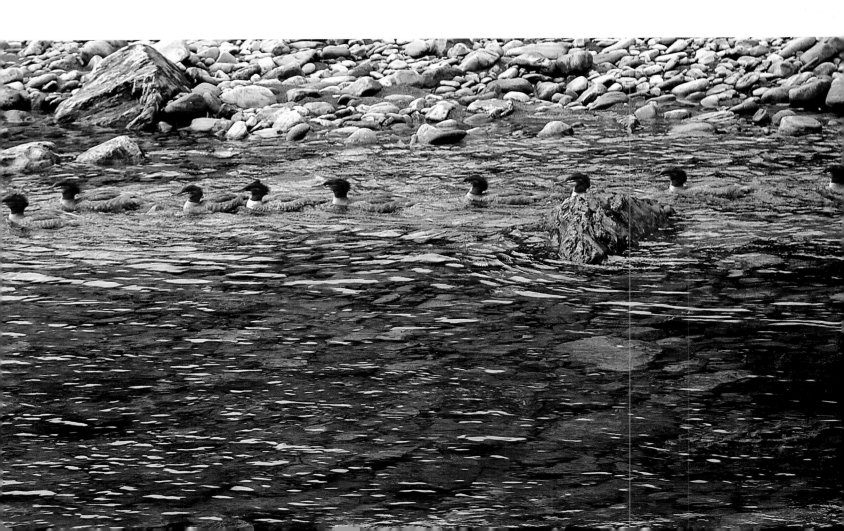

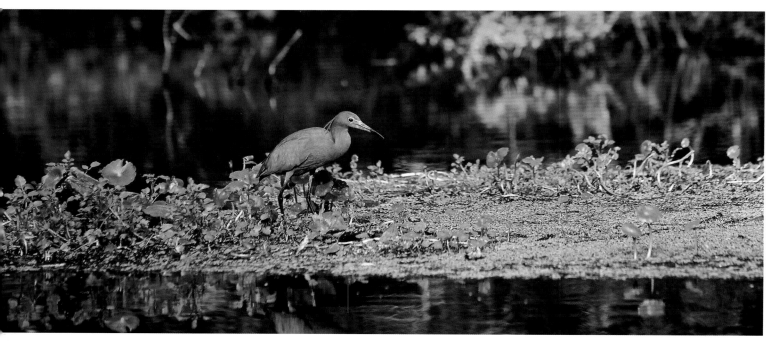

A little blue heron stalks along the fruitful waterline of the Wekiva River near Orlando, Florida. Only a few wild and scenic rivers have been set aside in the biologically rich subtropical ecosystems of the Deep South.

these rivers through the years, and as I've met conservation advocates and wild and scenic river managers, I've become fascinated by the accounts of how each waterway was protected. Some of those stories are told here.

As the heart of this book, a portfolio of photographs in chapter 5 showcases our wild and scenic rivers. Captions introduce readers to the splendor, ecology, and allure of these special places. Then chapter 6 considers efforts closely related to the wild and scenic designations, and chapter 7 probes the challenges ahead. It's my hope that—like tributaries to the greater flow—these stories and pictures might each add to the understanding and to the inspiration of all who care about rivers.

Every stream in the wild and scenic system was added because people were motivated to save their waterway, if not from the explicit threat of a dam that would completely bury their place under a reservoir, then from strip mining, clear-cutting, or overdevelopment. Every river here represents an expression of special care for wild frontiers or familiar homelands. Furthermore, the results of wild and scenic work extend far beyond riparian banks. History shows that when we save a river, we save a major part of an ecosystem, and we save ourselves as well because of our dependence—physical, economic, and emotional—on the water and its community of life.

With breaking waves, the Rogue River churns through
the Pacific Coast Range on its way to the Pacific.

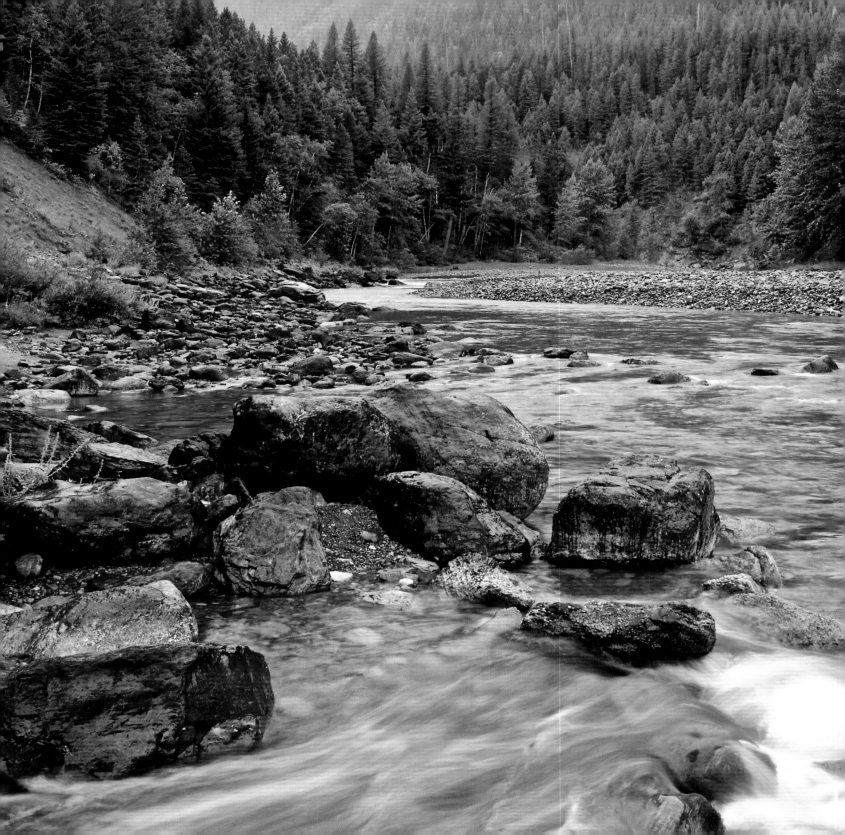

Changing the Currents of the Past

Even though they moved west after college, the twin Craighead brothers never escaped outdoor memories of growing up along an Appalachian river. "As kids we canoed and swam in the Potomac," John remembered in an interview with me at his wildlife research center in Missoula, Montana. "Up at the Seneca Breaks we caught bass and drank from the river. Bald eagles nested there."

John and Frank Craighead settled in Montana and Wyoming, where they pioneered the modern era of wildlife biology. They adapted the first radio collars as a way of tracking wild animals' movements. They sought out temperamental grizzly bears in their winter dens. Yet, part of the Potomac stayed with the two scientists, fueling their love of rivers. They rafted upper Hells Canyon of the Snake, which—before three dams constructed by Idaho Power Company—still thundered with the majesty of the Grand Canyon itself. Even in winter they boated Idaho's Salmon River, legendary since the time of Lewis and Clark. They made films on the Salmon's Middle Fork, where they first publicized the term *wild river*.

Then came a quiet adventure that would change the course of river protection. The Craigheads returned home.

"Years after we had moved west, we went back and saw the Potomac," John recalled. With strip mining, the water had become polluted. Dams were proposed. "It wasn't anything like what we had known. I realized that we still had wild rivers in the West, but we wouldn't for long if we didn't do something to save them."

Opposite: The Middle Fork Flathead flows from the Great Bear Wilderness of Montana's Northern Rockies, where John and Frank Craighead conceived the idea of a national system of protected rivers.

Soon enough the Craigheads found themselves fighting an Army Corps of Engineers' plan for Spruce Park Dam on Montana's pristine Middle Fork Flathead. And it wasn't long until they realized that their river had become threatened because another dam proposal, on the Flathead's nearby North Fork, had been thwarted only because it would have flooded into Glacier National Park. Defeating one incursion simply pushed the problem elsewhere. The brothers realized that rear-guard battles, with net losses at the end of the day, would be an endless curse if there were not some viable initiative for protection.

Working toward that goal, Frank Craighead urged that rivers be systematically classified in a hierarchy that in the autumn 1955 *Naturalist* magazine he identified as "wild rivers, semiwild rivers, semiharnessed rivers, and harnessed rivers." He reasoned, hopefully, that once rivers were categorized, people would see the scarcity of quality streams, and support protecting them.

In the June 1957 issue of *Montana Wildlife*, John Craighead added to his brother's vision and wrote eloquently about the need to establish a system of protected rivers. Building on the wilderness preservation idea advanced by Aldo Leopold thirty years before, Craighead wrote, "Rivers and their watersheds are inseparable, and to maintain wild areas we must preserve the rivers that drain them." Wild rivers were a "species now close to extinction" and were needed "for recreation and education of future generations." The idea percolated steadily in Craighead's mind and, ever the scientist, he wrote in the autumn 1965 *Naturalist* that wild rivers were needed as "benchmarks" for comparison of environmental changes.

"I had worked on the wilderness legislation with Olaus Murie, Howard Zahniser, Stewart Brandborg, and others," John recalled, "but they were most interested in specific areas of wilderness, many of them without rivers. The more I became involved, the clearer it became that we needed a national river preservation system based on the wilderness system, but separate from it."

The Craigheads' idea of protecting a criterion group of rivers appeared on a stage where rapid development was taking place on rivers across America. The Mississippi, Tennessee, and Ohio had been flooded with reservoirs back-to-back. Blocked by dams, then diverted, the Colorado shrunk to bone-dry on reaching Mexico. Because of dams, the world's finest salmon runs were reduced to a token few in the Columbia basin. Plugged in fourteen hundred places, California rivers were diverted to serve perpetual booms of sprawl and agriculture. Wild rivers in nearly every region of the United States were becoming scarce.

By the mid 1960s, seventy thousand sizable dams had been built and thousands more were proposed or under construction, with no end in sight. The Delaware was to be flooded in Pennsylvania, the Allagash and Saint John in Maine, the Middle Fork Eel in California. At the Yukon River in Alaska, a reservoir the size of Lake Erie spilled across the drawing boards of an eager Army Corps of Engineers.

The Tuolumne River's Hetch Hetchy Valley in Yosemite National Park had been dammed after John Muir's last heartbreaking battle, but that precedent of building dams in National Parks was overturned in the 1940s at the North Fork Flathead in Glacier National Park and Kings River in California. Then in 1955 conservation groups faced a higher-profile dam-fight to spare the Green and Yampa Rivers in Dinosaur National Monument from Echo Park Dam. They prevailed, but the dam was cleverly moved downstream—beyond national park or monument boundaries—where it flooded the Colorado's Glen Canyon, to the extreme regret of a privileged few who had seen that desert Eden. Until the 1960s, conservationists had mobilized for protection of only a few rivers, mostly where national parks were imperiled.

Then, after an ill-conceived plan to dam the Grand Canyon further escalated the fight for free-flowing streams in the 1960s, citizen opposition arose at scores of sites, including the Middle Fork Flathead where the Craigheads battled—activism described in detail in *Endangered Rivers and the Conservation Movement*. Concerns now ranged far beyond national park boundaries. Dozens of dam fights were lost, but after determined campaigns, citizens successfully defended other rivers, including New York's Hudson for its beauty and wildlife and Oregon's Rogue for its rich runs of salmon. Landowners banded together to save riverfront homes in farms and towns, anglers fought for their favorite haunts, and paddlers organized to prevent their finest whitewater from being entombed and their favorite river trips from going the way of Hetch Hetchy.

Uncoordinated battles to save rivers multiplied and, like the Craigheads, more people became aware that America was running out of natural streams. Meanwhile, the costs of development escalated. Under greater scrutiny, economic justifications of further dam-building began to fail. Alternatives were promoted to better meet needs. Scientific expertise increasingly backed conservation. Dam fighters became politically savvy. Yet still the threats continued and—as the Craigheads realized—opposing them one by one after commitments for development had hardened still put river protectors on the losing side.

Like the Craighead brothers, Paul Bruce Dowling had spent his youth in the Appalachians of central Pennsylvania and had become a wildlife biologist. He moved halfway across the country and, as secretary of The Nature Conservancy's budding Missouri chapter, volunteered with the Current River Protective Association, which proposed a "river park" with public recreation sites instead of a planned reservoir.

Dowling wrote to Senator Stuart Symington asking for a federal study of protection options countering the dam.

In an interview with me in the Washington, DC, headquarters of Dowling's America the Beautiful Fund in 1983, he recalled, "Across the country we had national parks, and here I saw the potential for 'national rivers'— maybe ten or twenty of the unique gems—free-flowing streams representing the different physiographic regions." Symington agreed, and put in a request, and in 1956 the National Park Service responded by proposing the Ozark Rivers National Monument. At hearings in 1957 Dowling made the first reference to "national rivers" as a designation.

Ted Swem, director of National Park Service planning at the time, recalled to me how he and his staff, receptive to these ideas, were soon drawn not just to the protection of parks, but to whole river corridors. "We hoped that the Current River proposal would be prototypical, and that we could come forth with other river proposals." Swem's team studied Montana's Missouri River below Fort Benton in 1959 but were thwarted by federal agency infighting. For Maine's Allagash, they proposed a national recreation area, promptly vetoed by influential logging companies and the state. They considered Florida's Suwannee, finding little support.

Undeterred, two of Swem's staff, both paddlers and fishermen of long standing, took the initiative. John Kauffmann of Washington, DC, embraced a long tradition of canoe culture, paddling wherever he could to experience the timeless flow of rivers and later writing *Flow East*. Stanford Young, a westerner, fell in love with steelhead fishing in Pacific-coast waters. Without congressional authorization or even much direction from their own agency's leadership aside from Swem's go-ahead, the planners began to lay the framework for a national rivers system, all in a way that today's bureaucrats can scarcely imagine within the constrained political climate of modern times. Swem's staff began to think big about changing the way the government functioned when it came to water. He recalled that

after studying protection options for the Current, Allagash, and Missouri, they "began talking about the possibility of a *system* of rivers."

Meanwhile, President Eisenhower had taken a curious stand against federal dams. This was not because of any ideology shared with the Craigheads, Dowling, or Kauffmann, but rather in opposition to what his fellow Republicans called "creeping socialism." Instead of public investments, Eisenhower wanted private development of remaining dam sites. Indeed, power companies were poised to do the damming—and profiting—themselves. However, with lingering New Deal populism, the Senate was unconvinced that private utilities would best serve the people. Perhaps more to the point, senators had already become entrapped in what would later be called the dam builders' "iron triangle." The first side of this institutional bulwark was the dam-building bureaucracy—the Army Corps of Engineers and, in the West, the Bureau of Reclamation. The second was the constituency of local boosters—bankers, realtors, contractors—all hungry for federal largesse in construction money. On the third side sat politicians that the local boosters elected to office. Buying into the Iron Triangle's machinations, the Senate formed a Select Committee on National Water Resources to retaliate against Eisenhower's attack.

Ted Schad, staff director of the committee, had come from solid development lineage as a Bureau of Reclamation budget director justifying the ill-fated Echo Park Dam and others. But in a weekend hiking group he happened to meet Wilderness Society director Howard Zahniser, whose weighty charisma influenced the young bureaucrat. "Zahniser convinced me that Echo Park Dam should not be built," Schad recalled in an interview with me at his retirement home in suburban Washington. Moving up the career ladder to the US Bureau of the Budget, Schad professionally adjusted to the needs of his new boss, and

wrote Eisenhower's water projects veto messages. But then migrating to the Senate Select Committee's new staff, he again found himself working under politicians eager to build dams with taxpayer dollars.

A credit to open-mindedness, Schad could see dam building both ways—private and public. And owing to Zahniser's influence, he was even willing to listen when, at a Senate field hearing in 1959, the ruggedly built, sun- and wind-weathered Craighead brothers appeared out of nowhere. Undeterred by the hostile political environment, surrounded by the frowns of local boosters, and facing politicians unabashedly enamored of the Iron Triangle, the matched pair of grizzly-bear aficionados boldly articulated their vision of what America really needed—not more dams endlessly plugging more rivers—regardless of who built them—but just the opposite. We needed a system of federally protected waterways where there would be *no* dams. They didn't realize that there was one receptive face in the crowd—Ted Schad's.

Now aware of the larger picture, and moved by Zahniser's gospel with a Craighead flair, Schad sat down to pen the highly anticipated Select Committee's 1961 report. Couched there within the senators' predictable glow for concrete, and with a shameless echo of the Craigheads' rhetoric, Schad recommended that "certain streams be preserved in their free-flowing condition because their natural scenic, scientific, aesthetic, and recreational values outweigh their value for water development and control purposes now and in the future." It was a revolutionary idea—especially for a committee whose existence was predicated on the promotion of federal dams.

With the slightest hint of a smile in our 1983 interview, Schad admitted to me that his senators may not even have noticed the wild river recommendation. It was one of many. The committee adopted the report without discussion of the protection idea. This modest startup was

A dam proposal here in Copper Canyon of the lower
Rogue River provided impetus for local fishing outfitters to
support the creation of a wild and scenic rivers system.

Congress's first endorsement of a national rivers system—an idea that would amazingly progress from such tenuous and, one might say, shrouded beginnings to gain widespread bipartisan support under the full light of day.

With a stroke of good timing, the professional river advocates at the Department of the Interior had meanwhile been pushing in the same direction. Kauffmann and Young planted seeds in the other house of Congress, through the Committee on Interior and Insular Affairs, which reported, "There still remain in various sections of the country natural free-flowing streams whose integrity might be preserved in the face of the water-control onslaught if conscientious planning to this end were applied."

Picking up on the theme in 1962, members of the interagency Outdoor Recreation Resources Review Commission issued what soon became a classic report, *Outdoor Recreation for America*. Pathbreaking in many ways, it stated, "Certain rivers of unusual scientific, esthetic, and recreation value should be allowed to remain in their free-flowing state and natural setting without man-made alterations." In this skillful policy proposal, the enthusiastic Interior Department planners had laid the Wild and Scenic Rivers groundwork.

Now they waited only for a leader who was ready to act.

"As a congressman in the 1950s, I was pro-dam," lawyer Stewart Udall confessed in a 1983 interview with me at an unlikely coffee shop near the University of Pittsburgh, where Udall—in "retirement"—was amassing evidence for a court case on behalf of Navajos aggrieved by radioactive waste and the Atomic Energy Commission.

"I voted for the upper Colorado project that flooded Glen Canyon."

Udall hesitated for a few seconds and a sip of tea to let this disconcerting fact sink into my brain. Since the 1960s, Glen Canyon's flooding had become eulogized as the ultimate sacrifice to the altar of excessive water development.

This unparalleled loss became known as "the place that no one knew." David Brower—America's ranking conservationist for half a century—repeatedly recounted his failure to halt that dam as the "greatest sin" of his life.

Udall explained, "I instinctively identified my values more with the Sierra Club than with dam building, except that I was from Arizona, and you couldn't go to Congress from there and be against dams."

On a field trip, rarely allowed by hard-nosed committee chair Wayne Aspinall, Udall and his family were among the last groups to float through Glen Canyon before it was drowned. Each day was more beautiful, more sublime, more at peace than the last, Udall recalled. But too soon, the trip ended. As the young congressman stepped off his raft, he knew that he would never see the living canyon again.

"I got off the river with very mixed feelings," he recalled. "I didn't feel guilt stricken, but I kept saying to myself that we hadn't done a very good job in the West of achieving balance. In deciding where to put dams we had made mistakes. So I began to have doubts."

Then, in 1961, with a fateful move for the entire American landscape, President Kennedy appointed the privately doubtful but politically adept Arizona congressman as secretary of the interior. "Suddenly I had the national responsibility," Udall recalled, "and that put on my shoulders the burden of thinking for the nation and not just for Arizona, which is what a congressman would do when it comes to water."

Udall personified the upheaval happening in water development philosophy. He had supported dams that were the epitome of river destruction. But with the help of advocates and professionals who were working to save their rivers, and inspired by the heady alchemy that effervesces when a person clutches a paddle, steps into a canoe or raft, and kicks off from shore, Udall saw with increasing clarity the need for preservation. He would grow to

stand uniquely as a river developer and a river saver both, bearing the complications and compromises inherent in holding two opposite views at once. Yet, avoiding both paralysis and the sway of sharp-suited lobbyists that inflict lesser politicians who find themselves on the fence, Udall felt empowered by his new insight. Thinking of Glen Canyon, forever gone, he gained courage to act on his views.

During Udall's first year on the new job, a prescient Senator Edmund Muskie, from Maine, urged the secretary to tour the Allagash River, threatened by dam builders. The experience "took" for Udall, who shed more of the baggage he had carried as a dam-loving westerner. He committed to helping Muskie spare the most iconic river of the North Woods—an effort chronicled by historian Dean Bennett in *The Wilderness from Chamberlain Farm*.

A few months later Udall paddled on Missouri's Current River with local advocate George Hartzog, who was so persuasive and competent that Udall later appointed him director of the National Park Service. Udall and his family were also guided down the Snake River through Grand Teton National Park by the illustrious guide, Verne Huser. "I pumped him full of river magic," Huser still vividly recalled in a 2015 interview along the Rio Grande, where the inveterate eighty-four-year-old river guide was still leading field trips and turning people onto nature. All told, it was a lot of river time for Udall, the son of Mormon ancestors who had pioneered settlement of the American desert with the likely belief that the most beautiful river was a ditch running full to a field of alfalfa.

Then came an even greater catalyst for Udall's portentous commitment to free-flowing streams. Dworshak Dam on Idaho's North Fork Clearwater was slated to terminate the premier steelhead run on the continent, along with a wildness whose loss loomed tragically unconscionable in the mind of anyone who had ever set foot in the verdant place. "Conservationists opposing it came to me

and wanted me to help in the fight," Udall recalled. Unfortunately, the fate of that Edenic Northern Rockies enclave had already been politically packaged and sealed. Yet the Clearwater's loss made the plight of too-much-damming all the greater in Udall's mind. "It dramatized for me the flaws and misconceptions in the dam-building philosophy of the New Deal. For me, this is where the kernel of the idea for the wild and scenic river bill came from." With publication of *The Quiet Crisis* in 1963, Udall wrote, "Generations to follow will judge us by our success in preserving in their natural state certain rivers having superior outdoor values." He specifically mentioned the Allagash, Suwannee, Rogue, Salmon of Idaho, Buffalo of Arkansas, and Ozark Mountain rivers of Missouri.

As Udall continued with me in the Pittsburgh coffeehouse, his story got better and better. "Under President Kennedy, the Wilderness Bill was the landmark legislation. As it came closer to law, my thinking began to turn more toward rivers legislation that would complement and be another kind of wilderness bill." Udall had become familiar with the literature and asked Frank Craighead to prepare a policy paper on river classification. Then he wrote to his colleague, agriculture secretary Orville Freeman, to organize an interagency Wild and Scenic Rivers Study Team. Now emboldened in bigger ways, Interior staff led by Stanford Young asked for nominations from federal agencies and states in 1964. He and Kauffmann collected a list of 650 rivers, which they culled to 67 and then 22 for field studies.

Records of the 650 have ironically been lost to water damage at a federal storage facility. But a list of 74, which John Kauffmann assured me was similar to the original 67, was published in a Departments of Agriculture and Interior brochure called, simply, *Wild Rivers*. Kauffmann dredged this item of limited distribution from a trunk of personal archives at his retirement home in Maine and gave it to me when I visited him there several years before

he died. The list was obviously created by people who knew what they were writing about. But the most refreshing fact about this long-lost, half-century-old document is its independence from political constraints. It might be regarded as the original lineup of classic American rivers with natural values—perhaps the most politically unencumbered agenda for wild and scenic rivers ever articulated. Even today, it reveals much of the best of America's rivers estate.

Allagash, Maine
Animas, Colorado
Ausable, New York
Big Fork, Minnesota
Big Hole, Montana
Black Warrior, Alabama
Blackfoot, Montana
Blue, Indiana
Buffalo, Arkansas
Buffalo, Tennessee
Cacapon, West Virginia
Cache la Poudre, Colorado
Cheat, West Virginia
Clearwater, Middle Fork, Idaho
Colorado, Utah, Arizona, Nevada, California
Connecticut, New Hampshire and Vermont
Cumberland, Kentucky and Tennessee
Current, Missouri
Deschutes, Oregon
Eleven Point, Missouri
Feather, Middle Fork, California
Flathead, North, Middle, and South Forks, Montana
French Broad, North Carolina and Tennessee
Gasconade, Missouri
Gila, New Mexico
Green, Wyoming

Greenbrier, West Virginia
Gros Ventre, Wyoming
Guadalupe, Texas
Hoh, Washington
Hudson, New York
James, Virginia
Kern, North Fork, California
Linville, North Carolina
Little Wabash, Illinois
Madison, Montana
Manistee, Michigan
Methow, Washington
Missouri, Montana
Mullica, New Jersey
Namekagon, Wisconsin
Niobrara, Nebraska
Oklawaha, Florida
Penobscot, East and West Branches, Maine
Pere Marquette, Michigan
Potomac, Maryland, Virginia, West Virginia
Queets, Washington
Rio Grande, New Mexico, Colorado, Texas
Rogue, Oregon
Sacramento, California
Saint Croix, Minnesota, Wisconsin
Saint Joe, Idaho
Salmon, Idaho
Salt, Arizona
San Juan, Utah and New Mexico
Savannah headwaters, North Carolina, South Carolina, Georgia
Shenandoah, Virginia, West Virginia
Skagit, Washington
Smith, California
Snake, North Fork, Idaho
Susquehanna, New York, Pennsylvania

Suwannee, Georgia, Florida
Tangipahoa, Mississippi, Louisiana
Teton, Idaho
Upper Iowa, Iowa
Wacissa, Florida
Wapsipinicon, Iowa
White, North and South Forks, Colorado
Wind, Wyoming
Wolf, Wisconsin
Yellowstone, Montana, Wyoming
Youghiogheny, Maryland, Pennsylvania

While all these ideas for a national rivers system were emerging, the parallel track to protect Bruce Dowling's Current River had led to a stunning success. In 1964 the Ozark National Scenic Riverways were designated by Congress as America's first explicitly protected river corridor—a prototype to the wild and scenic rivers system. When the Wilderness Act passed the same year, Udall, his staff, and conservation leaders looked to their next opportunity.

"Sometimes you see two waves," Udall recalled, "and you jump on the second wave and ride it in." The timing of this politically savvy surfer was perfect. The idea gained traction with an ease to be envied in the decades to follow: "President Johnson's chief of staff kept saying, 'Johnson wants new legislation.' I told him about the wild and scenic rivers idea and he said, 'That sounds great, get it ready.'" It might have sounded "great" to that high-ranking bureaucrat because everyone, at the time, was aware of Lady Bird's love of nature and her advocacy for natural beauty, and of the First Lady's keen influence on the president.

Udall worked with amenable congressmen, and the first wild and scenic rivers bill was introduced in 1964 by Idaho senator Frank Church who, along with his wife Bethine, had a deep love affair with his state's resonantly free-flow-ing rivers—Salmon, Selway, Snake. For Frank Church, these called up emotions far stronger than any fear that the young congressman had of his state's aggressively right-wing, anti-federal bent.

Called the "Wild Rivers Act," Church's bill initially focused on the extraordinary rivers of the West. It was then broadened by Pennsylvania's conservation power-house, Representative John Saylor, to include "scenic" and "recreation" rivers. Senator Gaylord Nelson added the Saint Croix and its Wisconsin tributary, Namekagon, later quipping to me in characteristic style, "These were the bill's only rivers east of the Mississippi, though they weren't very *far* east of it."

The idea was bounced up from Secretary Udall, and in the 1965 State of the Union address, President Johnson urged approval of a wild rivers bill, stating, "We will continue to conserve the water and power for tomorrow's needs with well-planned reservoirs and power dams. But the time has also come to identify and preserve free-flow-ing stretches of our great rivers before growth and development have made the beauty of the unspoiled waterway a memory."

It was a pivotal moment in the history of river conservation: a president said that the time had come to not only develop our rivers, but to also protect them.

National conservation groups, canoe clubs, and dam fighters packed hearings on the bill in 1968. The hearing records reveal that, while expectations centered on great western streams such as the Middle Fork Salmon, it was the Saint Croix, Eleven Point, and Little Miami—all Midwestern—that received the greatest support. No surprise: each faced a dam proposal. So did the Rogue in Oregon, where the renewed specter of Copper Canyon Dam propelled normally conservative outfitters meeting at Illahe Lodge to urge their brand new senator, Mark Hatfield, to help. The Middle Fork Feather in California was added

to the bill even though two dam sites had already been approved by the state.

But with a lofty air of entitlement, as if they had never been defeated at Echo Park thirteen years before, the federal dam builders weighed in for their favorite projects. Characteristically boasting ownership of an entire region, Tennessee Valley Authority Chairman Aubrey Wagner objected to the French Broad River and also to the Little Tennessee where Tellico Dam was proposed. Embedded in the iconography of the West, Wyoming's Green River—with postcard-perfect Squaretop Mountain towering at its headwaters and recognizable owing to any number of cowboy movies—was reserved by the Bureau of Reclamation for a speciously justified irrigation dam to water a few desert cattlemen. The upper Skagit was hastily removed from the bill at the request of Seattle City Light, which proposed Copper Creek Dam to complete its existing complex of massive dams and reservoirs already sprawling the whole way into Canada. The Tocks Island Regional Advisory Council supported protection of the Delaware, but only above Tocks Island Dam site, where the powers-that-be didn't even imagine the sophisticated army of citizen opposition that was staging to rise up against them.

Among those contested dam sites, only Tellico was ever built. After the Little Tennessee's near-miss as a wild and scenic river, one of the classic 1970s dam-fights there sought to expose the economic absurdity of the dam (a cabinet-level committee ruled that the project's total accumulated benefits would not justify even the final 5 percent of expenditures to finish the dam). But the valley was

The Rio Grande was one of twelve rivers and tributaries protected in the original Wild and Scenic Rivers Act of 1968. The river courses through volcanic rock of northern New Mexico in Rio Grande del Norte National Monument and charges onward through whitewater torrents of the Taos Box.

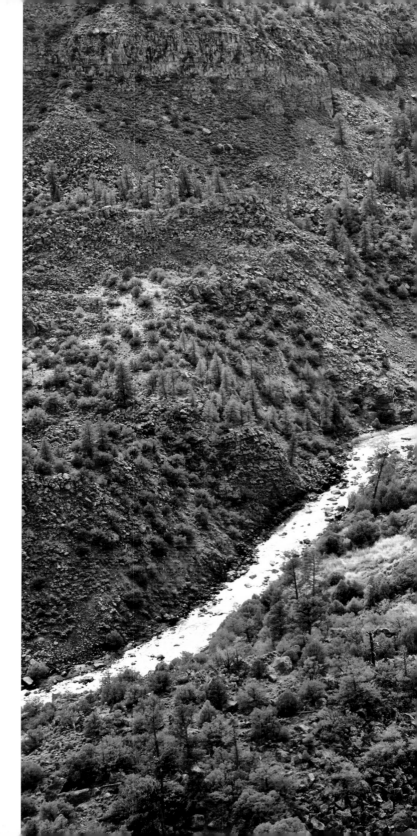

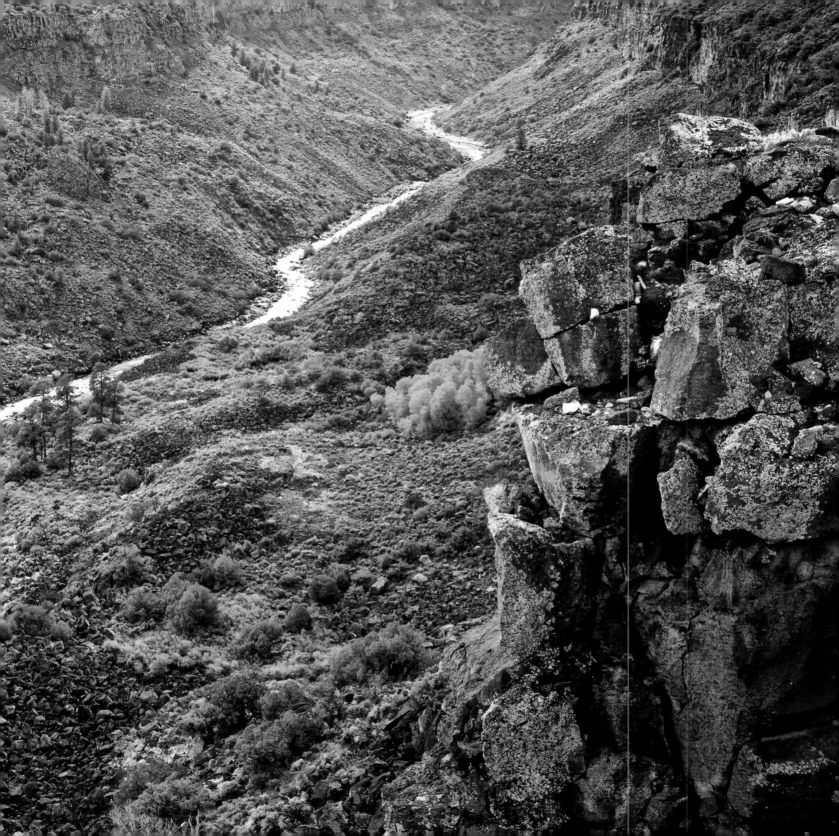

ultimately flooded, including heartland of the Cherokee nation, beloved homes of Appalachian farmers, and the last known native habitat of a small endangered fish, the snail darter. This heart-rending tale was told thirty-seven years later in *The Snail Darter and the Dam*, by Zygmunt Plater, the thirty-four-year-old lawyer who successfully and almost single-handedly argued his case before the Supreme Court and spent years in the river's defense, only to lose with enactment of a late-night congressional amendment obviating all other federal laws and executed from beginning to end in forty-two seconds. Forty-two.

None of the other dams in question were built. But the exclusion of those rivers from the wild and scenic bill was testament to the dam builders' lingering power in a time of change.

With opposition more home-spun and enduring, West Virginians fearful of a government "land grab" rejected the Potomac and its stellar tributaries in antigovernment, pro-landowner rhetoric later claimed by the so-called wise use movement of the 1980s. Key tributaries—Shenandoah and Cacapon—were dropped in the bill's final draft.

Wanting no wild and scenic rivers at all, the irrigators' National Reclamation Association countered that "the concept does not conform to the principles of multipurpose development." And at the House Committee on Interior and Insular Affairs hearing on July 3, 1968, fist-pounding Sam Steiger from Arizona growled, "Under the guise of protecting scenic values, this legislation will stifle progress, inhibit economic development and incur a staggering expenditure."

But Stewart Udall knew the opposition well. He had grown up with them. And he knew what he was doing. "We had the momentum," he recalled to me, "and the dam people who didn't like it just weren't in a frame of mind to fight it. I had been pretty good to them, giving them some of the things they wanted, including dams. So I looked them in the eye and said, 'We're going to balance things off.'"

Robert Eastman, later director of rivers programs for the Department of the Interior, reflected on the 1960s. "Back then, if you had a good idea, you could put it to work. The people were concerned about conservation. They wanted to protect natural places. Times were good, and people didn't mind spending funds on parks and rivers." Likewise, Ted Swem wistfully reflected, "I don't know if we'll ever have a period like that again."

Factoring into these professionals' insightful reflections on their times, the coming decades would show that the earlier conservation agenda benefitted by operating under the radar of landowner and anticonservationist agendas. Together these would lead to political organization assuring that advances of the 1960s will indeed not likely be seen again—at least not any time soon.

With bipartisanship unimagined for conservation issues today, the Senate had already unanimously approved the wild and scenic bill 84–0, and then it passed the House 265–7.

Eager to promote his domestic visions amid deepening darkness of the Vietnam War, on October 2, 1968, President Johnson signed the National Wild and Scenic Rivers Act into law. It designated parts of eight rivers plus four tributaries; really twelve rivers in all: the Middle Fork Clearwater with its branches, Lochsa and Selway, in Idaho, including the Penny Cliffs Dam site, the Eleven Point in Missouri, Middle Fork Feather in California, Rio Grande and its tributary Red River in New Mexico, Rogue in Oregon, Saint Croix and tributary Namekagon in Wisconsin and Minnesota, Middle Fork Salmon in Idaho, and Wolf in Wisconsin. The act also identified twenty-seven streams for study and consideration (eighteen of those were eventually designated).

Although an earlier draft had simply named one category of national river, the final law created three classes: wild, scenic, and recreational. Wild rivers are "vestiges of primitive America." Scenic rivers have "shorelines or watersheds

still largely primitive and shorelines largely undeveloped but accessible in places by roads." Recreational rivers "are readily accessible by roads" and "may have some development along their shorelines."

The classification system solely reflects the degree of existing development along the rivers and not other "wild," "scenic," or "recreational" attributes. Nor do the classifications dictate the full scope of management—that's left to specific plans. Rather, the classification system is an artifact of three factors. The initial rationale grew from work by the Craighead brothers proposing a "classification" of rivers to identify those most worthy of protection. Second, as the bill evolved, interest grew to include eastern rivers, and architects thought that special classifications were needed to accommodate less wild candidates. Finally, conservationists thought that a degree of refinement made a stronger bill. It's not apparent that anyone considered troublesome ambiguity that was introduced: some people would think that "wild" rivers mean dangerous whitewater. Others would assume that "recreational" rivers mean accommodation or enticement of crowds. Public under-

standing of the classifications would become a sticking point in many of the specific wild and scenic proposals to come.

Growing out of Senator Muskie's efforts to protect the Allagash, and the tightrope of state versus federal protection that he walked, the act allowed for state management of federally designated rivers—a provision enacted two years later for the Allagash and later still for twelve other rivers, with largely unsatisfactory results (see chapter 3).

Reflecting sharp foresight by its authors, the act quietly called for further studies of rivers that might be designated in the future, for agency recognition of additional rivers during regular planning processes, and for Interior and Agriculture department staff to aid states in protecting rivers through other means (see chapter 6).

What had begun with a love of America's rivers had turned to outrage at what was happening to them, and then these conflicting emotions were channeled into a visionary new law to protect America's finest streams. The powerful currents of history could be changed. But passing the Wild and Scenic Rivers Act was only the first step.

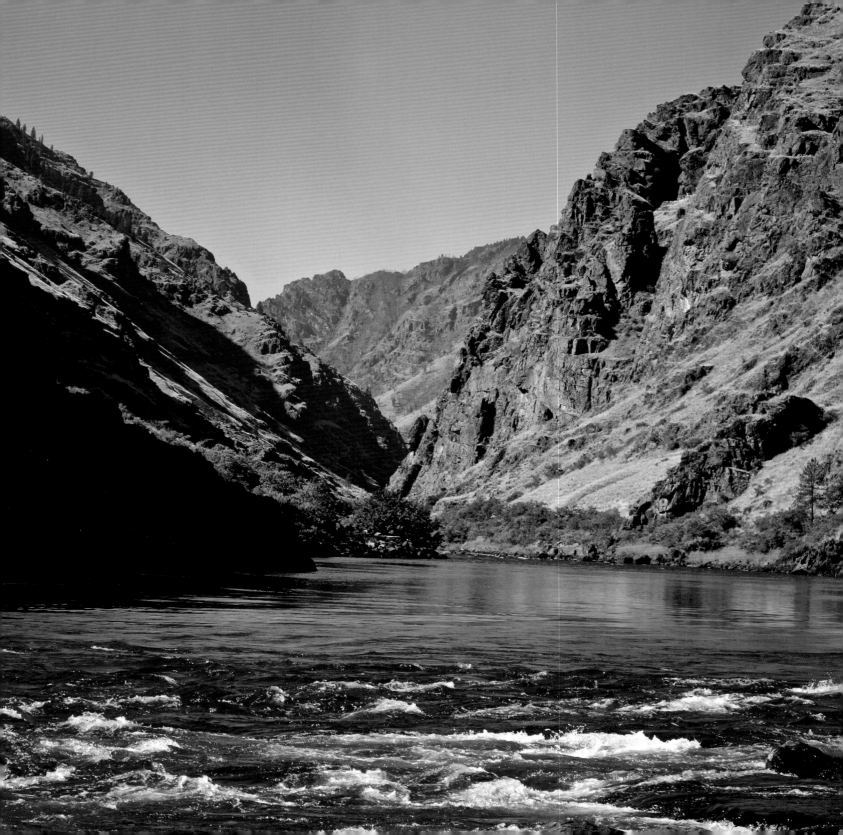

Preserving Spectacular Rivers

BUILDING A MOVEMENT

As the Craighead brothers had envisioned thirteen years before, river supporters in 1968 now had a program of their own. But the hard work of passing a law did not guarantee that much of consequence would result. The movement had only begun.

During the next few years little attention was given to expanding the wild and scenic rivers system of twelve initial rivers and tributaries. Yet there was no doubt that the program was intended to grow; a Congressional Report on July 3, 1968, had admitted that the number of rivers in the original act was "relatively modest . . . not because the committee believes that there are no other streams than those listed in the bill that deserve protection, but because the necessary studies have not yet been made."

Slowed but not stopped, dam builders in the early 1970s were still impounding streams all across America. They were running more on momentum than defensible economic or hydrologic rationale, but nonetheless, the politics supporting dam construction remained ironclad. Activists couldn't get ahead of imminent threats enough to work for long-term protection, and in an era that preceded the proliferation of river and watershed organizations that came two decades later, there wasn't much help to go around.

Owing to Senator Gaylord Nelson—personally committed to protecting the Saint Croix River ever since he had been Wisconsin's governor and perhaps before—the act was amended in 1972 to add more mileage there. Meanwhile, reports for some of the twenty-seven authorized study rivers were started by the Bureau of Outdoor Recreation

Opposite: Designation of the Snake River as wild and scenic in 1975 spared it from damming through Hells Canyon at the border of Oregon and Idaho.

(in the Department of the Interior) and Forest Service. But otherwise the wild and scenic program languished. It had always been championed by supporters within the bureaucracies but lacked an organized citizen constituency, and most of the public support had been directed at a few specific rivers. The Wilderness Act, in contrast, had attracted an impassioned cadre, loyal not just to a few wild lands that they knew, but to the *idea* of wilderness. The Wilderness Society had been organized decades earlier by Bob Marshall and other luminaries of the early conservation era, and it promulgated a wilderness philosophy with whole books and conferences dedicated to its meanings and applications. Meanwhile, river consciousness seemed to be stuck in incubation mode, with scarcely a book, research paper, or political essay on the subject.

For the same reasons that a protected rivers system had not been advanced earlier, river conservation remained low on the list for national environmental groups, busy with wilderness, parks, wildlife, water quality, air pollution, and stopping nuclear power plants. State groups for river conservation had begun to be formed, such as Rivers Unlimited in Ohio in 1972 and Friends of the River in California in 1973, but no group stepped up to advocate for the national wild and scenic system.

Recognizing this vacuum five years after the legislation was passed, biologist and whitewater canoeist Jerry Meral, who had founded Friends of the River to fight New Melones Dam on California's Stanislaus River, called for a "coalition on American rivers" with an article in the American Whitewater Affiliation (now American Whitewater) journal. Bruce Hannon, who later led the battle against damming Illinois' Sangamon River, also made the case. A discussion was started, and in March 1973, thirty-three conservationists met in Denver at the invitation of Coloradoan Phil LaLena. The group included Meral, Claude Terry from Georgia, Mike Fremont from Ohio, Jerry Mal-

lett from Colorado, Rafe Pomerance (who later served as director of Friends of the Earth), and Dave Foreman (who later started Earth First). They formed the American Rivers Conservation Council (in 1988, under the leadership of Ken Olson, the name was shortened to American Rivers, which I use throughout this book). Brent Blackwelder, of the Environmental Policy Institute, was everyone's choice as chairman.

Son of a minister, Blackwelder had begun his secular mission for the environment by fighting trumped-up dam-building plans of the Soil Conservation Service. Then he brilliantly led some of the country's greatest battles against uneconomic dams and megalithic water developments, including Tocks Island Dam, Dickey-Lincoln Dam, and the Tennessee-Tombigbee Waterway. A master of analysis, logic, and political debate, Blackwelder seemed to be half a thoughtful and kindly college professor and half a cold-blooded political operative. With an unwavering fervor to protect rivers and to correct a century of wrongs on the American landscape, he testified to Congress one hundred times and became the chief spokesman of dam-fighting in an intensely consequential age of river conservation lasting until 1980—an era when the high-stakes battles meant protecting a river or seeing it totally disappear beneath the flat water of a new dam.

Even in 2015, Mike Fremont—still racing canoes and running marathons at ninety-three—clearly recalled the determined spirit of the Denver meeting. "Eventually we got to where we knew money was needed, and Brent threw a hundred bucks down. Everybody pitched in and pretty soon we had a few thousand dollars to start an operation." Formed explicitly for the purpose of advancing the wild and scenic system, the group remains the only one at the national level embracing the rivers program in its core mission. Thus, the story of American Rivers is intimately linked to the history of the wild and scenic program, and vice-versa.

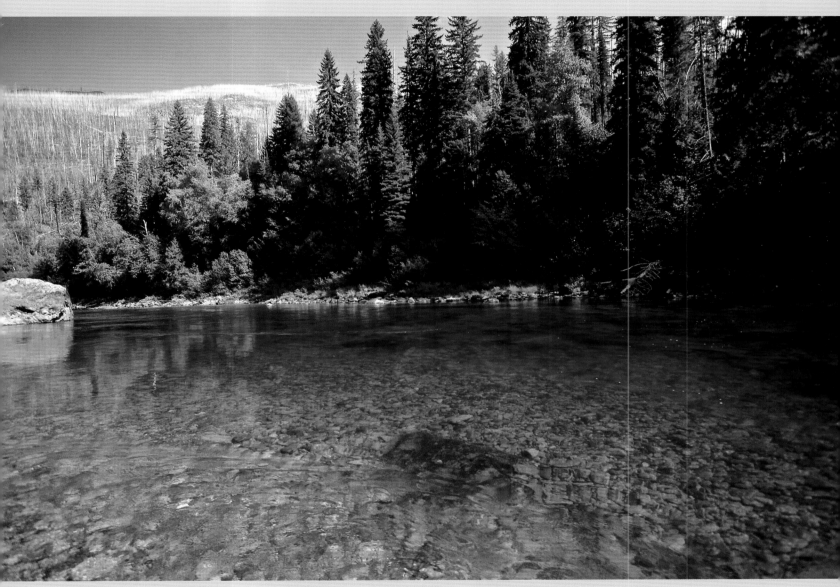

Crystal-clear waters of the North Fork Flathead were named wild and scenic in 1976, along with the South Fork above Hungry Horse Reservoir and the Middle Fork. Excellent water quality is one of the attributes that justifies designation.

For director, at $400 a month, a committee of the board hired a fiery young activist, Bill Painter. He was a veteran of the 1970 environmental teach-in at the University of Michigan, which preceded the nationwide 1970 Earth Day celebration instigated by Senator Gaylord Nelson, propelling thousands of young Americans on the path of environmental activism. Three years later Painter became American Rivers' one-man staff in a stiflingly cramped two-man office, literally thigh-deep with Blackwelder's mountain of unfiled reports, memos to everyone, and multiple legislative drafts constantly under strategic and consequential revision. Painter's no-nonsense Virginian mountain drawl complemented Blackwelder's finely studied approach and tone. Undeterred by the challenges facing him, Painter soon committed to the New River of North Carolina as the test case for his untried, unknown, freshly budding organization of a few hundred souls, at most.

The Blue Ridge Hydroelectric Project had already been licensed to dam the New, and opposition to it was hopeless by any definition. Riverfront land had already been condemned by the private power company. Appalachian residents had already been roundly kicked out, leaving tumbledown remains of a mountain culture in ruins. But even as the construction schedule loomed and the bulldozers figuratively lined up, opposition grew angrier. And smarter.

Painter learned his political ropes by sudden and total immersion, setting a pattern for his new organization as the Washington, DC, connection for citizens battling dams. Buttressed by economic arguments and support from the state government, which maddeningly failed to thwart the Federal Power Commission from allowing the private utility to steamroll onward across the state's citizens and geography, American Rivers succeeded in nationalizing the loss of "the world's second oldest river." Its path had predated even the uplift of the ancient Appalachians. Painter's allied band of river folk and the North Carolina governor eventually persuaded the secretary of the interior

to stop the dam by administratively designating the New as wild and scenic in 1976.

The New emerged as a game changer. Through wild and scenic river designation, a dam was stopped where construction had been virtually assured. Painter, Blackwelder, and their gutsy little army of river aficionados reasoned that if they could stop the damming of the New, they could stop any ill-conceived water project they set their minds to. The coming years would show that this was almost true.

Meanwhile an equivalent drama had unfolded in Hells Canyon of the Snake River at the supremely rugged, remote, wild border of Idaho and Oregon. The canyon's upper half had been blithely inundated for hydropower in the 1960s, and the lower half had been slated for what was arguably the worst dam proposal in American history. A seven-hundred-foot Bureau of Reclamation edifice, ironically called Nez Perce after the Indians who had been illegally and violently evicted a century before, would have flooded not only the remaining half of Hells Canyon, but also Idaho's Salmon River. The dam was slated to block the greatest run of Chinook salmon the world has ever known and drown the heart of the West's largest wilderness. That dam was stopped but, in the compromising tenor of the times, and reminiscent of the Craigheads' Flathead experience, the dam builders simply migrated upstream above the Salmon River confluence in order to begrudgingly spare the ranking poster child of wild America.

There in Hells Canyon of the Snake, competing private and federal sponsors vied for the coveted permit, stairstepping their jealously jurisdictional squabble up to the Supreme Court, where no one expected Justice William O. Douglas to play a profoundly wild card. An unabashed outdoorsman and river lover, Douglas declared that the Federal Power Commission must consider not just *who* would be privileged to dam the Snake, but whether or not the river should be dammed *at all*.

Taking the liberal justice's opinion in stride, the dam builders proceeded as if entitled until unexpectedly halted in their tracks by a fearless and articulate Sierra Club lawyer just starting his career in Seattle. Brock Evans one day answered the door to the surprise visit of Floyd Harvey—an Idaho jet-boater (later turned rafter) who loved Hells Canyon and persuaded Evans to intercede. The young lawyer hustled and filed an appeal minutes before midnight of the deadline. This triggered a multiyear delay, allowing a tenacious cadre of dam fighters to gradually gain political traction, starting at a flat zero and ending with Idaho governor Cecil Andrus declaring the dam would be built "over my dead body." With commitments like that, river advocates turned to the new Wild and Scenic Rivers Act, along with national recreation area status, for permanent protection of the lower half of the original Hells Canyon in 1975.

As the New and Snake campaigns neared their cliffhanger climaxes, the Chattooga—a popular and unquestionably superlative whitewater river flowing through national forests in North Carolina, South Carolina, and Georgia's surprisingly rugged mountains—was bursting at the seams with thousands of visitors drawn, for better or worse, in the strange and lurid wake of the dark movie *Deliverance*, which had been filmed there. Local Sierra Club activists realized that wild and scenic status could give the Forest Service the push needed to manage the boom, which was destined to outlast the initial fad and continue through an enduring era of blossoming river recreation. Claude Terry, a microbiologist and rafting outfitter—who, along with his engineer pal and whitewater pioneer Doug Woodward, had gained notoriety as a stunt-man-canoeist shredding Chattooga rapids in *Deliverance*—was active in the campaign. Governor Jimmy Carter wanted to see the controversial river, and his path led to Terry, who several times guided the adventurous statesman down the steep rapids, not from the relative safety of a raft, but in a canoe. Meanwhile, tire-less campaigning by the Georgia Canoeing Association had built support from the state's senators. But for unknown reasons, Henry Jackson from the state of Washington held the bill hostage in his Senate committee.

Alerted to the impasse, Terry took advantage of his special paddle-partner acquaintance and phoned the governor direct. You could still do that in Georgia, and the governor had evolved into one of the most enthusiastic river supporters ever to cross the American political canvas. With no need to recount their memorable whitewater adventures, Terry urged for support in his persuasive local drawl. Carter, it turned out, had backed Jackson's presidential bid in 1972, and so telephoned him with a message no less transparent than Terry's own message to the governor: you owe me one. The Chattooga thus became the South's first wild and scenic river in 1974. "Lots of folks deserved credit," Terry later recounted, "but the victory was really Jimmy Carter's."

With a bit less drama but no less significance, the three forks of Montana's Flathead were added in 1976. The designation included the Middle Fork's Spruce Park Dam site where the Craighead brothers had first conceived of the national system of rivers in the 1950s, finally closing that milestone chapter in the history of river conservation (though management issues of gas drilling along with coal mining in Canada's portion of the North Fork basin would not be resolved for three more decades). The same year, on the upper Missouri, where Ted Swem and his talented team had proposed national protection in their pioneering studies of the 1960s, 149 miles became wild and scenic.

Another three rivers in that era were designated through the act's alternative process: by the interior secretary at the request of a governor. First came the Allagash in 1970. Though the federal role was greatly diminished from a "National Riverway" first envisioned by Stewart Udall to a state-administered wild and scenic river, the Allagash's inclusion completed a cycle that Senator Muskie had started

with the new secretary several years before (the even-greater wildness of the nearby Saint John River was implicitly sacrificed in the process, though Dickey-Lincoln Dam there was later stopped by other means and, ironically, over Muskie's vehement objections). Then in 1973, at the urging of a politically savvy Cincinnati newspaper editor, Glenn Thompson, and championed by Mike Fremont and others as Little Miami Inc. (now Little Miami Conservancy), the midwestern river worked its way up from state to national designation. Ohio's Little Beaver followed in 1975.

These designations completed protection for all rivers that had been initially considered prototypes by the early visionary Interior Department planners, with the exception of the Suwannee, where state action was recommended in 1974. This failed, but in what should have been a model for the nation, a real-estate transfer tax later funded acquisition of Suwannee riparian frontage at a basinwide scale, and success was achieved at an otherwise unimagined level.

By 1977, 1,655 miles on nineteen river sections were designated. At that juncture, Painter moved on to a job with the Environmental Protection Agency and Howard Brown, who had analyzed water projects for the Congressional Research Service, became American Rivers' second director. His knowledge of water policy proved valuable in the Carter years when administration reformers aimed to recalibrate rules that had long tilted the playing field sharply toward water development. However, every new opportunity to safeguard rivers met with renewed barriers to changing the entrenched ways we treated our streams.

OVERCOMING RESISTANCE

Through the 1970s, dam builders who had not given up on their myriad plans doggedly resisted river protection, and another wave of antagonists gained purchase: private landowners. Soon leaving their fear of the dam builders behind, they now turned a less-legitimate fear of con-demnation against the river protection movement and began to angrily mobilize along private-land rivers of the East. Early on, architects of the wild and scenic law had heard from people who feared a federal "land grab," and so the act prescribed tight limits on acquisition authority. Within those limits, eminent domain was occasionally used to protect crucial frontage along a few of the earliest wild and scenic designations—Saint Croix, Eleven Point, Rio Grande, and Rogue—but even there, most was for easements that allowed people to remain living on their property. Nonetheless, protest increased, and agencies responded by abandoning the use of eminent domain. But that was not enough. Skeptical landowners, in an era of growing antagonism against all government, reasoned that condemnation might, in some cases, be *possible*. With cynicism of the post-Watergate era ripening into paranoia, many landowners flatly opposed any protection overture whatsoever under the assumption that their land would ultimately be condemned.

Also stunting growth, an official wild and scenic study of a candidate stream could drag on for seven years. Then an unfriendly administration could stall action indefinitely at the Office of Management and Budget. The General Accounting Office pulled no punches regarding these sticking points in its 1978 *Federal Protection and Preservation of Wild and Scenic Rivers Is Slow and Costly*. "The national system is growing slowly, and processes for adding rivers are not functioning well."

Onto this stage of disappointment, incisive criticism, and outright backlash, California representative Phillip Burton arrived like a congressional hurricane with an infusion of old-fashioned raw political power more fitting to the era of John Saylor or of far less benevolent political bulldogs from the past. Though he lacked the river-centric motivation that fueled the spirits of Saylor and Senators Nelson and Church, Burton happened to fall into chairmanship of the House Interior and Insular Affairs Sub-

Two sections of the Delaware plus nine other rivers and tributaries were included in the Burton Bill of 1978—the largest addition to the wild and scenic rivers system since its passage a decade before. This legislation eliminated the Tocks Island Dam proposal. The upper Delaware later became a battleground of controversy and an impetus to change the way planning was done along private-land rivers. The lower Delaware, shown here at Uhlerstown, Pennsylvania, was added to the program in 2000.

committee, and if he was going to be chair, he was going to do it right. Cashing in on political debts and shamelessly coercing those he could not convince, the red-faced, gesticulating, arm-twisting, knuckle-squeezing Burton led passage of the National Parks and Recreation Act of 1978 as no one else could possibly have done.

This largest parks bill in history not only moved rivers to the forefront of conservation policy but also changed the rules of land protection in America. It designated the middle Delaware as wild and scenic, where Tocks Island Dam had been virtually assured before melting down under organized citizen opposition, starting with a sensibly harsh critique of the project's seven-page environmental impact statement—a document that endures as humorously astonishing among the earliest archives of the National Environmental Policy Act. The Burton bill made Washington's Skagit the wild and scenic program's first network of tributaries, all vital to salmon. It safeguarded California's upper North Fork American, though even Burton yielded to his merciless elderly colleague, Bizz Johnson, and stopped short of Auburn Dam site—the senior congressman's pork-barrel pet of multiple decades. Two hundred million taxpayer dollars had been spent there aiming to provide irrigation water at giveaway prices, but then construction poised thirty miles above the city of Sacramento was halted after a nearby earthquake triggered alarms in 1973 (the dam remains unbuilt, and the river unprotected). Burton's bill also added a rare free-flowing section of the Great Plains' Missouri linking behemoth reservoirs, along with the canyon-bound Rio Grande in Texas, Pere Marquette in Michigan, and forested Saint Joe in Idaho.

The number of streams and the mileage in the wild and scenic system increased overnight 40 percent, and seventeen more study rivers were named. With other sections addressing national parks and wilderness areas, Burton's legislation approved 144 conservation projects in forty-four states and was dubbed by supporters and critics alike as "parks barrel" for its resemblance to pork barrel bills earlier limited to the greased politics and smoke-filled rooms of the dam builders.

With Burton's Parks Act, rivers were protected wholesale the way dams had been authorized in the past. The times appeared to be changing. But no one knew if this was just the Phil Burton factor, or if it truly marked a new era for rivers. The San Francisco lawmaker, struck down by a heart attack seven years later, left a legacy that dramatically raised the bar on what was possible for the conservation of public land and rivers.

EXTRAORDINARY OPPORTUNITIES

When Jimmy Carter became president in 1977, the wild and scenic system was entering its second decade, and the personable peanut farmer from Georgia brought cause for optimism, if not elation, among river conservationists. As governor, he had canoed the Flint River and then unapologetically pulled the plug on the Corps of Engineers' Sprewell Bluff Dam. Then he picked up the phone with critical leverage to make the Chattooga wild and scenic. For vacation, he didn't porch-sit in the summer heat of the farm but went rafting on the Middle Fork Salmon, much like Stewart Udall would have done.

Confronting the development agencies back when this meant detonating political bombs, Carter's administration began the process of setting new standards for water projects. He was one of few presidents to include the wild and scenic program in his annual message to Congress, reinvigorating the rhetoric of the act's original passage in his May 1977 address: "To date only 19 free-flowing rivers, totaling 1,655 miles, have been designated as part of the National Wild and Scenic Rivers System. . . . We must identify as quickly as possible the best remaining candidates for inclusion . . . before they are dammed, channelized, or damaged by unwise development along their banks." To

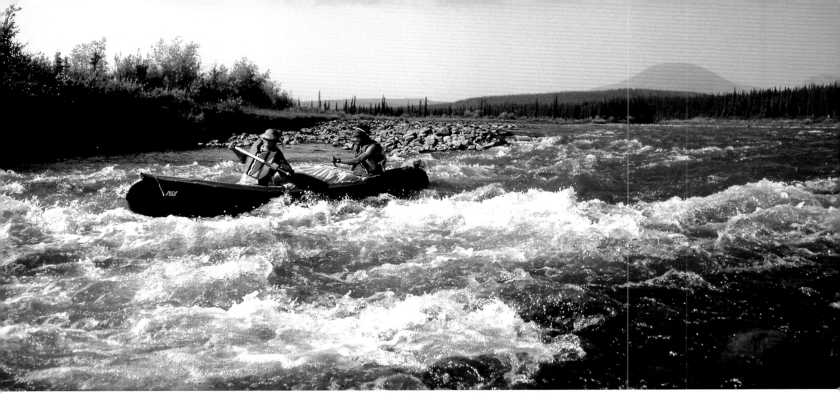

The Sheenjek was the third-longest of thirty-three major streams in the Alaskan National Interest Lands Conservation Act of 1980, totaling 43 percent of the wild and scenic system at that time.

those seeking a new world-order regarding rivers, Carter delivered notable disappointments, including failure to veto Tellico Dam, yet he made good on his 1977 address with the Nationwide Rivers Inventory (see chapter 6).

Near the end of his term in 1980, the president signed the Alaska National Interest Lands Conservation Act, designating thirty-four of America's wildest rivers (counting major forks as separate rivers). In Alaska, where hundreds of rivers qualified for national status, agency planners had used a "higher standard," as explained by Park Service rivers coordinator John Haubert. This premier list was selected, in part, because it largely lacked conflicts—twenty-four of the rivers were also enrolled in national parks or wilderness areas. "We did lose a few important ones," Haubert recalled, "including the Copper River where a road was planned, and the Kisaralik, soon to be proposed

for the infamous Pebble Mine." With the Alaska additions, the wild and scenic system grew by 3,427 miles.

The same year, Congress designated over a quarter of Idaho's Salmon River, which American Rivers' founders had singled out as a priority during their first meeting. The landmark waterway had been included in a near-final draft of the original Wild and Scenic Act but was stonewalled for years by Idaho senator James McClure. He was finally urged to compromise by fellow Idahoan Cecil Andrus.

Then, in one of the most intense political dramas of the wild and scenic program's history, the Carter administration acted to safeguard streams at the request of California governor Jerry Brown, whose enthusiasm was partly shaped by a raft trip down the Stanislaus before it was fatally flooded. Since the act's passage, other governors had requested secretarial designations for four rivers (and later

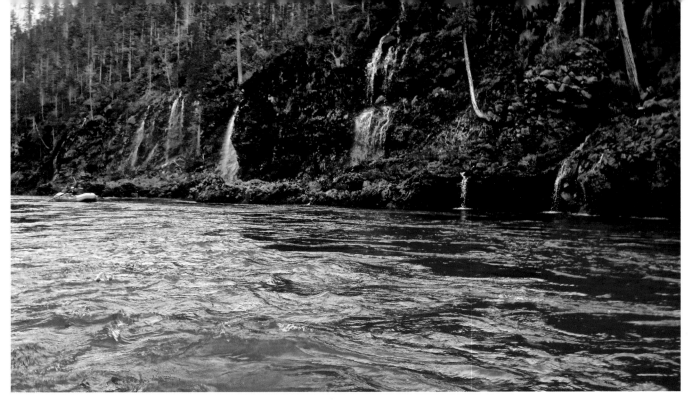

Virtually all major rivers in California's contiguous Smith, Klamath, Trinity, and Eel basins were made national rivers in 1981 after Governor Jerry Brown requested action by Interior Secretary Cecil Andrus, which he accomplished just hours before he left office. Here spring flows pour into the North Fork Smith in its incomparable roadless canyon.

for seven more), but those were overshadowed in sheer significance and numbers by Brown's appeal for the Smith, Klamath, Trinity, and Eel basins, plus the lower American River in Sacramento.

The California saga began decades earlier with plans by the Army Corps and Los Angeles to build Dos Rios Dam on the Middle Fork Eel. This spectacular damsite ranked first on a lengthy roster of reservoirs slated for the width and breadth of northern California in the 1957 State Water Plan. Dos Rios would have drowned the town of Covelo, buried Round Valley Indian Reservation, and flooded thirty miles of salmon habitat doubling as great whitewater. Local rancher and dam opponent Richard Wilson caught the ear of Governor Reagan, who uncharacteristically

signed a bill by conservation-minded state senator Peter Behr in 1972, boldly designating the Eel and adjacent Klamath and Smith basins in a new state scenic rivers system. This barred Dos Rios but compromisingly invited reconsideration in 1984. Furthermore, the state could not legally prohibit federal dam approvals. Heightening uncertainties, legislators from densely populated Southern California could undo the state designation in a single well-timed vote—say, after the next apocalyptic flood or during the next sizzling drought, both being inevitable.

A platoon of state and federal planners labored round the clock to prepare the essential Environmental Impact Statement. John Haubert recalled, "The intensity of the effort to protect those rivers was unequalled in the

government agencies. We thought there was no way an EIS as large as that could be done in six months. But it was." The team plotted their timeline literally down to the day. And—in far fancier Sacramento lobbying offices—so did the water developers. Throwing wrenches into the process at every turn, the well-heeled water and timber industries filed lawsuits in no less than five federal district courts. Their case was tenuous, but they didn't have to win. All they had to do was slow the river planners down.

The Carter administration's exit loomed ahead—months, then weeks, then days, and then to a final countdown of hours before the fanfare of Ronald Reagan's inauguration into a new era of government devolution. Finally, only fifteen hours before leaving office, at 8:45 pm on January 19, 1981, Interior Secretary Cecil Andrus designated the second-largest addition to the wild and scenic rivers system, increasing it by 25 percent.

Furious, Southern California water agencies and northern timber companies sued on technicalities—now their only grip on the legal system. More earnestly representing the opposition, Earl Blaise of the Metropolitan Water District admitted that the goal was to keep open an "option" to dam the Eel. Claiming that the EIS review period had been one day too short, a judge in 1983 declared Andrus' designations invalid. But ultimately an appeals court ruled that objection as "trivial" and restored protected status to the streams in 1984. Northern California's suite of wild and scenic rivers remains one of the most extraordinary in the nation.

IDEOLOGY TEMPERED WITH BIPARTISANSHIP

In 1981 the Reagan administration took charge with strident opposition to environmental protection. Completed wild and scenic studies languished at the president's Office of Management and Budget. High officials sought to ignore an executive directive from President Carter calling for review of federal projects that might disqualify eligible rivers for wild and scenic status (see chapter 6). Here's just one example: while coordinating rivers work for the National Park Service, Glenn Eugster received a phone call from a high administration official who curtly announced, "I understand you're using Carter's Executive Directive to review development projects. We'd like you to stop doing that." A young but seasoned bureaucrat, the smart Eugster unhesitatingly asked to see the new order in writing, which never appeared. After this rebuff, an administration official formally asked the president's Council on Environmental Quality to rescind the directive. John Haubert and two other Park Service staff met with the CEQ officials and convinced them to leave the directive in place. Reagan officials found a markedly more receptive audience at the Federal Energy Regulatory Commission, which was encouraged to "cut red tape" for new dams.

Even worse, by 1982 the development moratorium on eleven wild and scenic study rivers had expired. At California's Tuolumne, irrigation districts applied for dams and diversions that would have eliminated the premier whitewater run of the West. Oregon's Illinois River—proposed in 1967 but later dropped from the original Wild and Scenic Act—and Colorado's Gunnison River were likewise threatened by hydroelectric plans.

Though impoundments at these spectacular rivers and others remained on the drawing boards, the age of big dam building in America had reached its zenith and then its twilight. In the intense battle over California's Stanislaus, Friends of the River tried to halt New Melones Dam, but waged the battle too late—construction was well underway, and then completed, and ultimately the efforts to save the West Coast's deepest limestone canyon and most popular whitewater from flooding failed in 1981. This loss was demoralizing to many but, unseen in the political fog of

the times, a corner had been turned. Thereafter, prospects for new dams sharply waned due to citizen opposition, tightening budgets, and a lack of feasible sites that weren't already plugged by America's eighty thousand dams over six feet high. Plus, in an unlikely policy overlap between socially conscious Jimmy Carter and free-market zealot Ronald Reagan, new rules required beneficiaries of federal water projects to ante up a larger share of costs. This kind of economics boded well for river protection.

Despite Reagan administration hostility to conservation, a sense of congressional bipartisanship endured in ways that would be abandoned in politically divisive decades that followed, in the process reducing a sensible work-together mentality to nostalgia. But in 1984 a bootstraps campaign for the Tuolumne River mobilized tens of thousands of river runners to mail letters to Republican senator Pete Wilson, urging him to halt dam and diversion plans. Commercial raft guides performed impassioned on-the-water talks, and during lunch, day after day, week after week, they passed out postcards addressed to the California senator. Pressed at other points in a campaign led by John Amodio of the Tuolumne River Trust, Wilson eventually agreed to sponsor wild and scenic designation for one of the most imminently threatened rivers in America.

As director of American Rivers, Chris Brown labeled the Tuolumne the "most endangered river in America"—a dubious honor whose sound-bite-utility was not lost on strategists with the Committee to Save the Kings River two years later. They requested the "most endangered" recognition from American Rivers for their river just south of the Tuolumne. The media loved it, and the catchy "most endangered" status was subsequently formalized and broadened into an annual lineup of ten rivers. This enabled American River's savvy publicist, Randy Showstack, to propel the message into national forums. While actually saving those rivers from their threats is far more than any group can do in a typical one-year stint on the infamous list, the

distinction elevates the status of river campaigns, and the announcement continues to capture more media hype than any other regularly scheduled event of the river conservation movement. "Saving the Tuolumne was the highlight of that troubled era," Brown recapped. "It was the success that kept the wild and scenic system alive. It reenergized people and showed that, with strong local campaigns, we could still protect a great river."

With less threat and less persuasion needed, four other streams came to the system in 1984: Oregon's Illinois River, where a hydroelectric dam would have buried salmon habitat in one of the Coast Range's wildest gorges; the Owyhee in harshly beautiful desert canyons of eastern Oregon; the Verde through saguaro cactus forests in Arizona; and part of the Au Sable, legendary among fly-fishers in Michigan.

In 1986, after years of debate and heavy lifting by local activists and American Rivers, the Cache la Poudre and its dam-threatened whitewater became Colorado's first wild and scenic river. "We wanted a state omnibus bill, with the Elk, Piedra, and Gunnison, which had all been recommended by the Forest Service," Chris Brown said. "But that didn't fly." In a state where river protection efforts consistently bog down in the ideology of water rights, the brilliant Poudre remains the only national river.

Legislation in 1986 created the Columbia Gorge National Scenic Area; although deeply compromised, the measure also enrolled parts of Washington's Klickitat and the White Salmon River's stunning incision through volcanic rock where hydroelectric dams were defeated. Sections of Mississippi's Black Creek and Louisiana's Saline Bayou emerged as two lonely protected rivers in the Deep South. Another designation spared a spectacular stairstep of waterfalls from hydroelectric diversion at the Horsepasture River on North Carolina's Appalachian escarpment. In the end, and against all odds, the Reagan era coincided with strong advances for wild and scenic rivers.

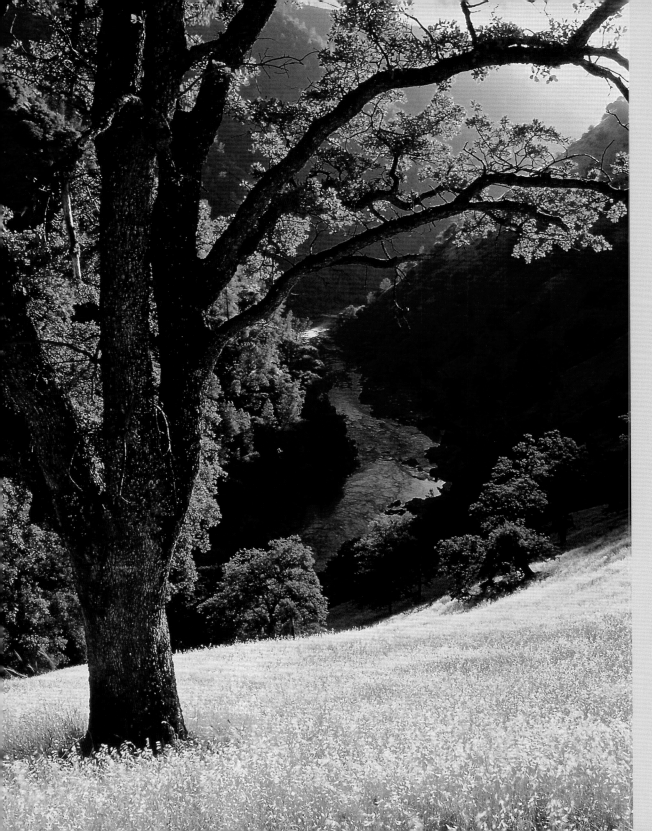

In 1984 the Tuolumne was protected through its Sierra Nevada foothills canyon. With federal dam permits pending, this was one of the wild and scenic system's most dramatic reversals of plans to impound and divert an extraordinary river.

As the system grew by fits and starts, so did American Rivers as an organization. In early years, shortfalls meant that even modest salaries intermittently went unpaid. Dedicated director Howard Brown dealt with this issue, in part, by living in a back room of the office. At one point, Brent Blackwelder and incoming chairman Rafe Pomerance personally signed for a bank loan to keep the organization solvent. Cash flow improved as director Chris Brown interspersed his passion in conservation work with "learning to raise money on the fly." But looking further, the board ambitiously launched a "great leap," luring Ken Olson from The Nature Conservancy of Connecticut expressly to bring the group into the fund-raising world. From 1986–1990 Olson increased revenue six-fold, doubled membership, tripled staff, and boosted the group's reputation as "America's principal river conservation organization." Chris Brown left American Rivers in 1988 but took a post overseeing wild and scenic rivers for the National Park Service and later the Forest Service. Indomitably committed to river conservation, he continued as an advocate long after his government retirement in 2011.

SNATCHED FROM THE FATE OF THE STANISLAUS

In 1987, in three of the most consequential designations ever, California's Friends of the River and affiliated groups applied what they had learned on the Stanislaus battleground and championed protections for three other extraordinary Sierra Nevada rivers explicitly endangered by dam proposals. Ron Stork began an illustrious lifetime of river conservation work by leading the Merced Canyon Committee in saving their stunning waterway just outside Yosemite National Park, where a federal hydropower permit had been issued. Kern River legislation backed by Friends of the River likewise blocked a hydro project on the Sierra Nevada's southernmost stream—a bouldered tu-

mult of whitewater dropping down from Mount Whitney, the tallest peak in the lower forty-eight.

The most dramatic river of the three, the Kings begins its flow in John Muir's high Sierra and plunges through the nation's deepest canyon. Below, in an idyllic savanna of girthy oaks, a 550-foot dam at Rogers Crossing was proposed by Central Valley irrigators, who—as the water elite of a region where irrigation reigned supreme—scarcely expected resistance. Under the leadership of angler Donn Furman, the Committee to Save the Kings River organized to defend the state's finest big-river trout fishery and some of its most popular whitewater.

In one year, a flawless campaign focusing on scientific and economic arguments, local media, and endorsements by civic groups and businesses proved that the tide of water development in America had indeed turned: the irrigation dam was defeated in Fresno—agribusiness capital of all California if not the nation. Magnificent forks in Kings Canyon National Park along with the main stem through national forest wilderness downstream were designated wild and scenic. But to expedite the bill and mollify its congressional opponent, the threatened reach below was declared only a special management area under the Forest Service, banning dams unless explicitly approved by Congress. Friends of the River still seeks to upgrade this designation to full wild and scenic status for the vulnerable section of the Kings. That goal appeared timely in 2015 when an industry-backed, Fresno-area congressman considered reinvigorating the Rogers Crossing Dam proposal.

Lessons from the Stanislaus fight had repercussions beyond California as well. After facing that agonizing loss, Phil Wallin—one of the first employees of the newly formed Trust for Public Land in San Francisco—moved to New Mexico where he "thought things would be simpler and where agribusiness and power companies didn't always get their way." But in his adopted home, he found "no

escape from water politics." Not long after he arrived in Albuquerque to establish a new TPL office, Wallin learned that the Army Corps and local players had conspired to flood the lower end of what many regarded as the state's most sublime river canyon. The Rio Chama flowed past cottonwood shores, red-rock cliffs, and mountain slopes dotted with ancient ponderosa pines. "I knew that federal wild and scenic designation was the only reliable protection," Wallin explained. He and others organized to designate the Chama in 1988. Realizing that no group was dedicated to helping similar local river conservation efforts, Wallin went on to form the nationwide organization, River Network, and to lead it for two decades.

THE OREGON MODEL

In 1988 the trajectory of the rivers program took an entirely different arc. A bold strategy was devised by the Oregon Rivers Council (now Pacific Rivers) to package a group of streams that the Forest Service had found eligible for wild and scenic status while crafting their national forest management plans (see chapter 6). The new planning documents provided a green light for wild and scenic consideration, bypassing the lengthy authorized studies of individual rivers. From a cast of dozens of waterways, council activists selected the most viable and illustrious candidates. Then they turned to their prominent senator, Mark Hatfield. For decades he had unapologetically carried freight for the timber industry but, now aging, he was tempted to establish a contrasting legacy of conservation. Some streams were foregone in political machinations, but Hatfield's omnibus bill included a whopping fifty-three rivers and tributaries. Never before had so many wild and scenic rivers been designated at once.

Inspired by the Oregon success, and backed by the United Conservation Clubs of Michigan and American Rivers,

Congressman Dale Kildee sponsored a bill in 1991 to designate twenty-two rivers (counting separate branches) across the national forests of Michigan. Repeating the model in the unlikely state of Arkansas, Senator Dale Bumpers carried a bill that protected eight national forest streams.

"Those were heady times," recalled Kevin Coyle of American Rivers, "and we thought we had really turned a corner with support for wild and scenic rivers." Coyle had started his remarkable career with the Bureau of Outdoor Recreation, shepherding some of the initial wild and scenic river studies in the Northeast. Then he directed American Rivers' conservation campaigns. After being promoted to president in 1990, his hard-headed leadership and sharp insight propelled the organization forward. Coyle's influence extended to other groups as well. On River Network's board, he conceived of the annual National River Rally, which immediately became the signature event of the river conservation community. Later, Coyle led the National Wildlife Federation's environmental education programs, every year reaching five million children and two million adults.

"It seemed like the sky was the limit," Coyle reflected of the 1988–1991 gains. But the next steps in statewide omnibus bills were thwarted in Washington, where all conservation initiatives mired in the Pacific Northwest's unresolved old-growth forest conflict, and in Arizona, where river advocates failed to trump a deeply entrenched, water-thirsty brand of politics that hadn't changed since Stewart Udall's days as a local congressman.

Indeed, the times were changing in regards to river conservation, but not necessarily in the ways that Coyle had hoped, and those changes were to take dramatic turns from the legacy of spectacular rivers protected in the 1970s and 1980s to decidedly more complicated, more nuanced, and more compromised methods of protection in the years to come.

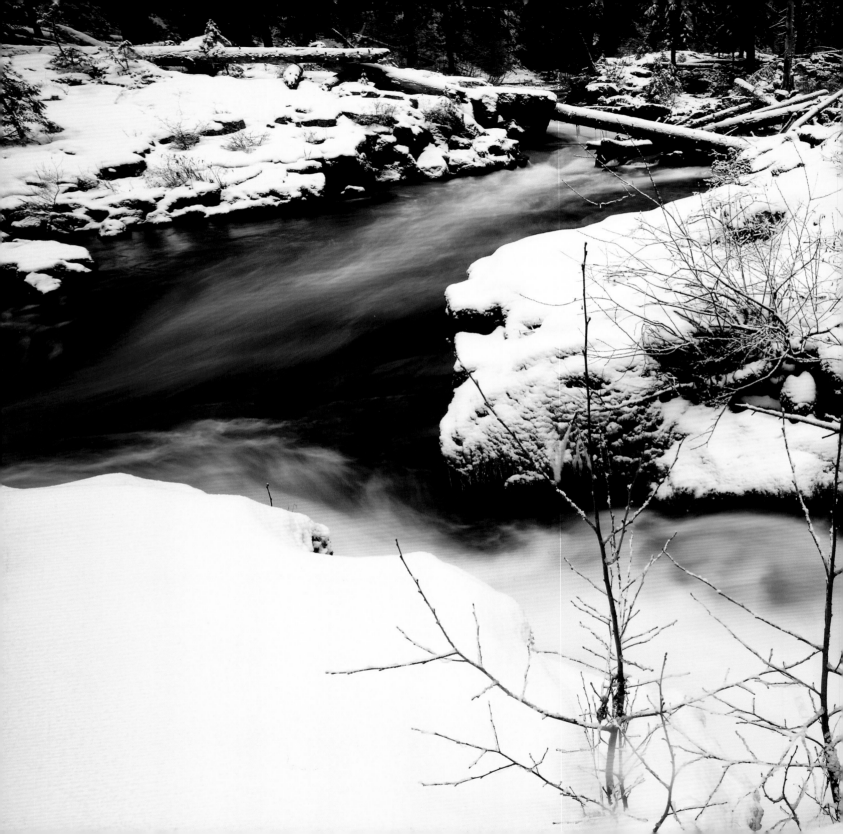

In 1988 the upper Rogue and fifty-three Oregon rivers and tributaries in all were made wild and scenic—the largest number designated at once. While the lower Rogue had been set aside in 1968, this upper forty miles were now included with spring flows originating from Crater Lake and then flowing through old-growth forests of the Cascade Mountains.

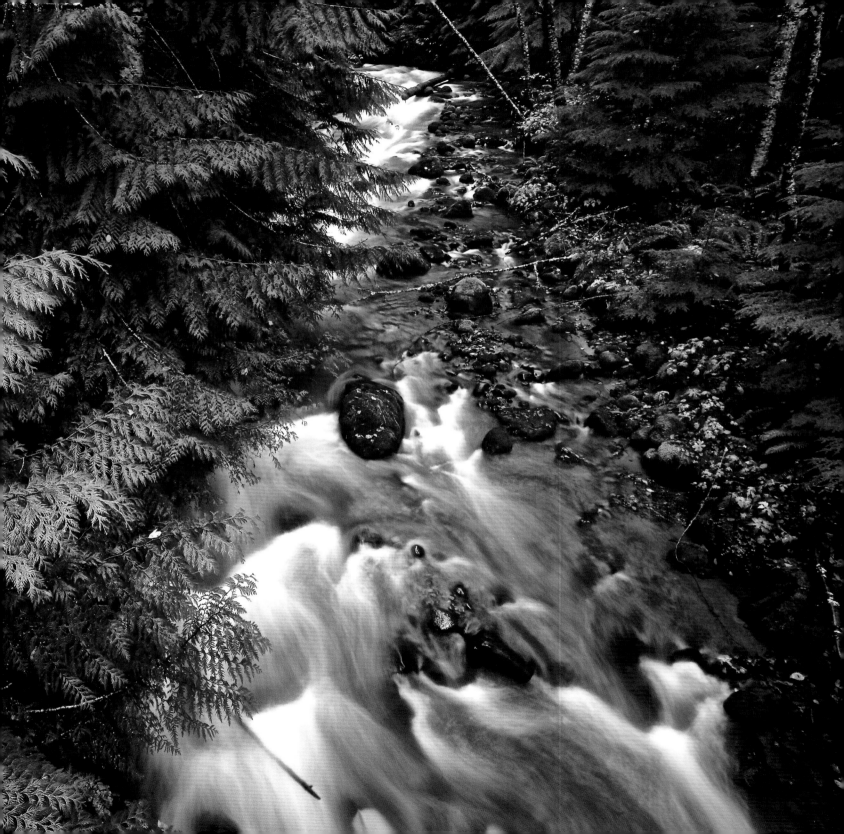

New Opportunities for Protection

CHANGING THE APPROACH WITH PRIVATE LAND

By fits and starts, many public-land rivers of the West had been designated wild and scenic, but meanwhile eastern rivers largely in private ownership had languished or, worse, erupted in rancorous dispute, with an especially rude awakening for the National Park Service at the upper Delaware in Pennsylvania, New York, and New Jersey. While designation of rivers similarly flowing through private land along Pine Creek in Pennsylvania, the Housatonic in Connecticut, and East Branch Fish Creek in New York had failed due to landowner opposition, the Delaware had ridden home to protection on the coattails of Phillip Burton's 1978 omnibus bill.

Burton's initiative seemed sensible because the proposed Tocks Island Dam was popularly trounced by the same bill. But the ill-fated dam had not been halted before the federal government had methodically condemned properties so that the Army Corps of Engineers could flood the valley with a reservoir. It's an understatement to say that the affected residents—at home along the Delaware for generations dating to colonial times—were disgruntled. Furthermore, squatters, who opportunistically and illegally set up housekeeping in the abandoned farm houses, were then evicted as well—some by misguided paramilitary tactics in the middle of the night in which the houses were literally torched. A strange mix of

Opposite: The Zigzag River of Oregon rushes through a grove of western red cedars as it descends from the snowfields of Mount Hood to the Sandy River. This and a suite of other streams were designated as wild and scenic rivers in 2009.

these culturally distinct but universally aggravated refugees moved upstream, taking with them an animosity for government that probed to depths no one could imagine.

Unsuspecting planners from the Park Service's design center in Denver got the job of drafting a plan for the new, wild and scenic upper Delaware River, a complex professional challenge in the best of times. But they seriously miscalculated the locals' willingness to cooperate in any sense of the word.

To be clear, federal regulation of land use was never possible under the wild and scenic law. Nor was widespread acquisition for the designated river. And the new, protected status for the Delaware expressly prohibited the kind of dam proposal that had twice evicted people downstream. But none of that seemed to matter. A firestorm of protest at the simple presence of government officials included a mob storming the stage at a Park Service public meeting, the burning of an agency employee's car, and the torching of the house of a news reporter who dared to present two sides of the controversy.

Back to the drawing board with their management plan, the Park Service settled into this frighteningly ugly scene for a multiyear effort, smartly hiring a tough, congenial, slow-talking, fast-thinking consultant who had cut his teeth as a river activist wrestling Red River Dam from the Army Corps of Engineers in Kentucky ten years before. Chuck Hoffman modestly called his job "damage control," but his extraordinarily thick-skinned effort, aided by another river-protection veteran he hired, Minnesotan Mike Presnitz, resulted in a management plan that garnered support from most local communities three years later.

Perhaps it's irrelevant here that the plan jettisoned any notion of public-land riverfront along the upper Delaware above Port Jervis—a splendid reach of waterfront that instead underwent a plethora of new real estate development. That section of river was not destined for the parklike feel

of earlier protected rivers such as the Current, Buffalo, Obed, or Eleven Point. But abandoning that possibility was regrettably essential to gaining local landowner support and, as it turned out, to the future of the wild and scenic rivers program in the East.

From their experience with the highly charged Delaware crucible, Glenn Eugster and a team of Park Service staff in the Northeast realized that along a private-land river, you get nowhere without support of the people who live there, and that a new approach to wild and scenic rivers was needed in the East. "We knew that a lot of people wanted their rivers to be protected," Eugster recalled. "They didn't want the federal government to be in charge, but that didn't mean we might not have a role to play in helping them."

Eugster had started his service with the Bureau of Outdoor Recreation working on the Nationwide Rivers Inventory, identifying hundreds of rivers worthy of protection (see chapter 6), and so he carried a forward-looking perspective that much more conservation work was waiting to be accomplished. Through the 1980s, he and others—in correspondence, conferences, and draft legislation—explored how the wild and scenic program might be supplemented with allied approaches tuned better to private land, urban rivers, recreational waterways, and heritage corridors. Arising from this, a State and Local River Conservation Act in 1988 was drafted but failed to pass, and other ideas for broadening the scope of river conservation were tested.

Though not officially named as such until the 1990s, "partnership" rivers emerged as a way forward for wild and scenic designations. With others in the Northeast, Eugster pioneered a new, collaborative approach, taking painstaking care to inform and empower local residents while providing venues to air and address all concerns. At the time, a few bright planners were just doing what made sense to confront the problem of local opposition to governmen-

tal involvement. In retrospect, it proved a crucial turning point for the wild and scenic rivers system. As Cassie Thomas of the Park Service team reflected, "The partnership approach is a great model where there's a strong local conservation ethic."

The congressionally authorized study—formerly aimed at vetting a particular river for wild and scenic designation and enabling its passage through Congress—was now used to develop a protection strategy and orchestrate a locally formulated management plan. This differed in fundamental ways from the old schedule of crafting the plan *after* designation by Congress. The new approach—drafting the plan *first*—quelled fears and mistrust that locals otherwise harbored until a belated plan was finalized—a sure set-up for paranoia throughout the intervening years. If not already in place, local land-use regulations such as floodplain zoning were adopted under the partnership model *before* the river designation occurred. Land acquisition by public agencies was proposed nominally or not at all, and post-designation management was led by a local council.

In politically astute enclaves, New England's river-supporting citizenry began to organize, typically securing support of their congressional member at the outset. By the time the planning effort was over, designation was virtually assured. With none of the Delaware baggage, Park Service planners in the Boston office, led by a talented landscape architect, Rolf Diamont, and then by visionary planner Drew Parkin, were now greeted warmly at most rivers where they worked.

The approach was applied in New Hampshire at Wildcat Brook, where a beloved waterfall, centerpiece to the quaint village of Jackson, was rudely threatened by a hydroelectric developer from outside the area. The town eagerly backed the protection plan and got their congressional representatives on board with wild and scenic designation in 1988. With guidance by Glenn Eugster, and then follow-up by

the Park Service's veteran Joe DiBello, New Jersey's Great Egg Harbor River, including the system's longest reach of tidal marshlands, was designated in 1992.

In 1993, townspeople rallied to protect Massachusetts' Westfield River with Park Service help. In neighboring Connecticut, citizens aided by Phil Huffman of the Park Service pulled forces for the West Branch Farmington, a local hot spot for fishing, tubing, and canoeing. Diversions to the city of Hartford were barred, though a rowdy Massachusetts contingent with little interest in listening to Huffman or their downstream neighbors declined to support wild and scenic status for the upper river.

In 1996 New Hampshire's Lamprey River was designated. Along all these streams, Park Service staff tactfully expanded their influence by helping local people with technical support and planning expertise. Word spread, and more local groups came forward with initiatives to safeguard their own backyard streams.

Having conservative instincts but also a durable ethic of sensible public good anchored in puritanical roots, New England had become a new center of river conservation activity. Even where community bias against federal involvement precluded wild and scenic status, positive effects spun off from the efforts. At New Hampshire's Pemigewasset, for example, hydroelectric dams were dropped and stream fronts bought as state parks. "Who's to say that's not success?" asked Park Service planner Jamie Fosburgh, who with Liz Lacy, Jim MacCartney, and others inherited the partnership work from its first generation of innovators.

Fosburgh in 2015 reported that under the partnership model, a protected river potentially many miles long "could be delivered with a four-year budget of $400,000—far less than what it would cost to buy even a small amount of river frontage."

By 2006 a total of fifteen rivers plus tributaries had become wild and scenic on the partnership model from

As the largest stream of the New Jersey Pine Barrens, Great Egg Harbor River carries amber bog waters down to Atlantic salt marshes. Striped bass and alewife herring spawn in clear tributaries. Flowing mostly through private land, this "partnership" river was protected in a campaign led by local sponsors with help from National Park Service staff. The partnership method changed the wild and scenic program's approach to private land rivers in the Northeast. The South River, shown here above the Highway 50 bridge, is one of eighteen designated tributaries.

Pennsylvania and New Jersey north. Most of these streams enjoyed continuing Park Service budget aid, which helped pay for local stewardship directors.

THE WATERSHED PERSPECTIVE

Wild and scenic designation efforts typically focused on single discrete reaches of rivers and on narrow corridors. However, as the program matured and entered this era of new opportunities—albeit complex and compromising ones—a growing awareness of watershed-wide issues and ecological thought pointed toward a more inclusive approach.

The idea of watershed management dates to the original forest reserves (later national forests) whose administration was prescribed by Congress in 1897, and also to Soil Conservation Service dust bowl efforts, and has since been revitalized a number of times. The approach recognizes that the entire watershed—all land draining into a particular stream—is critical for the stream to be safe from pollution and other damage. Looking at the larger watershed or basin-wide picture in the 1980s, both the Park Service and the Pacific Rivers Council recognized the need for more than one type of system for the protection of rivers and called for a "watershed" designation to complement wild and scenic rivers.

Their initiative never came to fruition, but to similar effect, tributaries were added to some new wild and scenic designations. Even back in 1980, the goal of protecting Alaska's relatively short but salmon-rich main stem Forty-mile River was the basis for designating 407 miles in that basin, including three forks and thirteen tributaries, many of them vulnerable to bulldozed dredging by gold miners. In the adjacent Charley basin, noted for clear water, eight tributaries were included in the legislation.

Upping the game, the 1981 designation of California's Smith River was all about watershed protection; forty-nine tributaries were added to the seventeen-mile main stem for a total of 397 wild and scenic miles. Under the act's guidelines—even for the smallest designated streams—waterfront corridors classified as "wild" through federal land, typifying most of the Smith basin, are safeguarded from logging and from new mining claims. Both industries had threatened the Smith.

Surprising many, the watershed approach gained even more traction with some of the private-land rivers of the partnership program. Totally "getting" the watershed concept, determined citizens ensured that tributaries were included with designation of the Eightmile River in Connecticut. Community planning there cleverly reset the corridor boundary—typically averaging a quarter-mile back from each bank—to include the entire watersheds. In Pennsylvania and Delaware, all of White Clay Creek's tributaries beyond first-order (uppermost) streams were designated. New Jersey's Great Egg Harbor River was enrolled with eighteen small tributaries.

The logic, importance, and benefit of protecting feeder streams is unassailable: what happens at the headwaters has consequences below. And regardless of size, streams can have the qualities required of the Wild and Scenic Act. Further, small streams contribute to the outstanding values for which a larger river is designated. Yet the inclusion of minor tributaries—many less than five miles long—raised new questions about selection of wild and scenic rivers. Do small streams meet the standards for regional and national significance required of the act and its guidelines? Will the effect of wild and scenic designations be diluted by bulking up the system with tiny streams? The length of a Saint Croix, Klamath, or Delaware is clearly more significant than that of a Cold Creek (two miles) or Rock Creek (one mile). But does that matter? Without answering these thought provoking policy questions, small tributaries of even modest qualities have generally passed the wild and scenic eligibility test

as "outstandingly remarkable" and "regionally significant" wherever political support has been strong.

Through the 1990s the wild and scenic system continued to grow, usually one river at a time. In Wyoming—river-rich but politically hostile to preservation—the Clarks Fork of the Yellowstone became the first designated river in 1990. This one-of-a-kind stream had a campaign to match. After local resident Lamar Empey's son-in-law died climbing in the nearby Teton Range, Empey set out to safeguard the river his son-in-law had loved to kayak, and to do that, he overcame deeply ingrained bias and formidable political obstacles embedded in his "Cowboy State."

The New World Mine was later proposed at the same river's headwaters with prescriptions for mountainside removal, blasting that would shake the earth for years, and toxic water percolating hazardously for a millennium behind tailings dams that were bound to someday fail at the edge of Yellowstone National Park. "We argued that the mine would affect not only Yellowstone, but also the wild and scenic reach of the Clarks Fork below," said Tom Cassidy of American Rivers. Halted in 1996 with Clinton administration acquisition of mineral rights, the mining threat shows how wild and scenic designation doesn't explicitly stop—but can help to curb—harmful developments even beyond corridor boundaries.

In 1991 Nebraska's Niobrara was designated wild and scenic, saving riverfront ranches from flooding by Norden Dam. This irrigation boondoggle would have inundated thirty thousand acres—more arable land than it would irrigate—but it unconscionably advanced on the dam builders' fast-track until falling victim to the combined forces of river conservationists and local ranchers. Vitriolic landowner opposition to the dam failed to translate to local wild and scenic support. Yet the bill passed with backing of Senator James Exon, Representative Doug Bereuter, and a dedicated supporter of river conservation nationwide, House subcommittee chair Bruce Vento from Wisconsin. In deference to the opposition, the congressmen added further limits to condemnation authority and established a local advisory committee. These solutions drew on lessons from the partnership model, though in this Nebraska permutation, opposition to protection resided within the local committee itself; one member was actively bulldozing in the riverbed and didn't want to stop.

In the original Wild and Scenic Act, several Pennsylvania streams had been backed as study rivers by "Big" John Saylor—the old-school, powerhouse Congressman who went toe-to-toe with hard-headed committee chairman Wayne Aspinall to muscle the original wild and scenic bill out of committee. But then Saylor died in an airplane accident, and his beautifully forested rivers were all but forgotten in a region where the congressman had clearly been out ahead of a provincial Appalachian culture. Nineteen years later, after the Western Pennsylvania Conservancy bought several Allegheny River islands and transferred them to the Forest Service, determination again grew for designation. Backed by progressive Republican senator John Heinz, the river was included in 1992. This broad artery's massive flow—largest river in volume designated east of the Missouri—was a rare score for the maturing wild and scenic system.

Saylor's other favorite was the Clarion, which he personally visited to promote protection at a float trip staged by a Clarion State University student group celebrating "Earth Week" during the summer following Earth Day, 1970. But the Clarion was declared too polluted and was officially shelved by the Bureau of Outdoor Recreation. In the following decades, pulp mill foam and day-glow-orange acid from strip mines were abated, so Western Pennsylvania Conservancy director Larry Schweiger took another run at

the mothballed proposal. "Congressman William Clinger's district was conservative, but he wanted to do good things," Schweiger recalled later when he served as president of the National Wildlife Federation. Schweiger billed the river as a legacy to Clinger's years of public service, and the congressman opportunistically inserted an amendment into a must-pass bill. Designation in 1996 contributed to the legacies of both Saylor and Clinger, and it closed the book on Saint Petersburg Dam, which had been considered by the Army Corps as recently as the 1970s.

With the elections of 1994, congressional politics shifted far to the right, and the unmasked hostility to federal conservation initiatives made the Reagan years look progressive. Yet receptive Clinton officials still managed to eke out some gains, including one of tremendous consequence. The city of Klamath Falls had proposed the Salt Caves Project—hydropower diversions that would deplete the Klamath River's thunderous flow transecting the Cascade Range. The Oregon Sierra Club and Oregon Rivers Council pressed the legislature and Governor Barbara Roberts to approve State Scenic Waterway status for the imperiled reach, and then to push for federal protection. Park Service planner Dan Haas labored hundred-hour weeks to meet the paperwork deadline. Hearing through a quiet informer that the city planned to file for an injunction against wild and scenic designation, Interior Secretary Bruce Babbitt rushed back to his office late on a Friday night to sign the proclamation, sparing the river in the nick of time.

WIDER PERSPECTIVES AND THE RIVERS OF 2009

Through the 1990s partnership rivers were the growing sector of the wild and scenic system. They required intensive support from local guardians and Park Service planners, but not from the staff of American Rivers. In fact, it was widely recognized that "outside" interests in these local campaigns would trigger more resistance than support.

Furthermore, the remission of dam building and its threats of total river losses had allowed what I described in *Lifelines: The Case for River Conservation* as a "second generation" of river activism to rise on the agenda. The new inventory of problems included polluted runoff from farms and logging, destruction of riparian habitat, the decline of salmon and other fishes, diversions drying up streams, invasion of exotic species, construction of small dams for hydropower, and the multiple effects of global warming. Much needed to be done.

The river conservation movement evolved in an effort to meet these challenges. Tom Cassidy of American Rivers noted one of several turning points in the organization's agenda. "The Mississippi overflowed its banks for two months in 1993 with the greatest flood in American history. For once, the airwaves were saturated with news of a river. However, it was all a tale of woe, offering nothing about the *cause* of the disaster, nothing about what could be done to *avoid* the disaster. So we jumped on that, and Kevin Coyle was soon pitching a persuasive case on *Larry King Live* that our nation needed to address floodplain management."

Cassidy added, "Then we learned that the Army Corps of Engineers had a lot of money to do the wrong things at Missouri River dams, and that the altered flows below them were wreaking havoc with habitat. Meanwhile, Pacific Rivers Council had been working on fish habitat and gained pathbreaking riparian protections under the Northwest Forest Plan. By incremental steps, the rivers movement was orienting more toward what *lives* in rivers. Restoration became a powerful motivation as we tried to get flows back into streams that had dried up, and to restore flooding to floodplains that had been farmed or developed."

Though American Rivers had been formed explicitly to advance the wild and scenic system, Kevin Coyle, presi-

dent from 1990 through 1994, and Rebecca Wodder, who carried onward to 2011, both recognized the myriad aspects of river conservation that demanded attention. Increasing staff from twenty-five to seventy-nine, Wodder described the group's broadening horizons as "seizing opportunities for restoration and for linking people to the rivers where they live." Knowing of my interest for this book, she added, "Goals for wild and scenic rivers were never dropped, but other programs clearly had to grow up around them if we were to live up to our name, American Rivers."

The group's expanding energy and staff were dedicated to a widening array of federal policy matters: defense of the Clean Water Act, relocation of floodplain development, stewardship of urban waterways, licensing of hydroelectric projects, and dam removal, which became a poster child of the rivers movement—restoration that I had forecast in the final chapter of my *Endangered Rivers and the Conservation Movement*. Director of conservation for much of his sixteen years at American Rivers, Andrew Fahlund recognized that foundations couldn't fund wild and scenic designations because of the essential political lobbying. "Plus, they were more interested in the new topics of restoration, dam removal, water quality, and hydropower reform. It was all good work, and nobody ever said wild and scenic rivers were *not* important. The priorities just shifted."

An extraordinary volunteer, retired lawyer Jack Hannon, carried American Rivers' wild and scenic work for several years. Then, at an organizational planning retreat, Andrew Fahlund suddenly had a flash of insight. He boldly threw out the goal of designating forty more rivers for the upcoming fortieth anniversary of the Wild and Scenic Act in 2008.

"Following a dead silence that lasted far longer than I liked, half the people in the room eagerly lit up," Fahlund recalled. "The other half looked at me as if I was crazy. But I knew we had some great partners in the field, with plans

in the pipeline, and that the political opportunities might align." Fahlund also had a particular river in mind.

While reviewing one of countless plans to relicense hydroelectric projects, he had been surprised and then captivated by a rare intriguing passage in the otherwise parched literature of the Federal Energy Regulatory Commission. Likely the work of a hired contractor, it was a historical accounting of Fossil Creek, describing emerald pools, red-rock walls, and shaded cottonwood corridors in the mountainous desert of northern Arizona. But the stream had been dewatered for a century, and FERC predictably and confidently planned to rubber-stamp "no significant impact" for another fifty years of desiccation. While American Rivers and its grassroots allies filed objections, the Yavapai Apache waged a spirited tribal campaign to bring their ancestral stream back to life. In the end, the project's owners agreed to retire the rusty-bolt facility at their own expense—something that rarely happens.

For the first time in a hundred years, water rushed through the riverbed that Fahlund had read about. Alien fish, including rainbow trout that had deliberately been planted or otherwise commandeered virtually every other cold-water stream in the state, were absent (though exotic crayfish remained). This gave state wildlife biologists the option to reintroduce *only* native fishes. Almost overnight the resurrected Fossil became one of the most biologically correct streams in the Southwest. Fahuland penciled it in at the top of his list of forty for the fortieth anniversary.

The catchy 2008 deadline proved a bit elusive due to presidential politics, but just a few months late for the Wild and Scenic Act's anniversary, in March 2009 the second-largest package of rivers ever was signed by the new President Obama. Though many of the streams are very small, ninety-one waterways were added. Fossil Creek became America's first wild and scenic river restored from complete dewatering.

In southern California, groundwork for protecting ten of the region's best streams had been underway for a decade by the tireless Steve Evans of Friends of the River. All ten were part of the 2009 package, including the Amargosa, an unusual desert stream with endemic fishes and spring flows running twenty-six miles before evaporating on the way to America's lowest acre, 282 feet below sea level in Death Valley. Evans' Amargosa stretched the concept of a wild and scenic river to include the vitality of this mere trickle in the desert.

In Oregon, nine streams flowing radially from Mount Hood's skyward rise were also designated, as well as two forks of the Elk River that extended safeguards for that coastal jewel to its headwaters.

Parts of two forks and thirty-four small tributaries of the Virgin River were designated through reaches already protected in Zion National Park and BLM wilderness. Testament to the theologically political conservatism of Utah, this was the first wild and scenic river in a state phenomenally rich in spectacular canyons.

In a remarkable breakthrough, following eight years of negotiations between Idaho Rivers United director Bill Sedivy and southwestern Idaho ranchers, sixteen rivers and tributaries were chalked up on the 2009 scorecard. Many were small, but the group included the Bruneau and upper Owyhee—sought by river advocates ever since the original Wild and Scenic Act was drafted.

"Once we got to know each other, we realized that we shared a lot of common goals," Sedivy acknowledged of his liaisons with the ranching community. A congenial giant, suited to his formidable task in every way, Sedivy added, "We all wanted the status quo, and I managed to make a lot of new friends." The players agreed on establishing an in-stream water right—a topic so viciously polarizing that it defies rational discussion throughout much of the West (the actual water right had to be established later through a tedious process at the state level). "Here," Sedivy explained, "we and the ranchers both wanted to prevent export of water to distant cities or power plants. The ranchers' use of water is not very great, and so we all agreed on saving it for both them and the rivers."

Topping everything in 2009, the upper Snake River, from its source near the border of Yellowstone and then continuing through Bridger-Teton National Forest and Grand Teton National Park, was approved, thirty years after a wild and scenic study of this eminently deserving candidate had been stonewalled by local ranchers. Scott Bosse of the Greater Yellowstone Coalition took inspiration for this package of the Snake's main stem plus key tributaries from his previous job arguing to get rid of four salmon-killing dams, far downstream, on Idaho's lower Snake. "I had seen how badly degraded the lower river was," he explained. "But up here, the headwaters were largely intact."

In Republican Wyoming, Bosse and others with the Snake River Fund, American Rivers, Trout Unlimited, and Jackson Hole Conservation Alliance fortuitously found a sponsor willing to break ranks with a long Cowboy State tradition of saying "no" to both conservationists and the federal government. Senator Craig Thomas' heritage growing up on a guest ranch at the edge of Yellowstone emboldened him to promote the rivers' protection and to stand tall in front of his stern delegation. Bosse's coalition engaged a political consultant who just happened to be Thomas' former chief-of-staff, and for campaign manager they hired a retired river guide with credentials as a well-connected conservative. "Wild and scenic rivers had a Republican lock on them," Bosse acknowledged, "so we needed a Republican key."

With his legacy in mind, Thomas courageously introduced the bill one month before his death to leukemia. "It looked like the campaign would also die," Bosse reflected. Without Thomas' leadership and cover, the bill could

be killed at any time, and most members of Wyoming's power elite were ready to do just that. "Even though he was known to be a friend of Thomas, Idaho senator Larry Craig fought the designation to Thomas' dying day—and beyond—with the irrelevant argument that Idaho's downstream irrigators were at risk."

The governor would appoint a new senator, so Bosse went to Thomas' funeral reception at the Petroleum Club in Casper, and with the senator's widow supportively at his side, he urged the governor to appoint a replacement who would hold true to Thomas' dying wish—that his rivers would be made wild and scenic. Later, in the splendid shadow of the Teton Range, Senator John Barrasso's opening event in Jackson was the local Land Trust picnic. Inspired by the best view from any potluck in America, along with a crowd of two hundred river supporters who were carefully organized to congratulate the senator on his new post, Barrasso returned to Washington to sponsor a winning "legacy bill" in honor of Craig Thomas.

The stunning upper Snake—archetypal river of the Rockies flowing elegantly through moose-filled wonder-worlds shaded by cottonwoods beneath the sky-piercing thrust of the Grand Teton—was designated along with portions of fourteen fish-filled tributaries, together termed "Snake River Headwaters."

2014 AND BEYOND

The rollicking 2009 success for wild and scenic rivers was followed by five years of unprecedented congressional gridlock—more about political polarization than anybody's attitude regarding rivers. Finally in 2014, a crafty amendment to the must-pass National Defense Authorization Act included five rivers. Washington's Illabot Creek joined the Skagit in one of the Northwest's best interlocking networks for salmon. With a treasured bald eagle preserve nearby, The Nature Conservancy championed this designation,

which undercut a hydroelectric permit that FERC had already issued for the small stream. Just east of Seattle, the exquisite upper Middle Fork Snoqualmie and its pristine tributary, Pratt River, were also enrolled.

On the partnership model, Vermont's first wild and scenic rivers were designated—the far northern Missisquoi and tributary, Trout River. Local resident John Little conceived of this effort when he learned about wild and scenic possibilities at River Network's annual River Rally. Also in 2014, three Northeastern river systems were named for study—a measure of the National Park Service's partnership staff, whose diplomacy continued to defy the political odds by building a wild and scenic waiting list from private-land rivers.

Regarding the program's popularity in the Northeast, Park Service planner Jamie Fosburgh noted, "While the early partnership rivers were threat-driven, the new ones are not. People have caught on to the model of local sponsorship with help from the National Park Service. They realize they don't need to be concerned about fears that typified earlier efforts. Proposals come from communities where people are knowledgeable and educated about planning, and are concerned about urbanizing pressures. They've already taken local action to protect their stream, and now they want to go the next step. From an atmosphere of mistrust two decades ago, wild and scenic rivers have become a popular tool for local governments in caring for their communities."

New challenges, however, arrived with drought in the West. A symbol of beauty in Yosemite National Park, the Merced River flows continuously elegant downstream through a Bureau of Land Management canyon where the Merced Irrigation District proposed raising New Exchequer Dam. This required rescinding wild and scenic status for the lower extent of the Merced's protected reach. Though the mileage involved was not great, Friends of the River fought the de-designation with an earnestness reminiscent

of their campaign to save the Stanislaus thirty-five years earlier. The group astutely recognized a dangerous precedent for eliminating wild and scenic rivers and they feared that this tactic would apply elsewhere if given half a chance.

Only one reduction of a wild and scenic river has ever occurred: at ranchers' request, thirty miles of the Middle Fork Feather—braided and intermittent through private headwaters—were removed by "redefining" the upstream terminus of the reach, described in House Report 94-486 of 1976. Its loss went unnoticed; indeed, it was surprising that the relatively inconsequential reach above the extraordinary Feather River canyons had been designated in the first place. But the Merced—river of Yosemite and a test case for how designations will endure when the forces against them intensify—was altogether another matter. "We are determined that the integrity of the wild and scenic rivers system will not be lost," said Friends of the River's veteran Ron Stork.

In 2015, American Rivers' director of river protection, David Moryc, said that the organization was again "focusing greater attention on the wild and scenic rivers system." This group and others worked for designation of sixteen Rogue River tributaries, aiming to halt BLM timber sales bordering the Rogue's original wild and scenic river boundary of 1968. Farther north, American Whitewater championed designation of nineteen spellbinding Park Service and Forest Service streams draining radially from Washington's Mount Olympus—one of several wild and scenic campaigns adopted by the premier organization of whitewater paddlers. Meanwhile, Scott Bosse, now working for American Rivers, and others championed a suite of streams in western Montana totaling seven hundred miles in the Gallatin, Smith, Dearborn, and East Rosebud Creek basins.

THE MANAGEMENT IMPERATIVE

While getting more rivers protected in the wild and scenic system has occupied citizen advocacy groups, managing the rivers after designation is the job of public agency staff. How rivers are ultimately cared for is one of the most important parts of the wild and scenic program, yet this imperative lacks critical resources and support for what's needed to safeguard the "outstandingly remarkable values" for which each river was designated. On dozens of popular streams such as the Rogue, Salmon, Obed, and Chattooga, management concerns have focused on recreation access, quotas for boating on the busiest rivers, acquisition of inholdings, logging curbs within the corridors, and control of mining even though this is encumbered by the archaic Mining Law of 1872.

Yet in the face of growing population and increased demand for recreation, some rivers have fallen between the cracks. For example, at the road-accessible portion of Oregon's Illinois River, four hundred cars and trucks gridlock the country road on hot summer weekends, and visitors encounter uncontrolled problems of trash, broken glass, verbal abuse, and even gunfire. The Forest Service spent $1.3 million on recreation facilities and adopted rules to address the mess, but the agency has nominal enforcement capability and received little cooperation from the sheriff in a county known for anti-federal views. Law-abiding citizens, whose presence would mollify the situation, now stay away from the ugly scene, and the risks preclude dispatch of volunteers.

Meanwhile, agency staff have faced new challenges and controversies. At the Saint Croix—Senator Gaylord Nelson's pride from the first days of the wild and scenic system—the National Park Service won a protracted court battle to scale back construction of an obtrusive new freeway bridge. However, in a political era bearing little resemblance to that of the great senator, Congress overrode the decision, green-lighting construction.

When challenged by Idaho Rivers United along the Lochsa and Middle Fork Clearwater Rivers, Forest Service staff maintained that hundreds of "mega-loads" of thirty-

foot-tall, three-hundred-yard-long oil-drilling machinery bound for the Canadian tar sands on an Idaho state highway within the river corridor were beyond the agency's purview. Lodged in the legacy of this debate is a midnight photo run in the *New York Times*. Illumined by flash, the foreground is filled by the broad back of Bill Sedivy, who stood on the highway's centerline along with much of the Nez Perce nation. In the background stood a truck driver and his shadowy mega-load, otherwise pushed and pulled by a team of eighteen-wheelers that had been halted in their tracks up the Lochsa. The opponents of "industrialization" of the wild and scenic route won an injunction, and after reviewing its obligations and its plan, the Forest Service ruled in 2017 that further traffic in mega-loads would be banned. The ruling indicates that wild and scenic managers can play a stronger role in the future of designated rivers and their surroundings, and reaffirms those in the agency who are striving to do exactly that.

The need for better attention to wild and scenic rivers is nothing new. Failure to address the management imperative was blatantly clear in 1989 when the New River became the first waterway enrolled on American Rivers' Most Endangered Rivers List *after* designation. Adequate local government regulation of riverfront trophy-home development along the New never did occur, and glassy picture windows of the rambling homes glare down at the riverfront today. To Bill Painter and his team of the 1970s, it's a sour postscript to a hard-won dam fight.

At the Allagash—first state-administered national wild and scenic river—conservation veteran Robert Patterson struggled against the state's failure to control logging, industry haul roads, multiple access points, and dam reconstruction. The river's post-designation plight led former American Rivers president Ken Olson to lead an impassioned campaign for reform from his home in Maine. The courts ultimately declined to require that the state uphold

federal wild and scenic standards under the strained rationale that state agencies don't have to follow an established protection plan. The case prompted an aging Stewart Udall to write the foreword for Dean Bennett's history of the Allagash: "Conservation legislation must be accompanied by everyday vigilance. There are people who will push and push to undermine the protections we have given our rivers and who will succeed in gradually whittling away gains thought to be permanent and lasting. We must remember that the battle, whether to protect a park, a seashore, or a river, is never won." Thirty-nine years after he had first seen the Allagash and become committed to a national system of protected rivers, the revered former secretary of the interior urged that people who care "must continually stand guard."

Although management plans are required for all federally managed wild and scenic rivers, completing, maintaining, and implementing them has been a challenge for hard-pressed agency staff. For many, wild and scenic responsibilities are sidelights to a spate of duties regarding recreation, planning, and habitat. A modern polling of professionals would likely find the same barriers to success that were voiced at a thirtieth anniversary forum held in 1998: inadequate staff training, lack of political support, mistrust, misinformation, private landowner resistance, and funding shortfalls.

A National Park Service survey in 2007 graded the management of their units in the program with a C, partnership units a B, and state administered rivers an F. The Forest Service annually evaluates its designated rivers by considering the status of plans and active management on the ground; in 2014, only 40 percent of the agency's rivers met established standards. Both agencies clearly recognized that improvement was needed. Having led the National Park Service's river efforts from 1983 to 2004, John Haubert reflected that "the failure

of federal agencies and local and state governments to fulfill their management obligations is my greatest disappointment."

Yet, the opportunities for conservation through better management of wild and scenic rivers are legion and compelling. Improvements in recreation management can be made by following what has been done on rivers with a long history of success: the Rogue, Middle Fork Salmon, Selway, Chattooga, and Eleven Point, for example. Improved cooperation with local people is key to success on many streams. Sponsored by the Forest Service and local volunteers, a "Cherish the Chetco" event led by local activist Ann Vileisis in 2012 energized the community with a timely message of cooperation and river stewardship. The partnership rivers of the Northeast offer multiple models of engagement.

Beyond traditional recreation issues lies a frontier of unmet management challenges for safeguarding river values. The effects of climate change, for example, can be addressed by limiting logging of riparian zones and steep slopes, by restoration of healthy flows where they've been diverted, and by protection of floodplains from development (see chapter 7).

ORGANIZED FOR THE TASK

Since its formation, American Rivers has played an essential role in shaping nationwide perspectives on the wild and scenic program and also as local advocates' connection in Washington. American Whitewater has joined in championing wild and scenic proposals. These and other national conservation groups analyze and support good conservation policies and oppose the bad, testify to Congress, weave their messages throughout the bureaucracies, inform the media, and usher local activists on lobbying missions through the halls of political power.

Yet few people involved have ever doubted the crucial importance of on-the-ground local and statewide groups in the designation of wild and scenic rivers. Without local support—and the backing of the local congressional member—few rivers except for extraordinary ones inspiring national campaigns would be passed. The Elk in Oregon, for example, owes its protection to a reformed, former industry forester, Jim Rogers, who garnered support even in a region dominated by timber interests. The leadership of local activist Phyllis Clausen was essential to stopping hydroelectric dams in the 1970s and designating the White Salmon in Washington in 1986. Success led in 2013 to the removal of Condit Dam, downstream from the wild and scenic reach but benefitting it with the return of salmon.

Case after case has proven that the local role is critical regarding knowledge of the river and of community politics. The persistence of local activists is required for multiyear efforts that national groups are not able to fund, and ultimately for convincing elected officials that they must deliver on the conservation agenda in order to be supported by their own voters. Yet these groups typically lack even nominal support. Their existence and effectiveness depends on the dedication of volunteers—hundreds of unsung heroes who have driven the river conservation movement, from Bruce Dowling on the Current River in 1955 to back-to-the-land Vermonters along the Missisquoi in 2014.

Statewide groups carry the ball where professionalism is needed and where national organizations lack focus, access, and connections. The work of Friends of the River, Idaho Rivers United, Oregon Wild, and the Greater Yellowstone Coalition were all crucial for the 2009 wild and scenic designations. In a few cases American Rivers' field staff have served in the role of statewide groups, filling in where other organizations don't exist or adding weight where others are engaged.

Covering another essential front, the River Management Society was formed from two earlier organizations in 1988 to serve professionals who manage, study, and protect rivers. It soon became a hub of knowledge and training—the prime vehicle helping professional managers to learn, share experiences, become inspired, and meet increasing expectations. Filling another void identified at the twenty-fifth anniversary celebration of the Wild and Scenic Act hosted by American Rivers, staff of the Forest Service, BLM, Park Service, and Fish and Wildlife Service created the Interagency Wild and Scenic Rivers Coordinating Council in 1995 to assure that the agencies act consistently and to provide policy guidance to managers and the public. With a thirty-year perspective in the Forest Service, and a record of dedicated attention to wild and scenic management and policy, Jackie Diedrich noted, "I know of no other entity that has provided so much support to field managers and the public with very limited higher-level support."

THE LONG VIEW

This chapter's tour through history has revealed evolving and expanding purposes that the wild and scenic rivers system serves. Recreation was central to the original efforts: in a statement reflecting others at the time, the September 4, 1967, Senate report on the bill urged protection of rivers that "still retain enough of their original character to provide the distinctive type of enjoyment and inspiration that increasing numbers of people are seeking." Protecting anadromous fish gained importance with the northern California designations of 1981 and the Oregon rivers of 1988; native fish were later highlighted with the Snake River Headwaters in 2009. Protecting habitat for endangered species was a reason to include streams such as the Sespe, Middle Fork Vermilion, and Rio Icacos. Rivers' roles in safeguarding whole ecosystems were emphasized in recent

cases such as the Illabot, which complemented the greater Skagit basin with its fish, bald eagles, and native forest. Community amenity and character were central to passage of partnership rivers in the Northeast, starting in 1988, gaining momentum through the 1990s, and continuing in 2014 when new study rivers came onto the docket. Now, climate change and the stress it will place on rivers, water supplies, communities, and all of life adds new rationale for safeguarding rivers (see chapter 7).

Following the original act in 1968, eighty-four amendments have been added for designations, for studies of 144 candidate streams, and for generic legal changes. Through these and other measures, the past half-century has clearly been America's richest in river protection.

Though the program started out with almost unanimous bipartisan support—passing the Senate 84–0 with leadership from Idaho Democrat Frank Church and clearing the House 265–7 with leadership from Pennsylvania Republican John Saylor—the chronology of new designations tracks political winds. A few big years account for many of the gains: 1978, 1980, 1981 (before the Reagan inauguration), 1988, 1992, and 2009. These occurred in the Carter, Reagan, Clinton, and Obama years backed by largely Democratic majorities with relatively few Republican votes in spite of that party's earlier support. Polarization by party increased dramatically after 1994.

Bursts of growth reflect special political circumstances that will not be repeated, such as the Burton Bill, the Carter-era Alaska designations, the Northern California additions by Secretary Andrus, and the Oregon omnibus bill. Yet, as 2009 attests, new and unforeseen circumstances will occur. Perhaps a package of "climate-change" rivers will take the stage in the troubled years to come.

While the number of designated rivers has continued to grow, the number of long reaches has not. Throughout the history of the program, twenty-seven sections of one

hundred miles or more (thirteen in Alaska) were designated before 1989—during the first twenty-one years. All but three occurred before 1982. The only river of one hundred miles designated since 1988 was Wyoming's Snake, and even it was fragmented into three parts. Rivers of twenty-five miles or more total 137; all but seventeen were included in the first half of the program's history. Simply a glance at a map of the wild and scenic rivers system shows that most of the designated streams are extremely short and not representative of whole rivers.

The low-hanging fruit appears to have been picked. Classics from deep in the lore of river-running such as the Middle Fork Salmon, Rogue, and Chattooga came into the system early in its history. Other successes, such as the New, Snake, Delaware, Tuolumne, Merced, Kern, Kings, and Rio Chama, owe to the explicit threat of dams. As that challenge subsided, interest in designating rivers waned as well; citizens mobilize when their rivers are on the chopping block but are less likely to labor in the political trenches if they think they don't really have to do it. Overlaying other difficulties, the political atmosphere with polarization, gridlock, and systematic right-wing challenges to virtually all environmental measures since 1994 have made it difficult to move the wild and scenic ship forward the way it advanced in the past. Yet great possibilities remain.

The unfinished agenda is large, but perhaps the most meaningful perspective is still seen in the long range view from the era of the Craighead brothers, when the nation was still bent on developing any river, at any cost. With a revolutionary idea inspired by the brilliant waters of the Middle Fork Flathead, the goal of protecting America's finest waters has gained widespread support, and the wild and scenic rivers system has grown to include hundreds of streams.

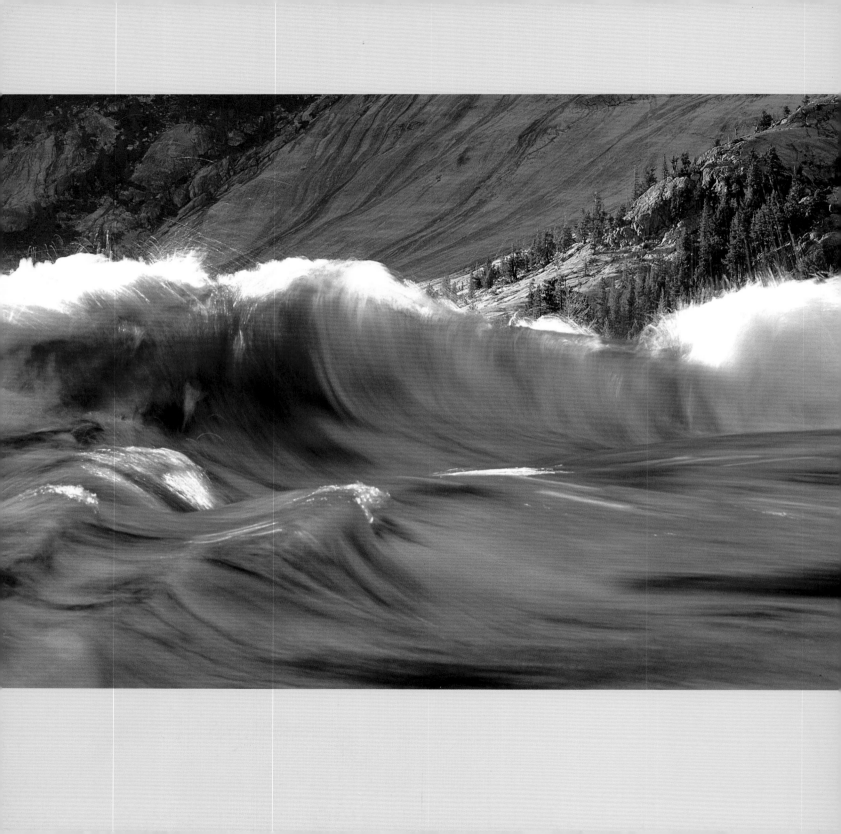

The Nation's Rivers

Almost since passage of the Wild and Scenic Rivers Act, I've been capturing photos of these lifelines. Cascading, riffling, and meandering from the Atlantic to Pacific, they highlight the American landscape. Some of my pictures were gleaned from river trips forty days long, others from quick stops at bridges. Most remote was the Sheenjek, far north of the Arctic Circle, though this honor could also go to the Rio de la Mina on Puerto Rico, an island one thousand miles out in the Atlantic Ocean. The closest rivers to me were the Elk, ten miles from my home in Oregon, and the American, just a bike ride away when I lived, for awhile, in Sacramento.

Can I rank the most beautiful? Certainly not. My favorite photo, however, is of California's Tuolumne. I arrived at the peak of springtime runoff on the day that the Tioga Pass Road opened in Yosemite National Park. I hiked downstream, waded thigh-deep across tributaries flooded in snowmelt, and camped along the river where I could linger as the sun dropped. Perched at waterline, I was rewarded with the view to a back-lit wave, oceanic at the brink of Glen Aulin Falls, and beyond to the granite-and-forest canyon far below.

While some wild and scenic rivers transport us through farmland, towns, and even a few cities or towns, I was drawn mostly to natural scenes that show these streams without the changes and the unbridled development that have come to most other rivers during the past two centuries.

Opposite: Peaking in springtime, the Tuolumne River billows into a six-foot wave at the brink of Glen Aulin Falls in the Yosemite backcountry.

Starting in the East and moving westward, this chapter's tour shows arteries as large as the Delaware and Snake Rivers and as small as White Clay and Whychus Creeks. Captions address the rivers' exceptional values and their locations. See appendix 1 for details of each wild and scenic length and designated reach—rarely including the whole waterway. See my list of sources, my earlier book, *The Wild and Scenic Rivers of America*, and www.rivers.gov for further information about each river.

As previous chapters attest, none of these scenes would be protected without the engagement of people who cared about the health, beauty, and future of their streams. Together, the photos that follow show a legacy of all who have been dedicated to protecting the best of America's rivers.

Wildcat Brook is the beloved centerpiece of Jackson, New Hampshire. Damming and diverting for hydropower were averted through wild and scenic designation in 1988.

With summer rainstorms threatening, Maine's Allagash riffles downstream from Chase Rapids. Alternating lakes and rapids offer a classic tour of the North Woods on this river prized since the time of Thoreau. This was the first national wild and scenic river to be administered by a state resource agency and remains one of the longest semi-wild rivers in the East.

Quiet water of the historic Sudbury River drifts past marshes and
forests west of Concord, Massachusetts.

Yellow birches and silver maples reflect in calm waters of the Concord River south of Highway 2. The Sudbury and Assabet join to form the Concord just upstream from this site. All three were named wild and scenic with the unusual recognition of literary values; these were daily haunts of Thoreau and Emerson.

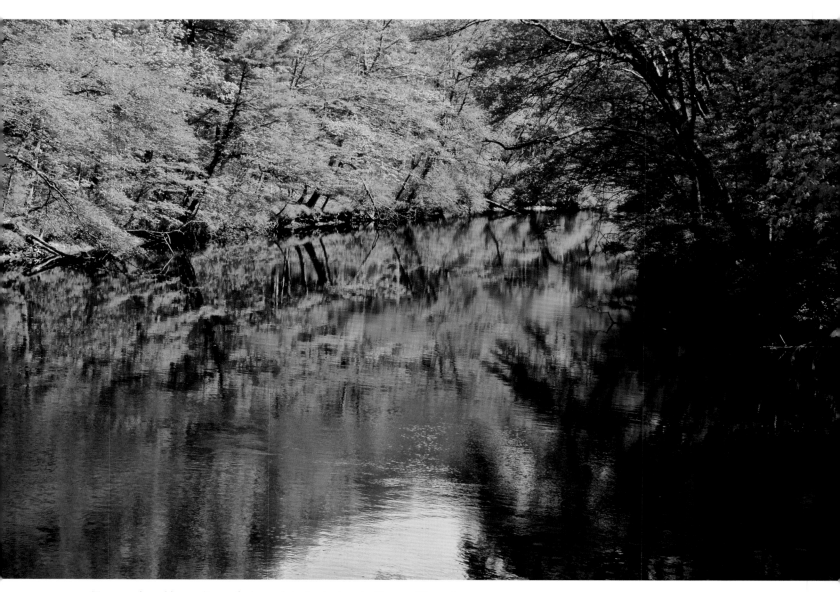

Towns and rural homes lie not far beyond the banks, but the Taunton River of southeastern Massachusetts sustains a rich riparian forest from its source, east of Bridgewater, to the estuary of Narragansett Bay.

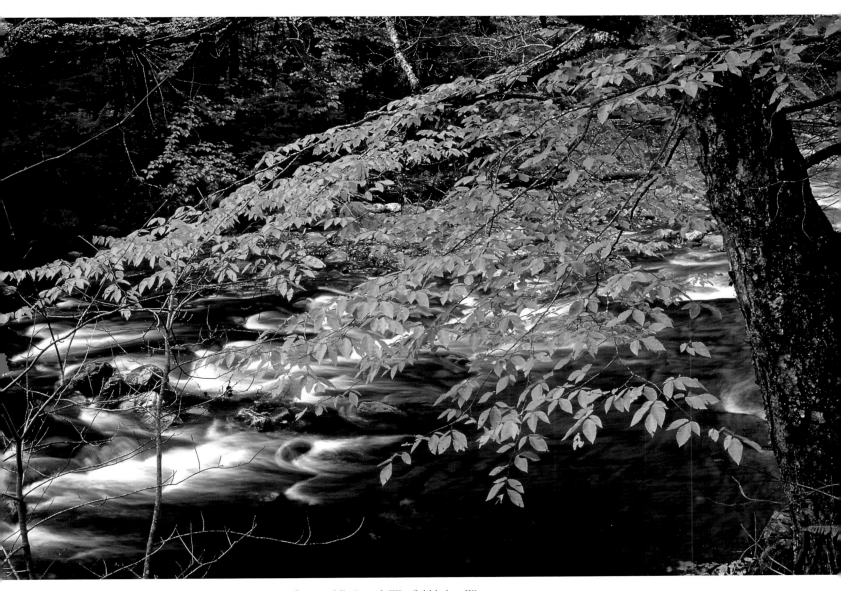

Autumn foliage of beech trees brightens the riffling Middle Branch Westfield below West Worthington, Massachusetts. Along with twelve tributaries incorporating scenic gorges, farms, historic villages, endangered species, and fine canoeing water, the Westfield was protected through the partnership model of local initiative.

Stewards of Eightmile River in southern Connecticut sought wild and scenic status to boost local planning directed at urban sprawl and new highway encroachments. This wooded scene is Devil's Hopyard State Park.

An artery of northern Connecticut, the West Branch Farmington nourishes its green riverfront with chilled waters below Riverton. The stream draws trout anglers in spring and canoeists and tubers in summer. Plans for diversions to Hartford were thwarted by the wild and scenic designation.

The Musconetcong riffles through Stephens State Park east of Hackettstown,
New Jersey, where trails follow the river. The trout fishery here is among the state's best,
and canoeists paddle past historic sites from the colonial era.

Great Egg Harbor River meanders in amber-black swamp water through the New Jersey Pine Barrens. Then, here at Mays Landing, south of Somers Point, tidal marshes finger out toward the Atlantic.

White Clay Creek is centerpiece to Carpenter State Park, Delaware, and White Clay Creek Preserve, Pennsylvania. This was the first case where a stream and all its tributaries were studied for wild and scenic status. All except first-order (highest and smallest) tributaries were designated, totaling 199 miles in the small coastal-plain basin.

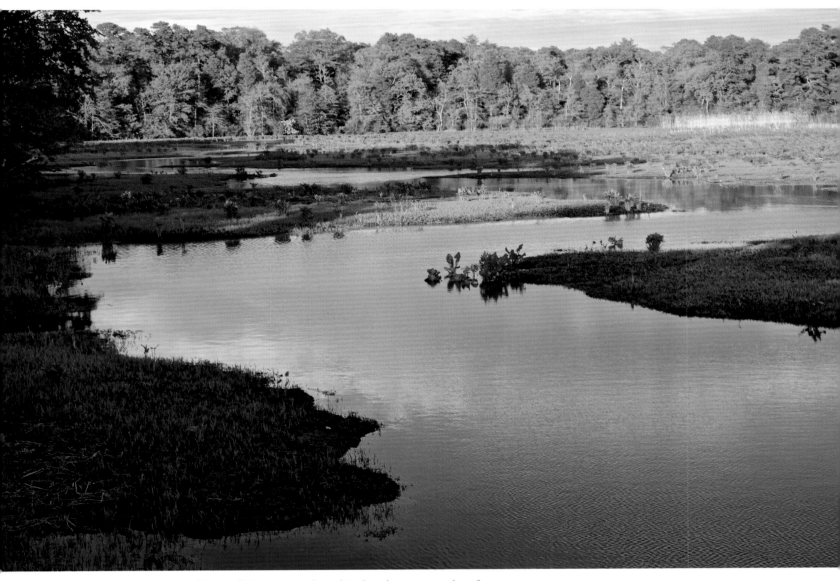

The Maurice (pronounced "Morris") River curves through its broad estuary, seen here from woodland trails at Peek Preserve near Millville in southern New Jersey. The river supports 53 percent of the state's endangered fauna species, including shortnose sturgeon. It marks the western boundary of the Pine Barrens and connects that famed region to Delaware Bay.

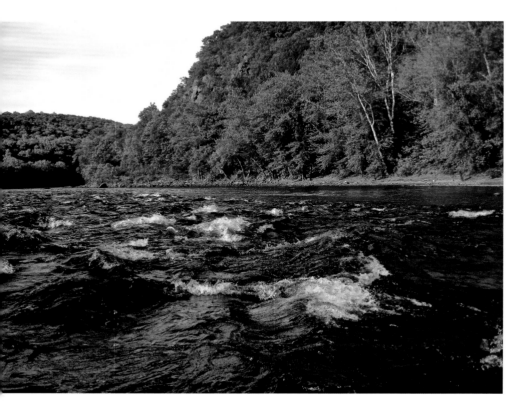

The Delaware ranks as the largest eastern river without main-stem dams. Most mileage is wild and scenic from the source at the East and West Branches confluence to tidewater in Trenton. This is the most complete designation of a major eastern river and perhaps our richest in cultural landscape. Minor rapids of the upper river are followed by lazy current through Delaware Water Gap National Recreation Area and then with occasional rapids past historic towns, offering one of the longest undammed river journeys in the East. This swift water lies upstream from Easton, Pennsylvania.

The Clarion River flows through northern Pennsylvania woodlands of Allegheny National Forest, Clear Creek State Park, and Cook Forest State Park—home to one of the finest old-growth groves in the East.

In several sections below Kinzua Dam, the Allegheny is wild and scenic for ninety miles—fourth-largest designated river in volume and largest in the East. With only minor rapids, the entire length offers a fine canoe journey featuring wilderness islands as well as old industrial towns and cottages along the shores.

In eastern Ohio, Little Beaver Creek flows through the first wrinkles of Appalachian foothills and offers a window to nature among farms, strip mines, and small towns. The stream supports sixty-three species of fish and draws anglers for bluegills. Here along the North Fork above Fredericktown, sycamores and silver maples shade calm backwaters.

Northwest of Columbus, Big Darby Creek—biological gem of the Midwest—cuts through dolomite and limestone, high in carbonate needed by forty local species of mussels for shell production. Healthy flows support eighty species of fish and fourteen animals on Ohio's endangered species list. Dams and diversion plans threatened the stream until the 1994 wild and scenic designation.

Yellow birch and other Appalachian hardwoods overhang Kentucky's Red River. Wild and
scenic designation here in 1993 precluded a 141-foot-high dam that had been proposed
in the 1970s to flood a gorge of unique geologic value hiding fourteen rare plant species.
Gentle windings can be seen from trail or canoe in Daniel Boone National Forest.

Rapids of Tennessee's Obed River sieve through rock gardens below Point Trail. Cutting deeply into the Cumberland Plateau, the river features wild gorges, whitewater, and rich assortments of plants and fish. Nemo Dam, proposed in the 1960s, led to the Obed's wild and scenic designation in 1976, which included contiguous reaches of the Emory River and Clear and Daddy's Creeks.

The South Fork New River tours Appalachian uplands of North Carolina before steepening in the thundering rapids of West Virginia's New River Gorge—a separate "national river" under Park Service management. The New, whose path transects the ancient Appalachians, is often regarded as the second-oldest river in the world.

At the zenith of the Appalachians in North Carolina, streams careen off the east slope with gradient unequaled in the East. The short, misnamed Horsepasture River stairsteps down a dazzling incline southwest of Brevard—one of the ultimate eastern locations for waterfall kayaking.

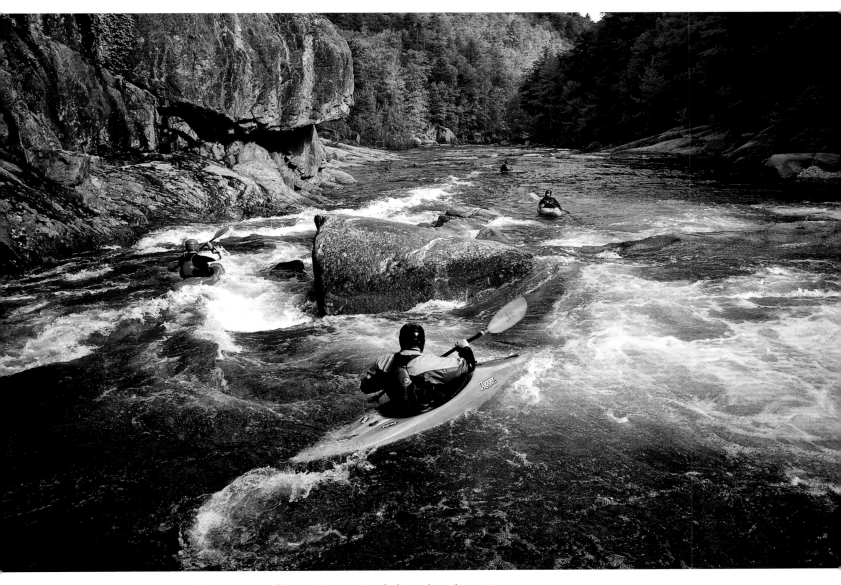

Wilson Creek plunges off the escarpment of the southeastern Appalachians through exquisite rapids during springtime flows, reached by riverfront road west of Lenoir, North Carolina. Heavy summertime use by people along the shores here challenges Forest Service managers.

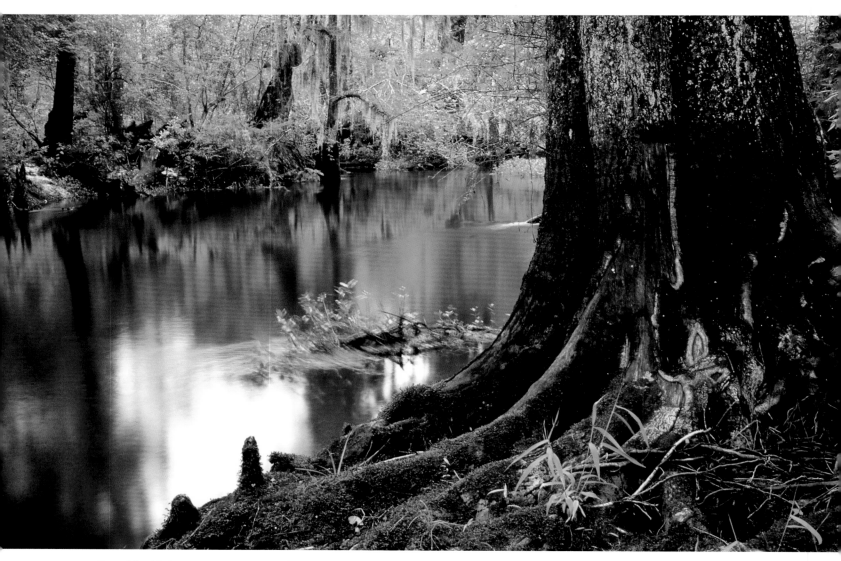

One of few black-water swamp rivers in the wild and scenic system, the Lumber meanders through the Atlantic coastal plain. Here at the Highway 74 crossing, bald cypress tower overhead. North Carolina hoped that this addition to the wild and scenic system would boost tourism in an economically depressed area. The state had acquired 11,000 acres spanning 115 miles to create one of the longest river-oriented state parks anywhere. Federal planners agreed to 77 miles as a wild and scenic river; for the remainder, they found inadequate assurance that local land-use regulations would protect key values. Canoe access is found at twenty-four areas.

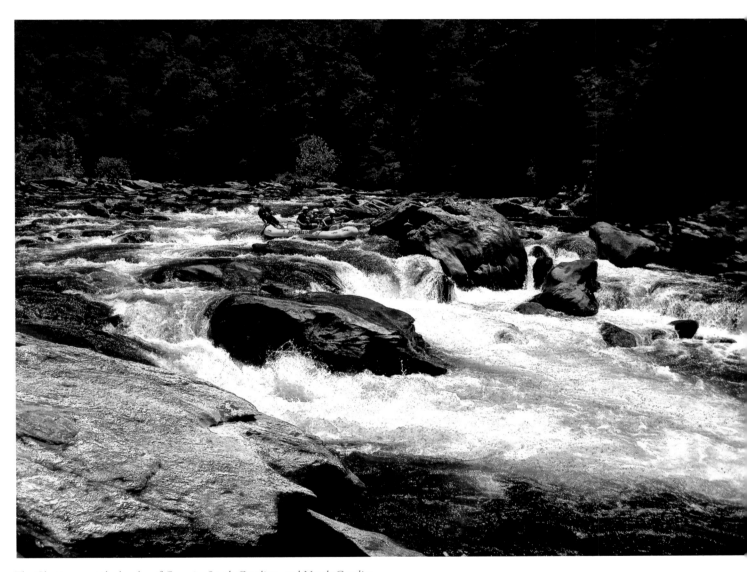

The Chattooga, at the border of Georgia, South Carolina, and North Carolina, ranks as classic whitewater in the South. Here "Section 4" offers some of the most challenging rapids regularly run in the East.

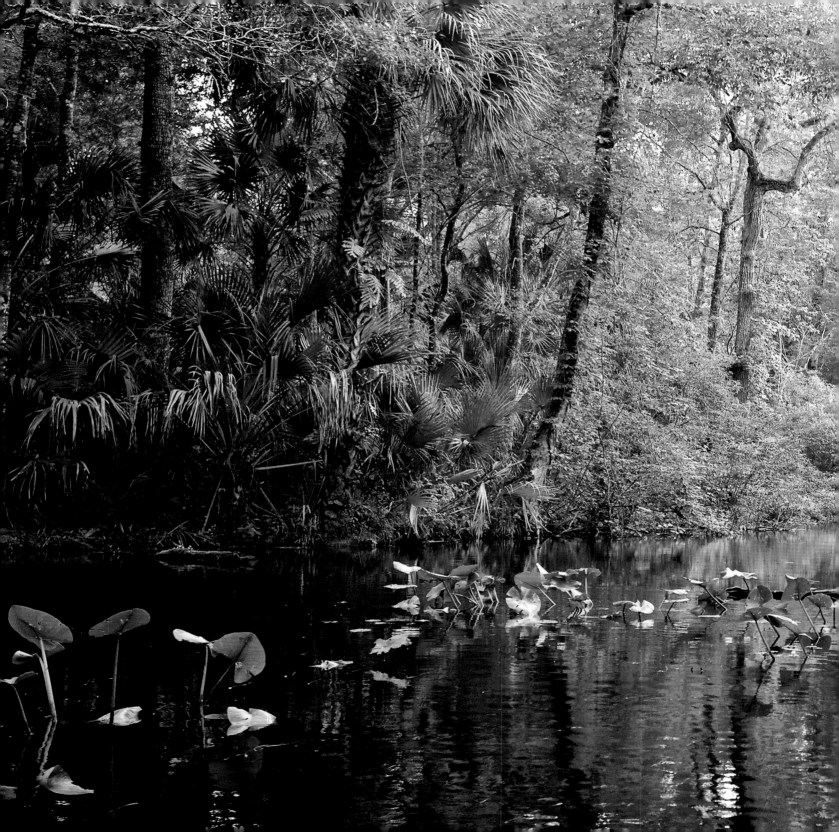

Its jungle-like enclave surprisingly intact within the Orlando urban area, Florida's Wekiva River slips in glassy calm from a spring-fed source at Wekiva Springs State Park and transports paddlers instantly to a corridor of subtropical palms and vines with singing birds and sunning turtles.

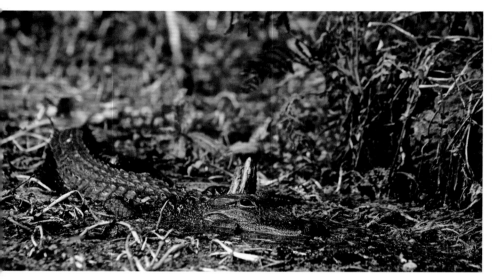

Lurking at the Wekiva's edge, an alligator gives me
full-eyeball as I pass in my canoe.

Flowing into the Wekiva, Rock Springs Run is also wild and scenic.
Slow water invites paddling upstream and down.

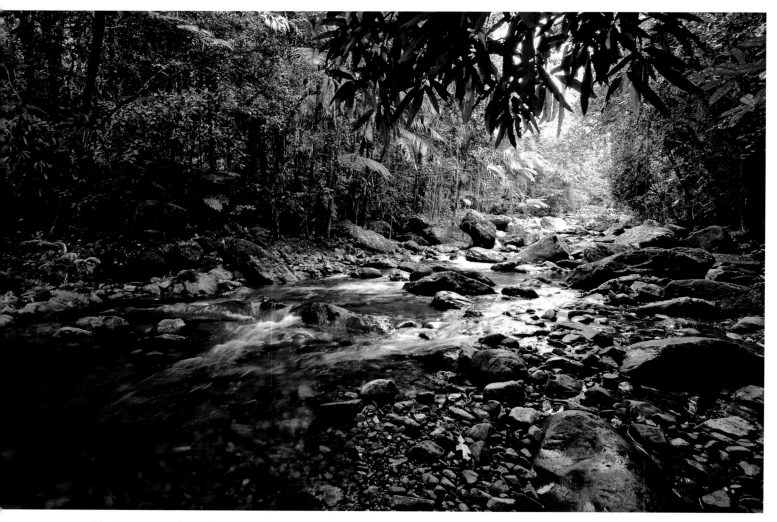

The Rio Mameyes bursts from
tropical mountains of El Yunque
National Forest, Puerto Rico.

Opposite left: eached by bushwhacking through jungle terrain, the
diminutive Rio Icacos drops steeply from highlands to tropical valley.

Opposite right: Even during tropical downpours, this waterfall and
pool of the Rio de la Mina along Big Trees Trail entertains visitors in
El Yunque National Forest. The lush canyon is home to endangered
Puerto Rican parrots and boas.

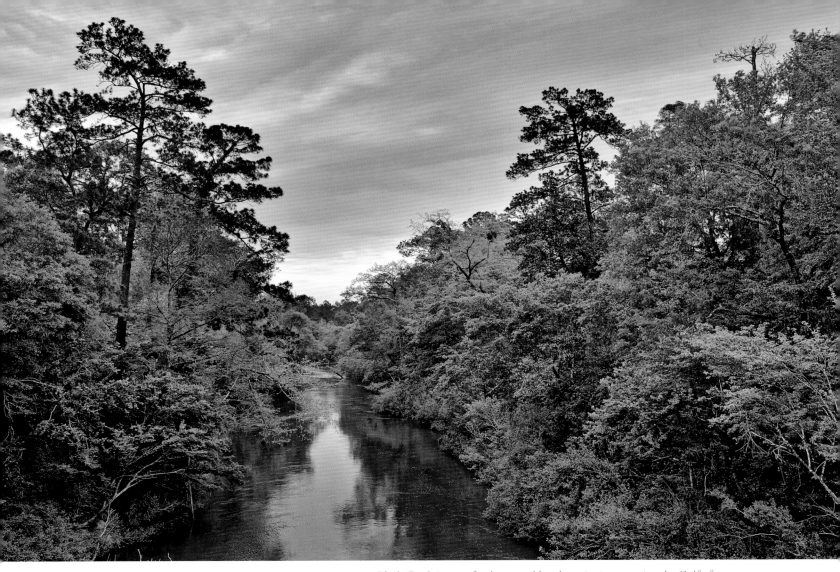

Black Creek is one of only two wild and scenic rivers nearing the Gulf of Mexico. Here the Janice ramp off Highway 29 is put-in for a scenic float to Fairley Bridge Road or an extended forty-mile outing with amber water and white sand bars. Though clear-cut in the past century, pines and broadleafs are again maturing throughout Black Creek Wilderness.

Opposite: Seen from a wilderness trail north of Double Springs, Sipsey Fork of the West Fork River, Alabama, flows past deep forests and sandstone bluffs in the southernmost reaches of the Appalachians. Flora and fauna of the coastal plain and uplands, including native fishes decimated elsewhere, mix here.

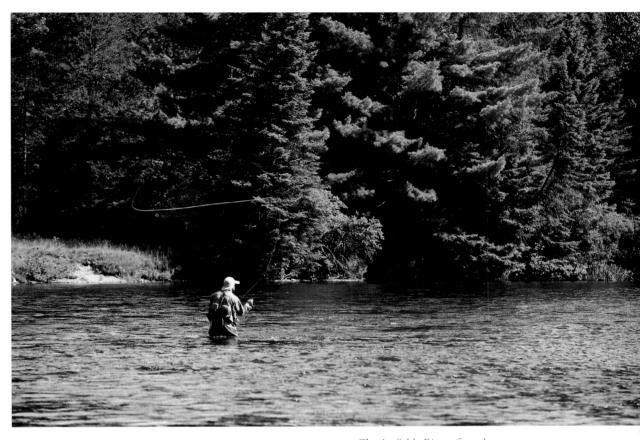

The Au Sable River of northeast Michigan has a long and storied tradition of fly-fishing for trout. Here the McKinley bridge access lies midway in a trophy-trout reach below Mio Pond. Only 21 of the river's 240 miles are designated as wild and scenic.

Our only wild and scenic river in the heart of the Midwest's Corn Belt, the Middle Fork Vermilion riffles on a sultry morning at a state fish and wildlife area northwest of Danville, Illinois. The river is refuge to fourteen endangered bird species plus uncommon mussels and fish. Paddlers visit in springtime; anglers cast for smallmouth bass. A water-supply dam was defeated here with state protection in the 1970s. Governor Thompson's request for national wild and scenic designation remains the only case where an interior secretary—Donald Hodel—refused. His successor, Manuel Lujan, designated the river.

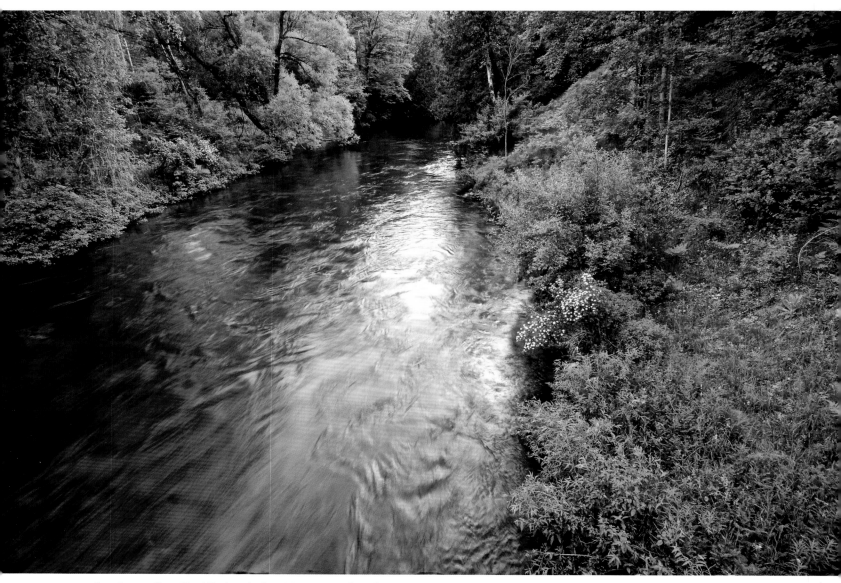

Seen here at Carrs Road Bridge, the Pere Marquette is the only major undammed river in lower Michigan, though a barrier stops lamprey from invading through the Saint Lawrence Seaway and preying on trout.

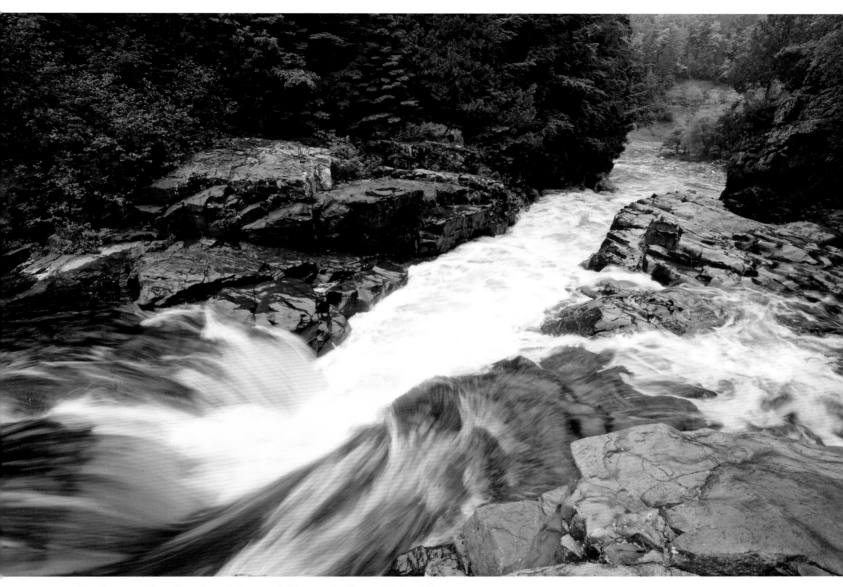

The Sturgeon River slices through its remarkable gorge in Ottawa National Forest southwest of Baraga on Michigan's Upper Peninsula. The corridor nourishes virgin balsam fir, state-endangered lake sturgeon, trophy brook trout, bald eagles, and otters.

In Hiawatha National Forest west of Manistique, the easterly of two Sturgeon Rivers on Michigan's Upper Peninsula pools beneath white pines and black spruces.

Opposite: Michigan's Black River thunders over Sandstone Falls, one of six spectacular stairsteps plunging toward Lake Superior. This is the only river with wild and scenic status extending to the largest of our Great Lakes.

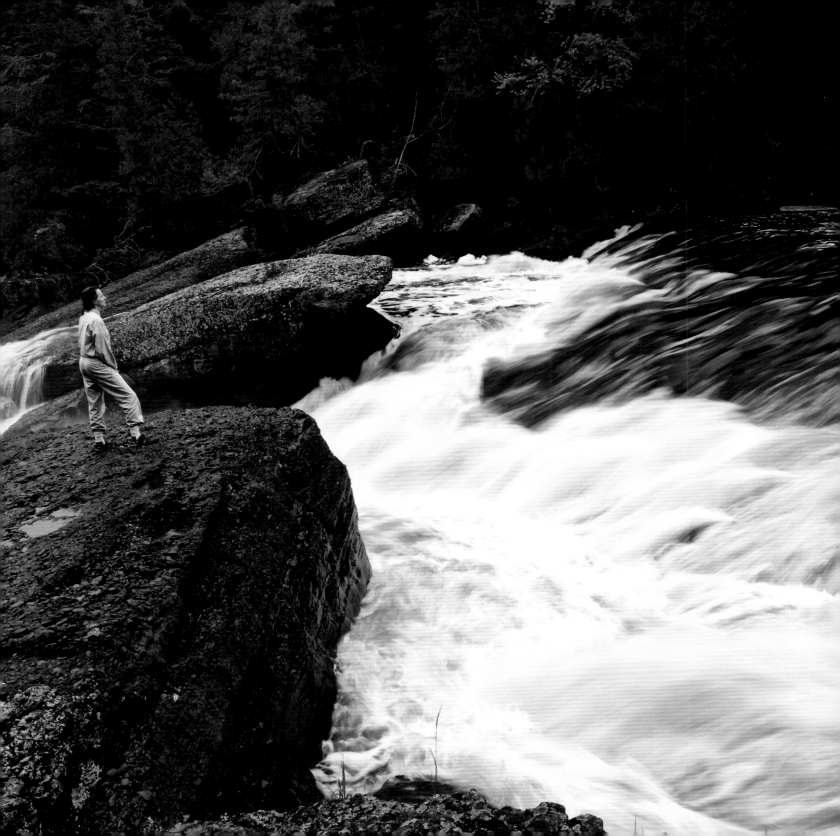

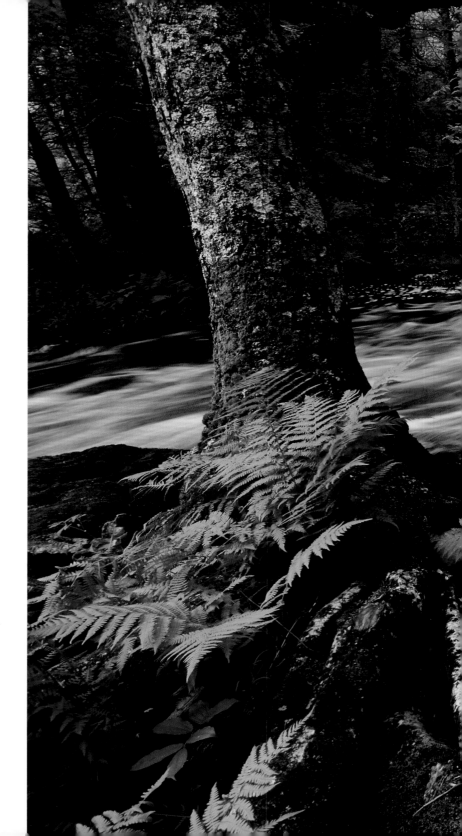

The Cisco Branch Ontonagon
foams over Kakabika Falls within
an enchanted gorge north of
Highway 2 in Ottawa National
Forest. The stream draws brook
trout anglers and canoeists.

98

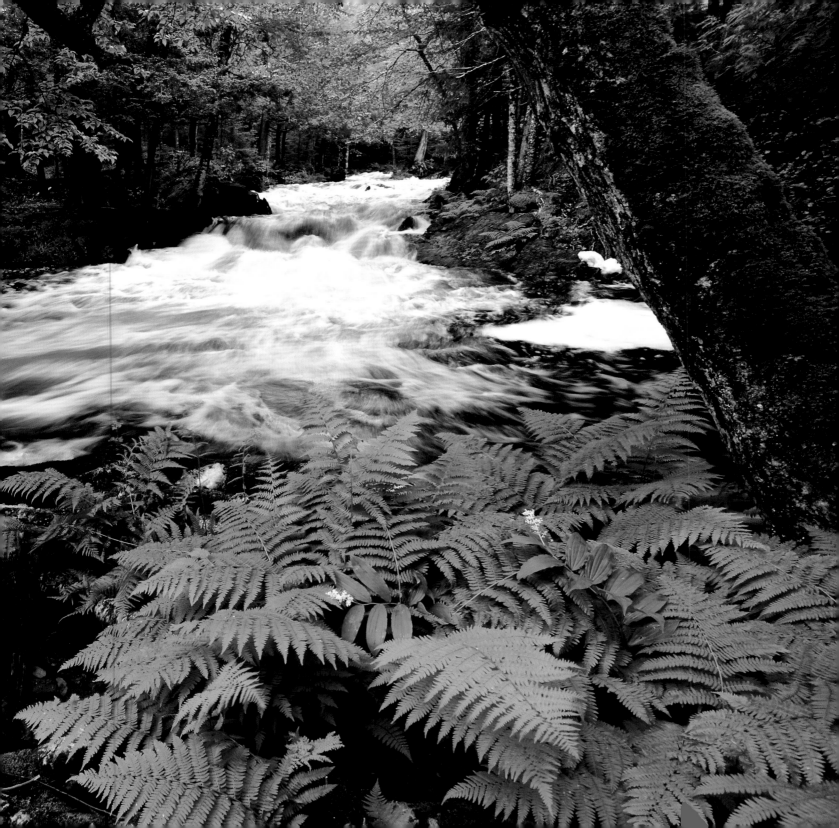

The Saint Croix at the Wisconsin-Minnesota border was one of two rivers east of the Mississippi enrolled in the original Wild and Scenic Act. The broad stream's gentle flows have been plied by canoeists starting with Native Americans and European explorers who found passage from the Great Lakes to the Mississippi with nominal portages here. Taylors Falls Dam separates upper and lower wild and scenic sections.

From source to mouth, ninety-eight miles of Wisconsin's riffling Namekagon were incorporated into the Saint Croix wild and scenic river designation in 1968, yet the Namekagon alone is the third-longest designated river in the East. Nearly continuous mileage of the two streams is wild and scenic for two hundred miles—the longest stretch outside Alaska. Several small dams were grandfathered into the legislation.

Mulberry River, legislated wild and scenic in 1992, is the longest of eight Arkansas streams flowing mostly through national forest. Popular among bass anglers and whitewater paddlers in springtime, the stream riffles here near Wolf Pen Campground northwest of Clarksville.

Offering fine midwestern canoeing, the Eleven Point River through Mark Twain National Forest was designated in the original Wild and Scenic Rivers Act. Spring flows from limestone bedrock seep through back channels such as this north of Highway 160. Greer Spring, second-largest in Missouri, doubles the river's volume. Designation stemmed from opposition to a dam that would have flooded twenty miles. Scenic easements prevent development of most private land, which involved about half the corridor.

Separated by a reservoir, two designated sections of the Missouri—America's longest river—border Nebraska and South Dakota. This is the second-largest wild and scenic river in volume of flow. Here the lower reach passes Ponca State Park west of Sioux City, Iowa. Rare pallid sturgeon and paddlefish survive, and the two reaches include five Lewis and Clark campsites.

Opposite: Upstream from Norden Bridge, a severe thunderstorm brews over the Niobrara—finest large river remaining on the Great Plains. Through the Sand Hills of Nebraska it offers an excellent extended canoe journey best known for paddling and tubing below Valentine.

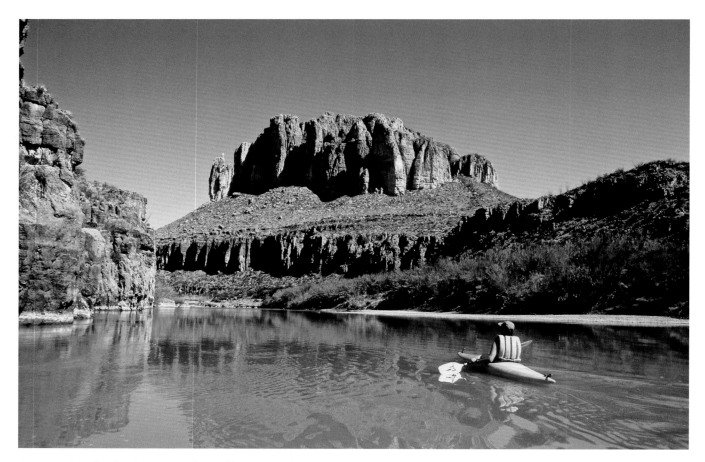

At our southern border, the Rio Grande is wild and scenic for 193 miles— the second-longest designated reach outside Alaska. One of the wildest desert rivers in America is seen here near Borland Canyon, formed by a tributary within the river's Lower Canyons. Water coming from New Mexico is almost entirely diverted; the flow below comes principally from Mexico's polluted Rio Conchos. Cattle grazing is uncontrolled on the Mexico side, but regardless, a paddling trip through Big Bend National Park and below is a desert classic.

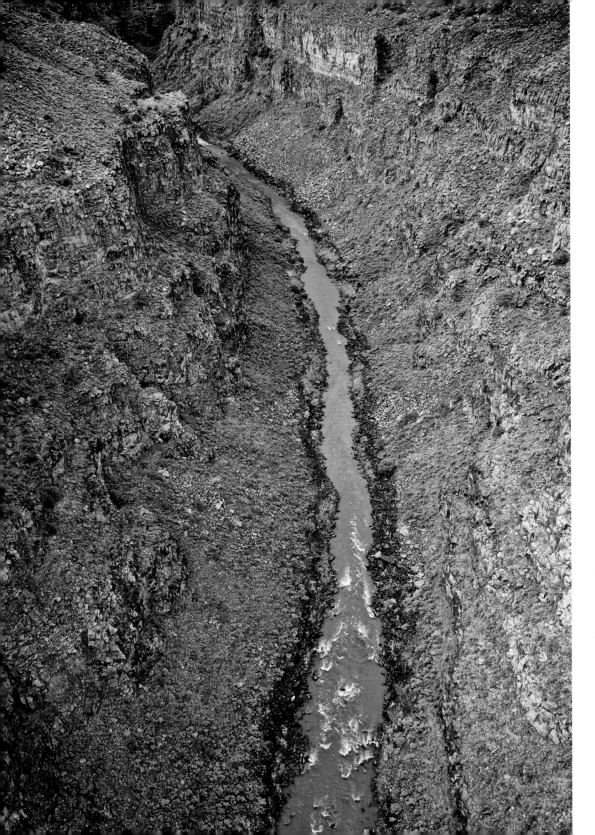

The Rio Grande begins in the Rocky Mountains of Colorado and after nearly total diversion, enters New Mexico where nourishing spring flows resupply the wild and scenic section. One of the more remarkable road-accessible canyon views in America is seen here from the Highway 64 bridge over the Taos Box.

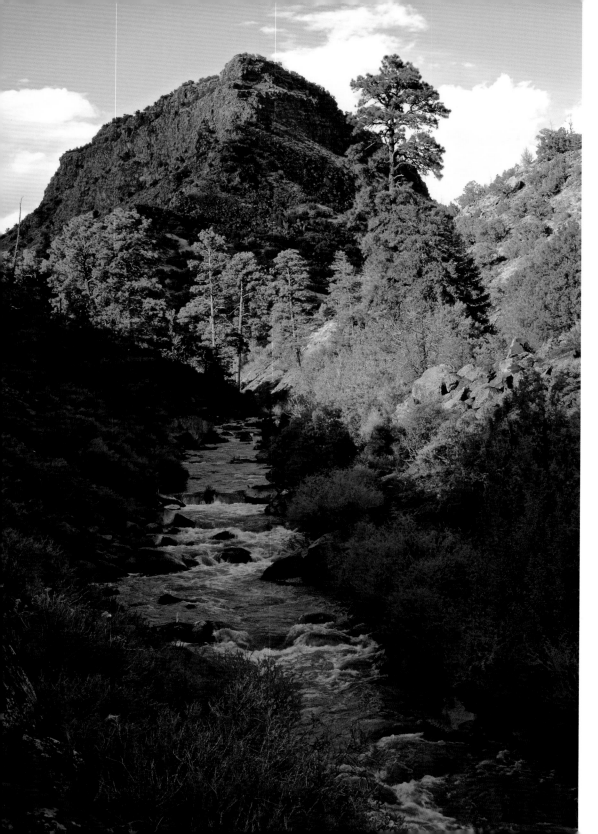

New Mexico's Red River descends
through a four-mile wild and
scenic section to the Rio Grande,
reached by trail at BLM recreation
sites west of Questa. Just upstream,
molybdenum mining refuse has
created an artificial mountain
extending for miles with 328
million tons of tailings. The state
proclaimed the river "dead" for
eight miles—the most extreme case
of upstream pollution affecting a
wild and scenic reach.

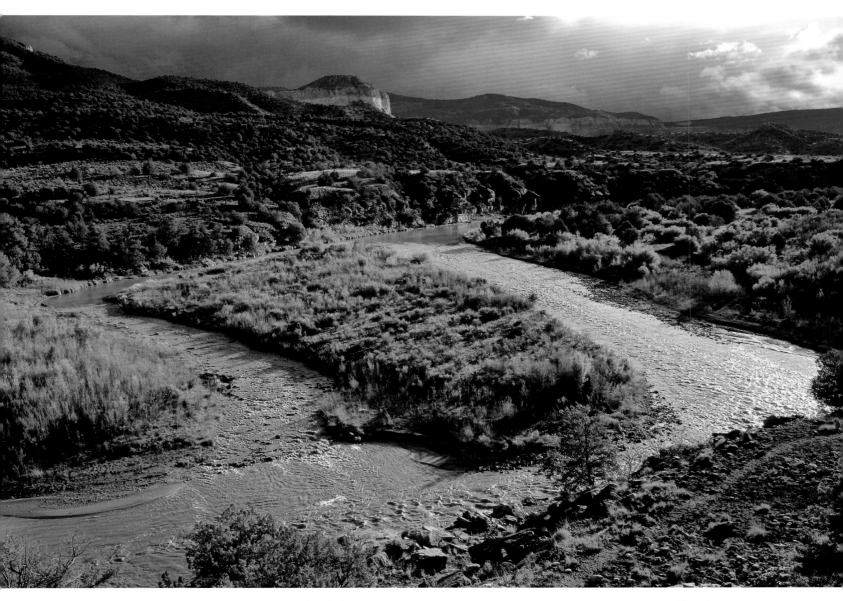

The Rio Chama flows through red rock and ponderosa pine savanna in northern New Mexico. Unique in the hydrology of wild and scenic rivers, this section between El Vado Dam and Abiquiu Reservoir includes artificially high flows with water diverted from the Colorado basin. The twenty-five-mile reach offers one of the most beautiful desert paddling trips.

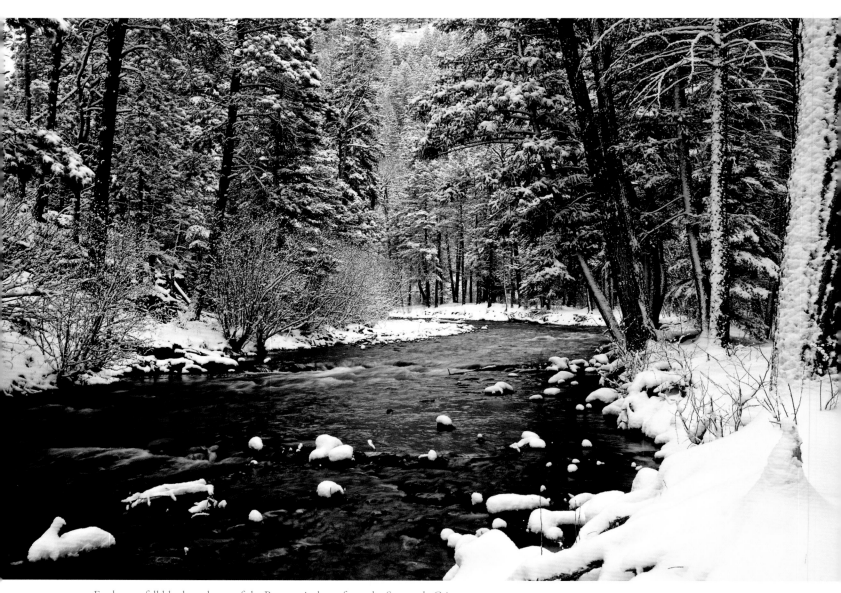

Fresh snowfall blankets shores of the Pecos as it drops from the Sangre de Cristo Mountains of the southern Rockies. The upper 21 miles through cottonwood, aspen, and spruce forests are wild and scenic. Downstream of these popular New Mexico trout waters, 750 unprotected miles of the Pecos are plagued by diversions, pesticide pollution, and residues from oil and gas drilling.

Pictured here in springtime, the East Fork Jemez winds from high meadows
of the Valles Caldera and through forests of ponderosa pines toward the
Rio Grande. Along Highway 4, eleven miles are designated.

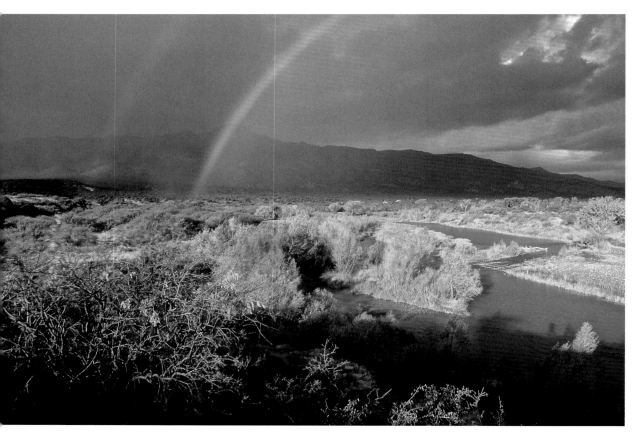

The Verde River at Beasley Flat, southeast of Camp Verde, Arizona, drops into canyons of the Mazatzal Mountains and later flows through a forest of saguaro cacti. This is the only river designated wild and scenic in the Sonoran Desert. Twenty-one fish and wildlife species are endangered or imperiled. Only half the river's eligible mileage was designated.

Fossil Creek bubbles through a stand of Arizona sycamores. Reclaimed from hydroelectric diversions, this oasis can be reached with a two-mile hike west of Strawberry, northwest of Payson. Lacking exotic trout, the reborn Fossil Creek is a rare refuge for native fish of the region.

Winter rains dampen the extraordinary canyon of the North Fork Virgin where the Three Patriarchs of Zion National Park point skyward as in a fairy tale. Upstream, the Virgin River Narrows offers one of the West's premier desert backpacking trips, barring flash-flood hazards. In 2009, thirty-eight tributaries were added to the wild and scenic system, most of them less than five miles long.

The Cache la Poudre and its South Fork, Colorado's only wild and scenic rivers, feature intricate rapids and imperiled greenback cutthroat trout. Highway 14 tracks this remarkable canyon where designation precluded several dam proposals.

114

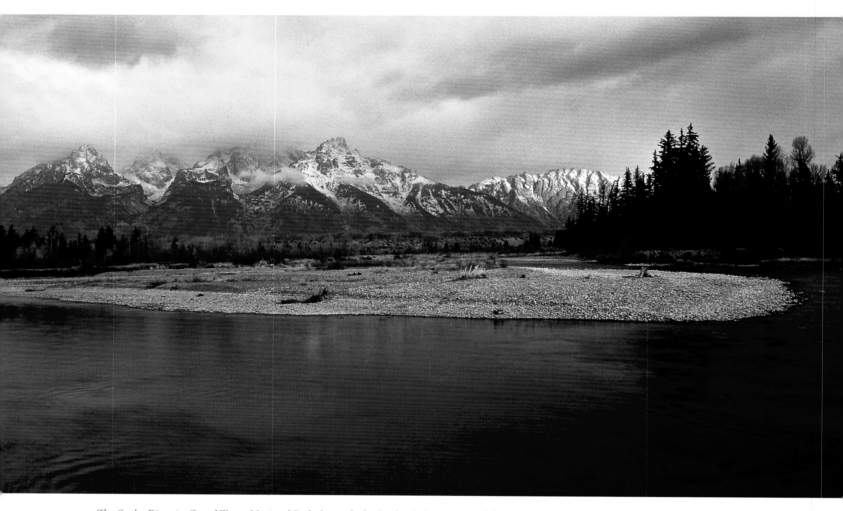

The Snake River in Grand Teton National Park, beneath the Rockies' photogenic uplift, ranks as an American classic, with a riparian corridor renowned for moose, bison, beavers, and bald eagles. Here above Schwabacher access, a late-season snowstorm dusts high peaks. Swift flows offer one of the West's most popular float trips. Wild and scenic status in 2009 enrolled fifteen tributaries as the Snake River Headwaters.

On the Continental Divide at Two Ocean Pass,
Pacific Creek—designated wild and scenic upstream
from Grand Teton National Park—spills westward.

The Lewis River rises in Shoshone Lake of Yellowstone National Park and sculpts a spectacular canyon, seen from unexpected views at pullouts tucked along Highway 89 near the southern end of the park.

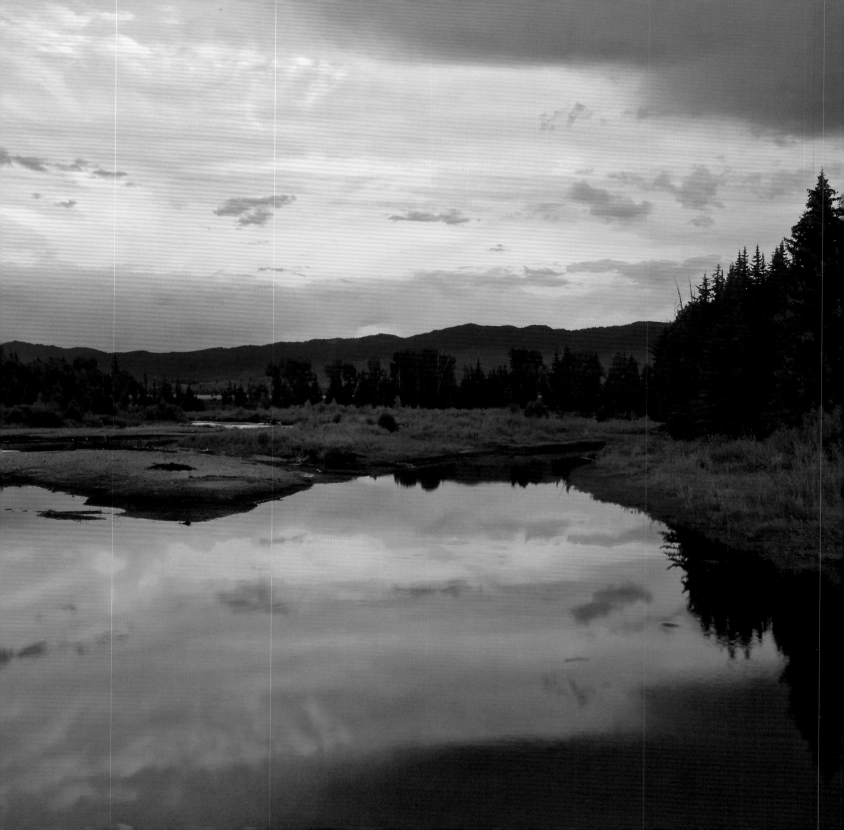

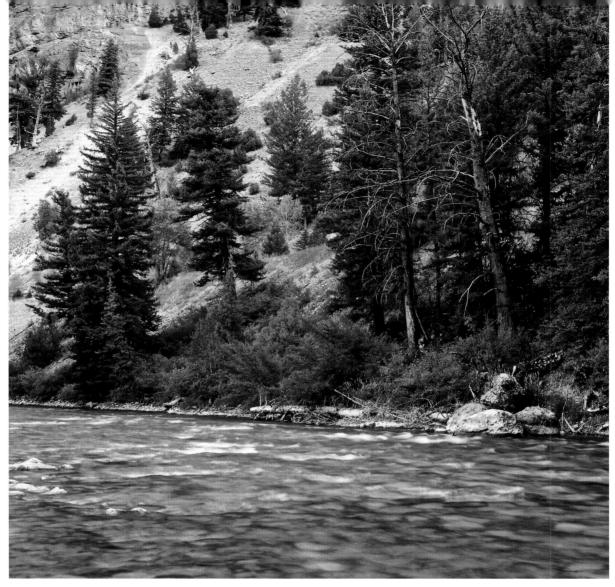

The Hoback, which offers excellent canoeing and cutthroat trout fishing, flows to the Snake River from the Gros Ventre and Wyoming Ranges. In the upper basin 136 gas wells had been slated for drilling, but to protect the river the Forest Service bought and retired mineral rights.

Opposite: Buffalo Fork of the Snake River takes shape in Bridger-Teton National Forest where three wild and scenic forks flow from wilderness strongholds of the Yellowstone region. Here the lower river traverses ranchland before entering Grand Teton National Park.

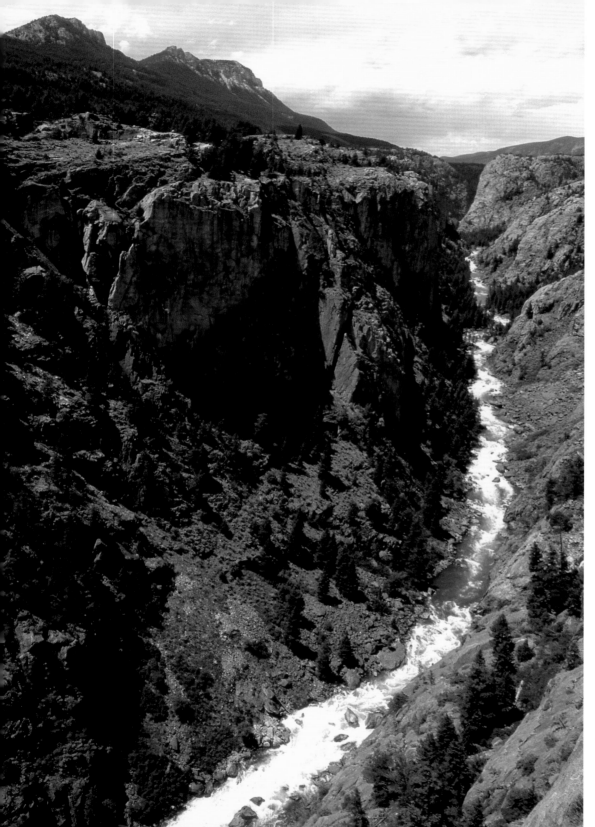

Wyoming's Clarks Fork of the Yellowstone—one of the West's wildest waterways—pounds through a glaciated, trail-less, virtually inaccessible granite canyon in the Beartooth Mountains northeast of Yellowstone National Park.

Montana's upper Missouri is the only section of the twenty-five-hundred-mile-long river that still looks much like it did to Lewis and Clark. Below Fort Benton the river eases through the plains for 146 miles past cottonwood groves and beneath the famed White Cliffs pictured here upstream from Coalbanks Landing.

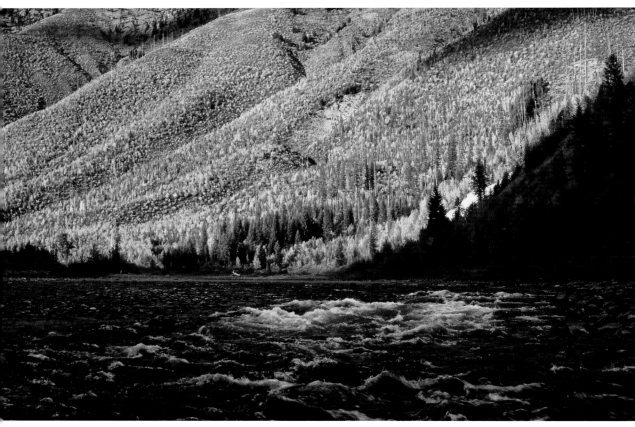

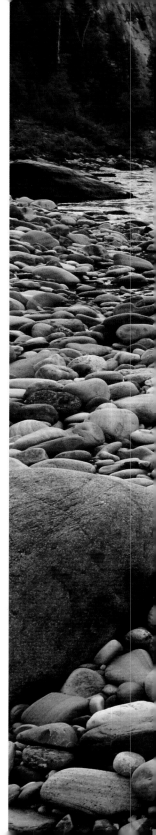

With headwaters in Canada, the North Fork Flathead marks the western boundary of Glacier National Park. Offering one of the West's outstanding canoe voyages and reached by a gravel road that's seldom seen from the water, the entire river in the United States is wild and scenic. Red, black, and white metamorphic rocks appear like a mosaic on the bottom of this stream whose astonishing clarity was imperiled for years by coal mining in Canada and gas drilling threats in Montana—now averted through international agreements and National Forest planning acknowledging the river's wild and scenic values.

The South Fork Flathead tours the Bob Marshall Wilderness, where intrepid rafters can pack their gear twenty miles on their backs or by horse and then float through wild forests and meadows. At the lower end, a gravel road ventures sixty miles along the shores of Hungry Horse Reservoir to an elegant canoeing reach and a vertical-wall limestone canyon.

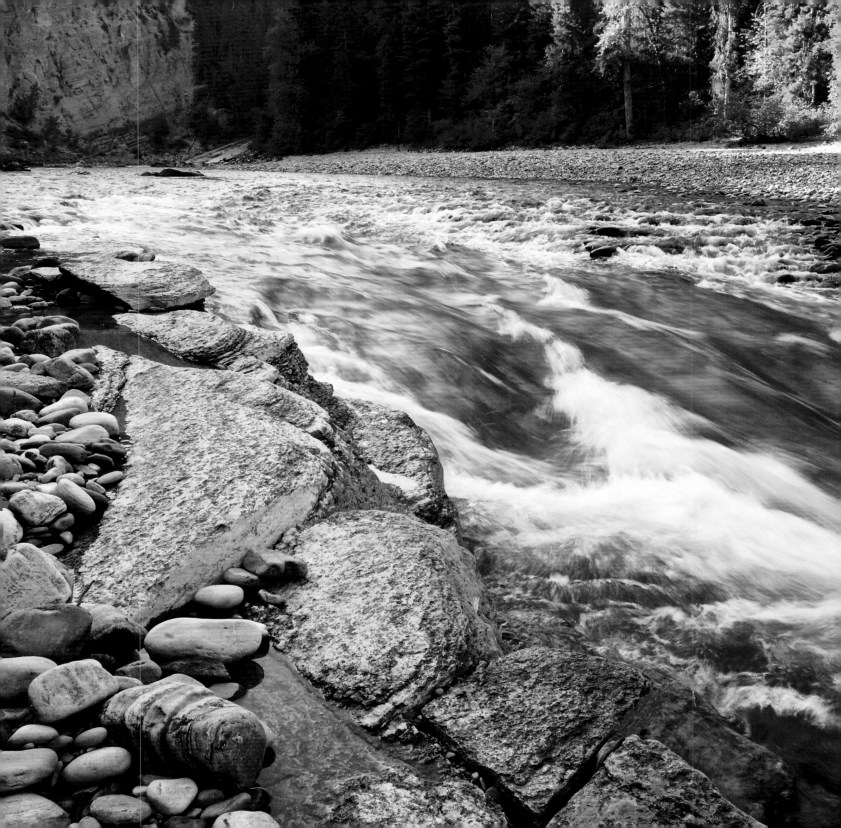

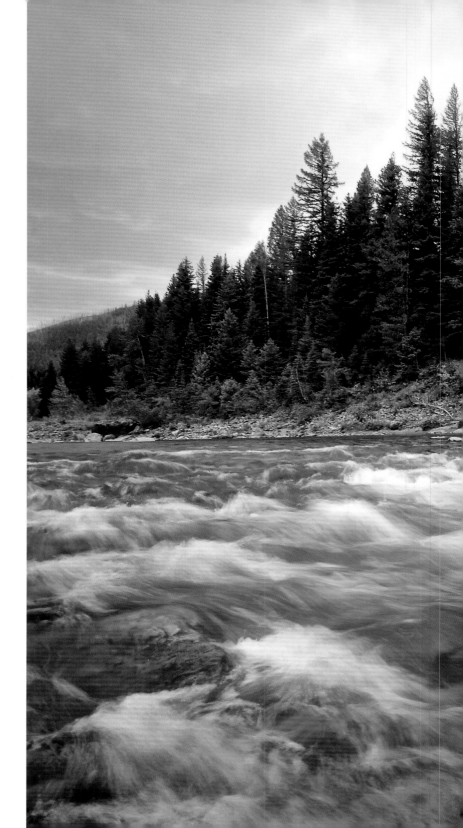

Tumbling down out of the Great Bear Wilderness and then
defining the southern boundary of Glacier National Park, the
Middle Fork Flathead, featuring native westslope cutthroat
trout and grizzly bears, is known as Montana's wildest river.
It's the nation's fourth-longest stream designated wild and
scenic from source to mouth. A few rafters pack or fly in for
whitewater expeditions; hikers can easily approach from a
trailhead along Highway 2.

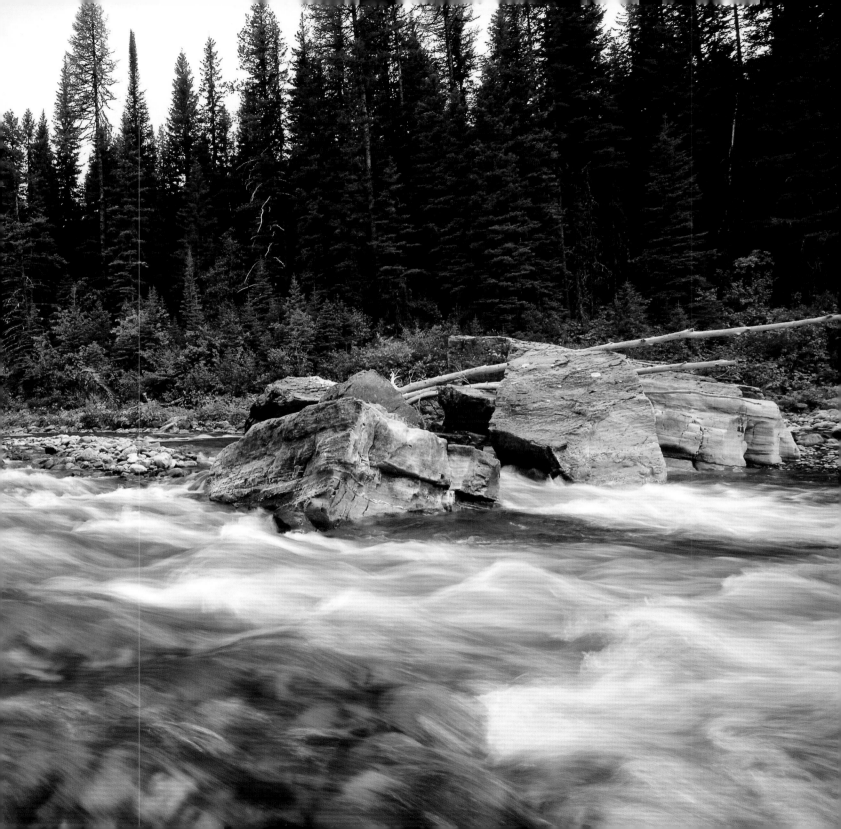

From volcanic uplands of the Columbia Plateau in southern Idaho, the Bruneau River cuts the deepest sheer-wall rhyolite and basalt canyon in America. A major tributary, the Jarbidge and parts of seven other streams, plus the adjacent Owyhee River and seven of its tributaries, were all made wild and scenic in 2009. Challenging boating here is possible in a short springtime season given adequate snowmelt from the desert ranges of southern Idaho and northern Nevada. This Bruneau overlook lies south of Highway 51.

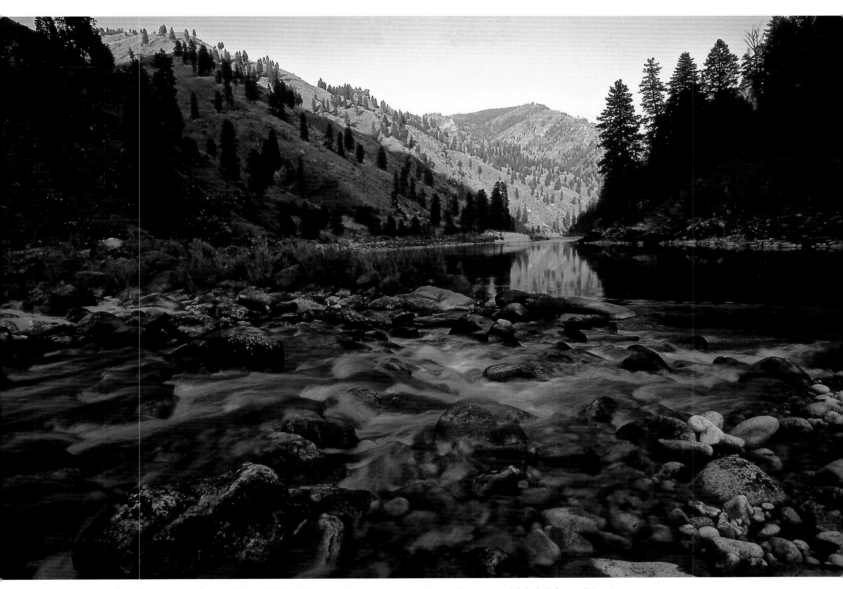

Outstanding by every standard—fish, wildlife, wildness, whitewater, river trips, and scenery—Idaho's Salmon River is the longest essentially undammed waterway in the West (a hatchery "weir" blocks passage in Sawtooth Valley). The river crosses through or around seven subranges of the Rockies. The heart of this epic journey is designated wild and scenic; however, only half the mileage recommended by the Forest Service was legislated—119 of the river's full and deserving 420-mile length. Here Sheep Creek contributes cold water for legendary salmon and steelhead runs.

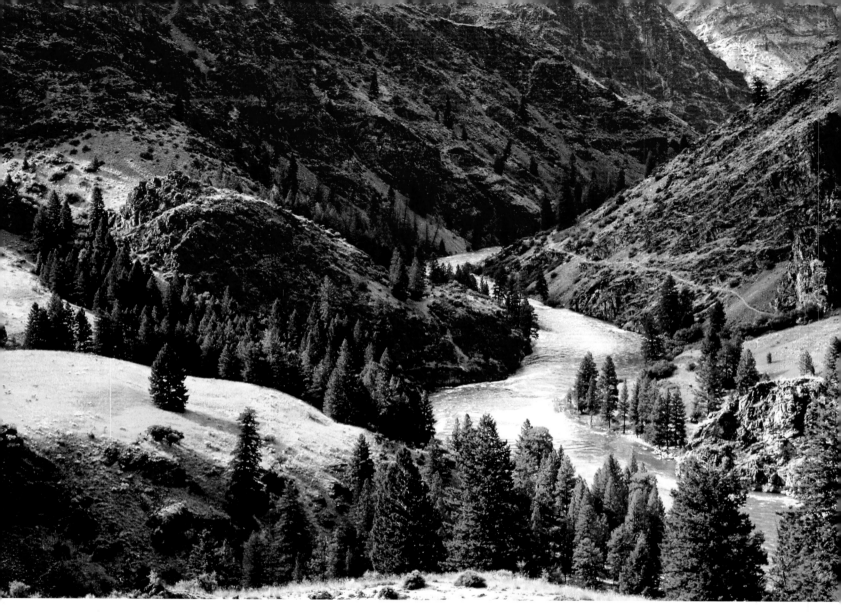

Topping many people's lists of favorite river journeys, the Middle Fork Salmon—seen here above Wollard Creek—flows through one of America's largest wilderness areas and offers exciting rapids, wildlife, and hot springs, along with some of the finest salmon and steelhead spawning habitat in the interior West. The full length of this stellar stream was among the initial wild and scenic rivers legislated in 1968, and it remains the second-longest designated river from its beginning, at the Bear Valley and Marsh Creeks confluence, to its mouth.

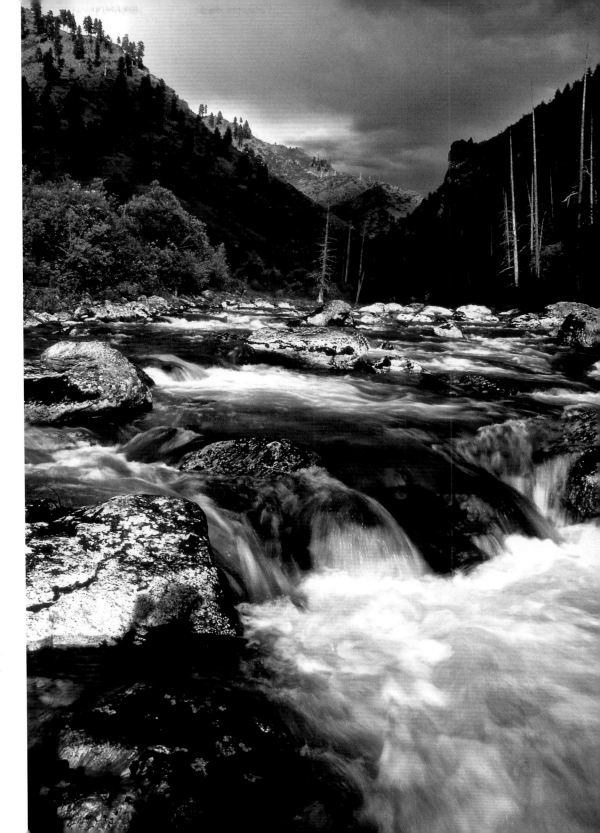

The Selway ranks among the most sought after river trips in the West. To preserve its flavor of wilderness, only one trip per day is permitted by the Forest Service. Boulder-ridden rapids continue to the confluence with the Lochsa.

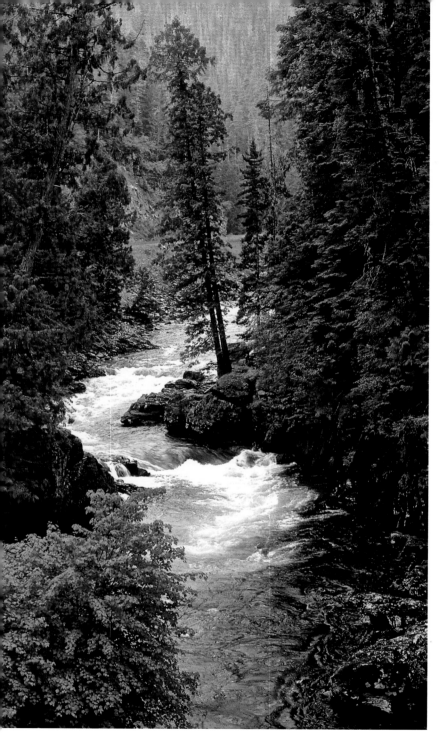

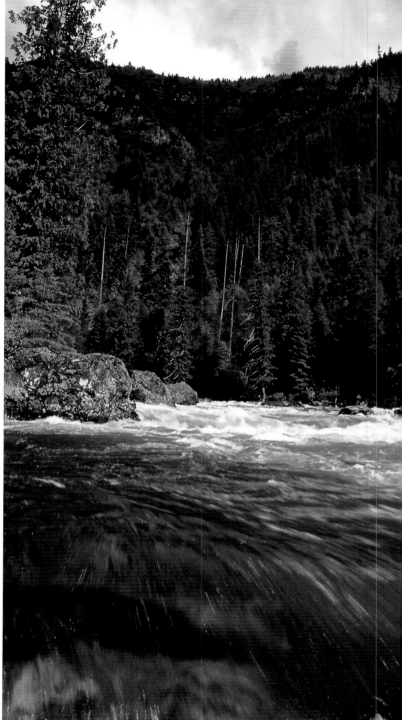

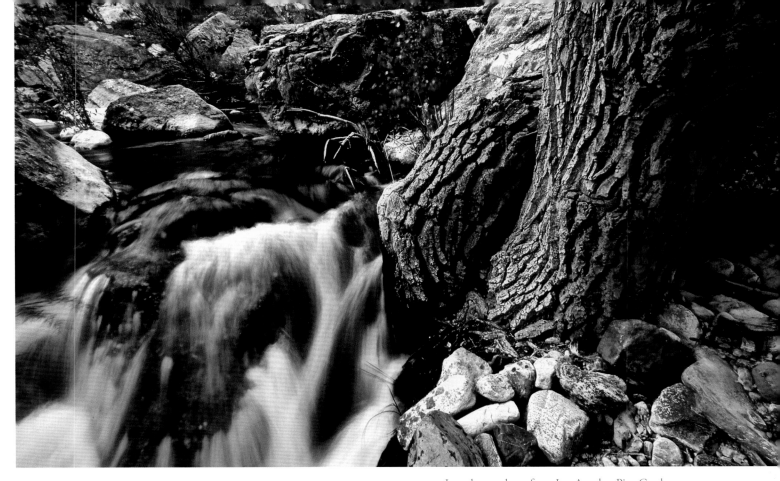

Opposite, left: The Saint Joe River winds from spruce woodlands of northern Idaho as a cold-water, bull trout heaven. Riverfront trails, whitewater boating, and angling draw people upstream from the logging town of Avery.

Opposite, right: The Lochsa was included with the Selway as part of the Middle Fork Clearwater in the original Wild and Scenic Rivers Act. Here the Lochsa rushes westward along Highway 12 from the crest of the Rocky Mountains.

Less than an hour from Los Angeles, Piru Creek cleaves the resolutely wild Falls Gorge across the San Gabriel Fault and through the Santa Ynez Mountains of erratically tilted strata, crumbling cliffs, and buttery sliding slopes twenty-five hundred feet high. Little access to the inner canyon is possible except for paddling by a few daring kayakers during rare Pyramid Dam releases. The endangered arroyo toad and red-legged frog survive here. A California Wild Heritage Bill proposed fifty-four miles as wild and scenic above and below the dam; seven miles were designated in 2009.

In the southern Sierra Nevada of California, the North Fork Kern descends, relentlessly breathtaking, from high country flanking Mount Whitney to sun-baked foothills above Kernville. Expanses of granite tighten into a ruler-straight canyon tracking fault lines. Sculpted by ice, America's longest and southernmost glacier-shaped valley widens to accommodate girthy pines and depthless pools between rapids. Rafters pack in their gear on horses for the Class 5 Forks of the Kern expedition. Others paddle the lower, road-accessible reach with its own adrenalin rush. New hydroelectric diversions were averted in lower reaches through wild and scenic designation in 1987.

Exceptional even among the Sierra Nevada's extravaganza of wild rivers, the Kings has the greatest undammed vertical drop in America—11,259 feet from the river's highest perennial source to Pine Flat Reservoir. It's also the deepest canyon, 8,240 vertical feet from Spanish Mountain to the river. Trout angling is considered the best among large streams in California. Here the main stem pools beneath Garlic Spur, reached by hiking, scrambling, and swimming upstream from the end of Trimmer Springs Road.

The South Fork Kings plunges downstream from Boyden Cave along Highway 180 in Kings Canyon National Park. Headwaters include some of America's most spectacular high country for backpacking.

Tehipite Dome towers thirty-six hundred feet above the Middle Fork Kings. Praised as the most comparable valley to the famed Yosemite (after Hetch Hetchy Valley of the Tuolumne was flooded), this reach lies eight thousand feet beneath peaks on both sides. Wilderness trails continue to headwaters at the North Palisade, the Sierra Nevada's third-highest peak.

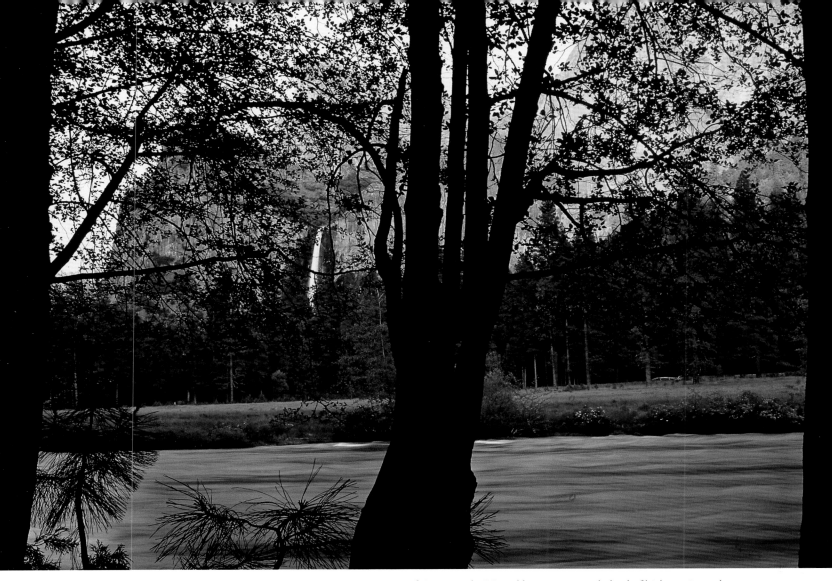

River of Yosemite, the Merced begins in a wonderland of high granite peaks, careens over Nevada and Vernal Falls, winds with incomparable elegance through Yosemite Valley, and continues with rugged whitewater below. This view in Yosemite National Park shows Bridalveil Fall on a tributary creek. Also wild and scenic, the South Fork Merced is one of few undammed California rivers with its full suite of native fish intact.

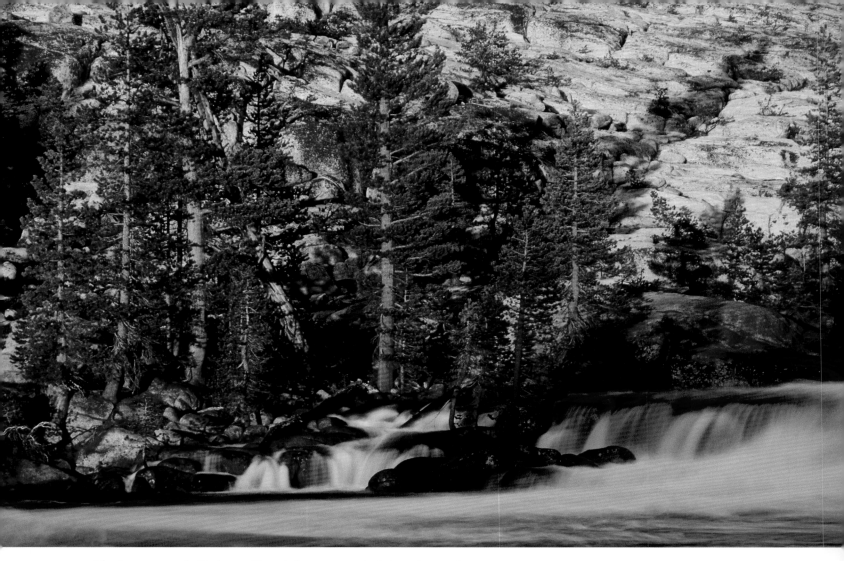

Glowing at sunset, the Tuolumne River pitches over a granite ledge as it enters its own Grand Canyon in northern Yosemite National Park. Spectacular trails follow the upper river's course. The sensational scenery of the upper river ends in the mud flats of Hetch Hetchy Reservoir, but the wild and scenic designation resumes through an eighteen-mile foothill canyon that includes the premier whitewater paddling run in California.

Opposite: Through Sacramento, the American is the most urban of all wild and scenic rivers. Levees shield development from flooding and likewise shield the riparian corridor from development. The greenway serves five million people annually who walk, bike, swim, fish, and paddle.

Above Iowa Hill Bridge, the North Fork American exits Giant Gap and enters the challenging rafting reach of Chamberlain Falls. The wild and scenic designation does not include a lower section threatened by the Auburn Dam proposal.

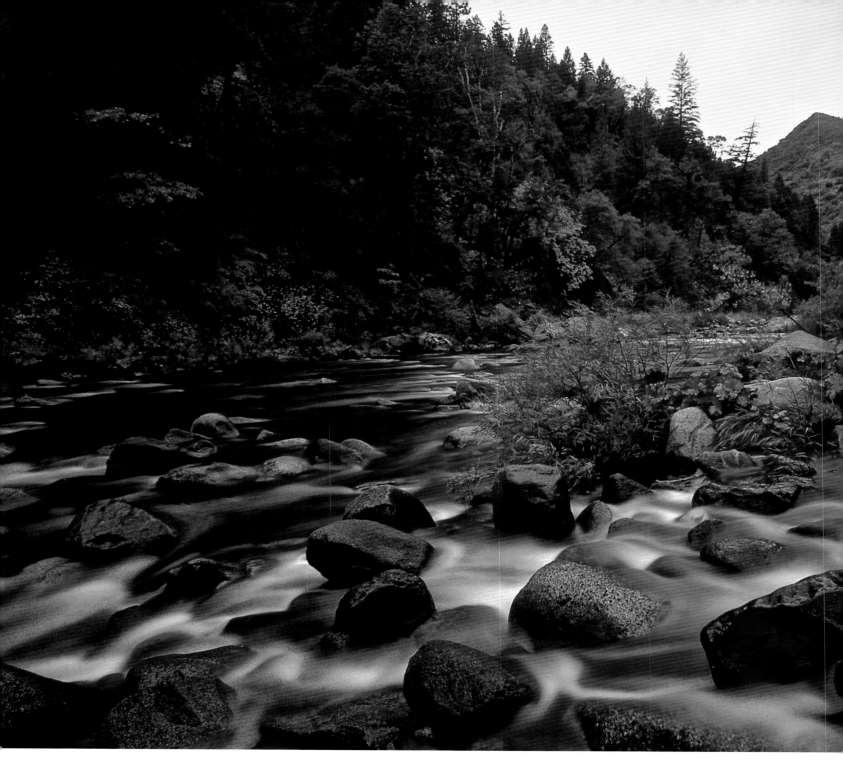

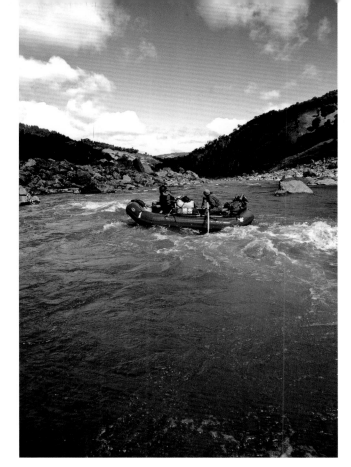

The main stem Eel is centerpiece to its watershed's 387 wild and scenic miles, including the main stem, three forks, and the tributary Van Duzen—all important to imperiled salmon and steelhead. Nationwide, only two basins have more designated mileage. Here, below the Middle Fork confluence, the main stem's blue-gray waters swirl in springtime freshets.

Among the original wild and scenic rivers, the Middle Fork Feather disappears in a forbidding canyon at the transition zone between forests typical of the Northwest and granite expanses of the Sierra.

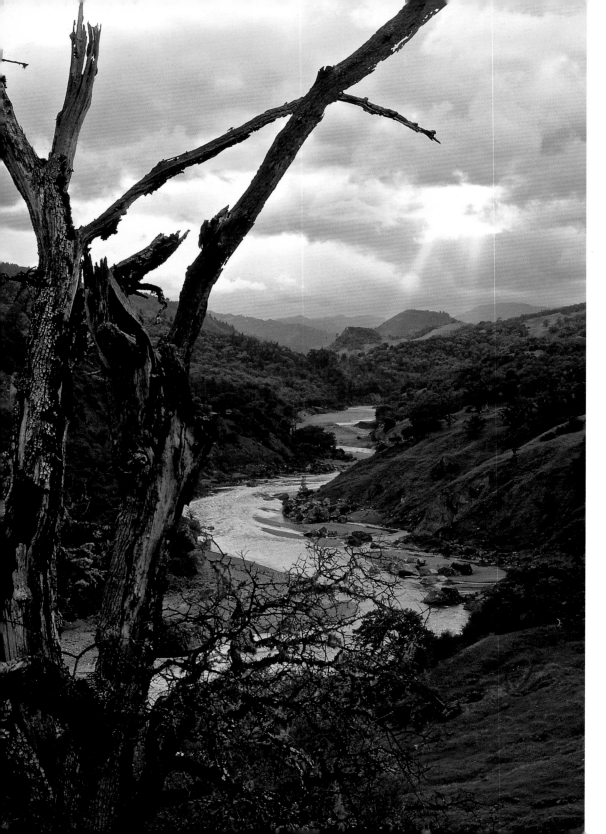

The Middle Fork Eel hides
in one of the wildest canyons
of California's Coast Ranges.
A fifty-four-mile river trip
includes one rocky portage
and idyllic savannas of oaks,
pines, and grasses.

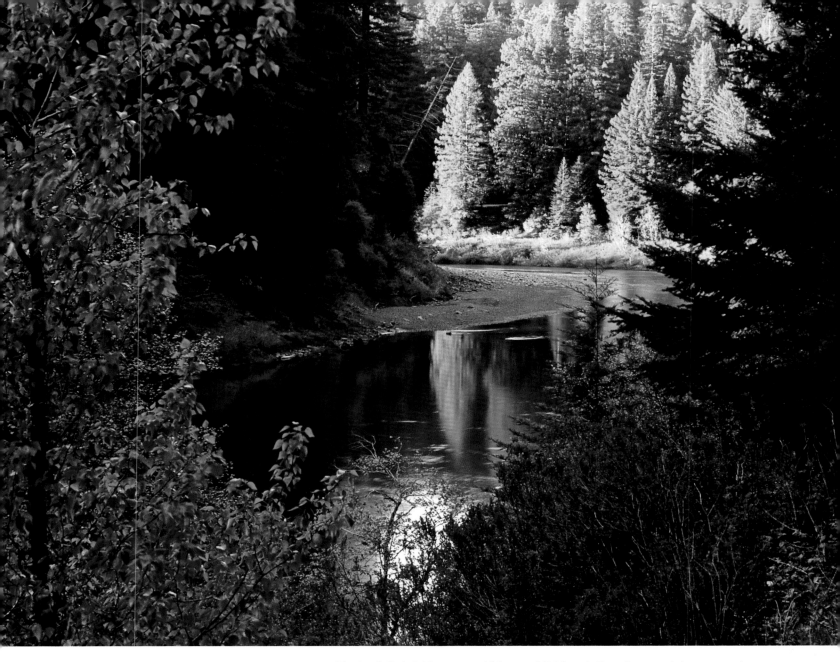

The South Fork Eel begins in wild forests of California's Coast Range and then eases with occasional rapids for sixty-four miles to the main stem—an extended canoe voyage in springtime and the finest paddling tour of redwood forests. The trip can be continued down the Eel for an expedition of 102 miles to the ocean. The South Fork has the Eel basin's best potential for restoration as a great salmon and steelhead stream.

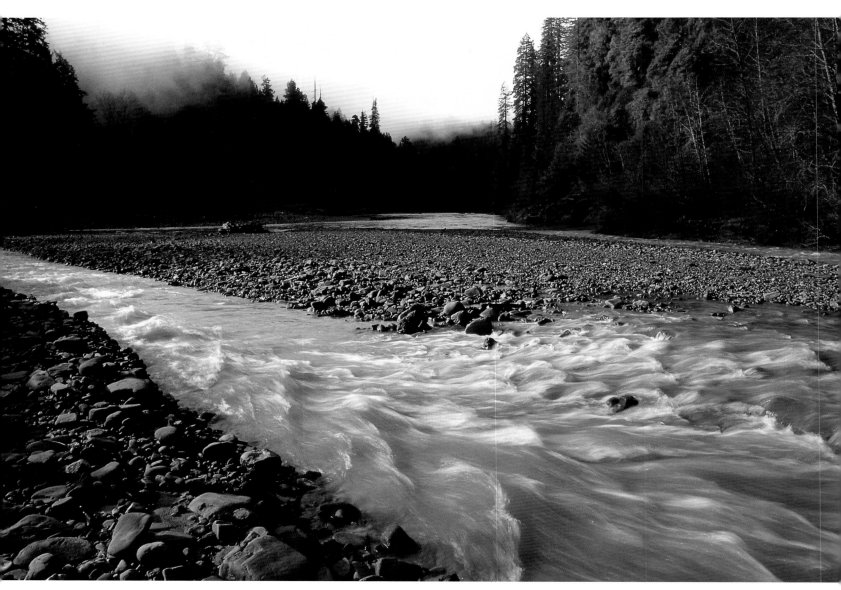

A seventy-four-mile-long tributary to the lower Eel, the Van Duzen drains the Coast Range's erodible Franciscan Formation. In this scene it picks up Grizzly Creek at a state park twenty-two miles east of Fortuna.

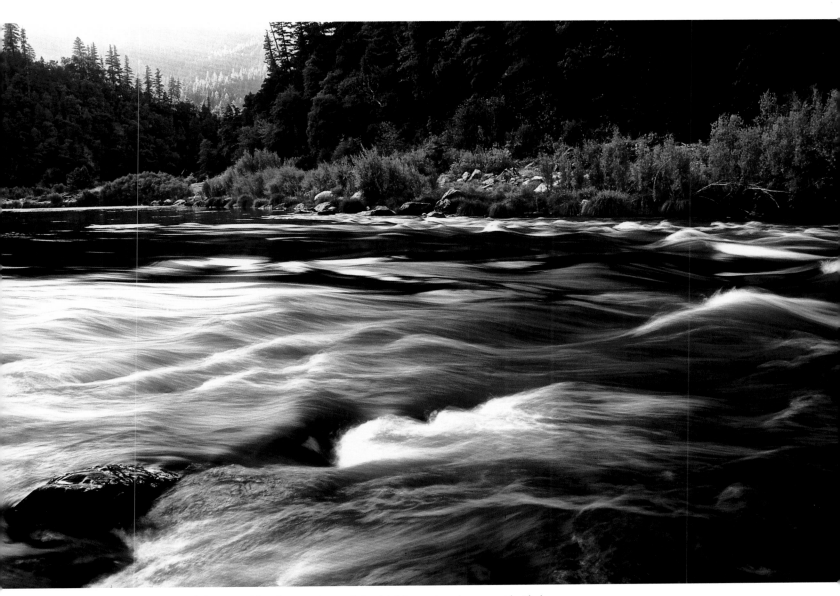

The Klamath is the seventh-longest wild and scenic river and the third-largest in volume outside Alaska. One of the great salmon and steelhead arteries of the West Coast, its runs are diminished and in some years devastated by diversions causing warm and low flows. It still offers one of the epic river trips of the West—a 188-mile journey from Iron Gate Dam to the Pacific with one mandatory portage by road. This is one of few multi-day trips on the West Coast with adequate flows all summer. The Klamath and its tributaries in California and Oregon are designated for a total of 573 miles.

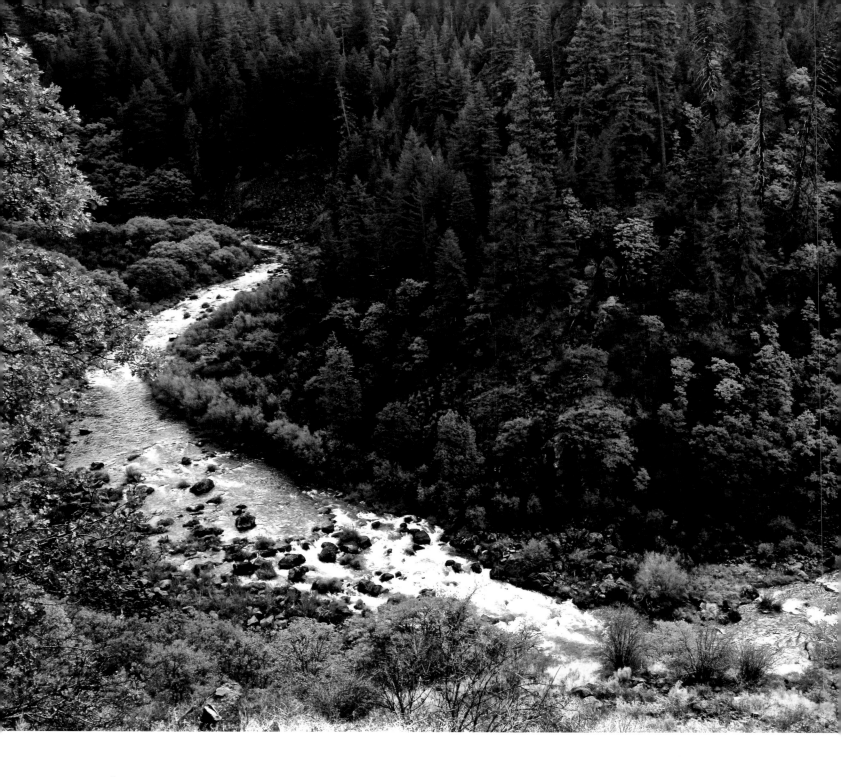

The North Fork Sprague is the finest of the upper Klamath's Oregon headwaters, winding through pine groves, high meadows, andesite canyons, and sagebrush hills. Anglers come for rainbow, brook, and brown trout. A section was omitted from wild and scenic designation in 1988 due to a now-abandoned hydroelectric proposal.

The upper Klamath River is dammed in Oregon and then cuts a singular gorge through the heart of the Cascade Range to California, where it's dammed two times again. The Northwest's biggest whitewater here is plagued by algae blooms from headwaters that are overheated by reservoirs and irrigation wastewater. The proposed removal of four dams would aid in restoration of this great river.

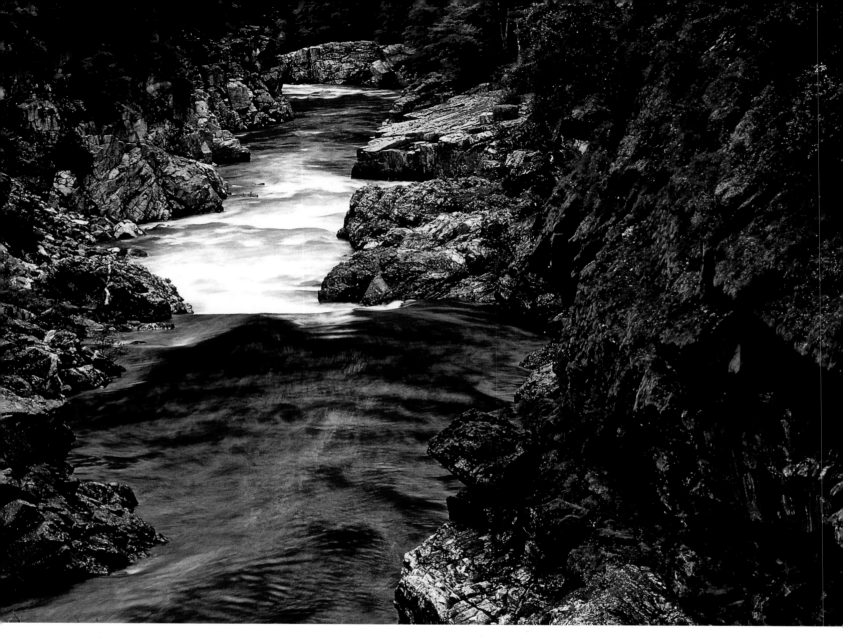

The Salmon River of northern California has wild fish habitat and brings to the beleaguered Klamath pristine cold water needed by salmon on their spawning journeys. One of the ultimate Class 5 whitewater descents, the river is reached by a cliff-hanger road east of Highway 96 at Somes Bar.

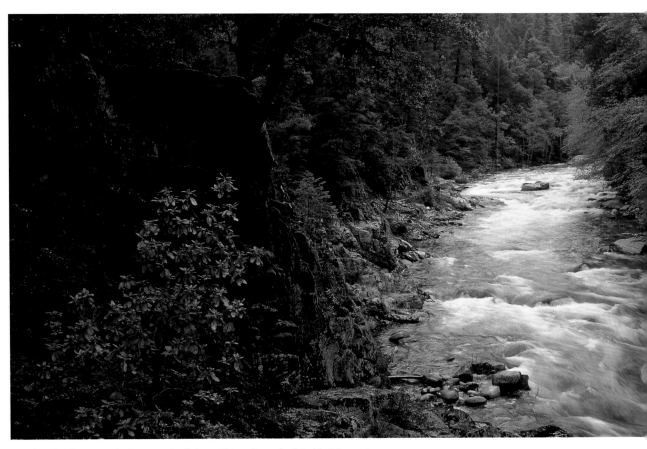

Wooley Creek pummels down to the Salmon River from the Marble Mountain
Wilderness. This important spring-run salmon and steelhead stream is reached by
hiking and scrambling from the Salmon River Road.

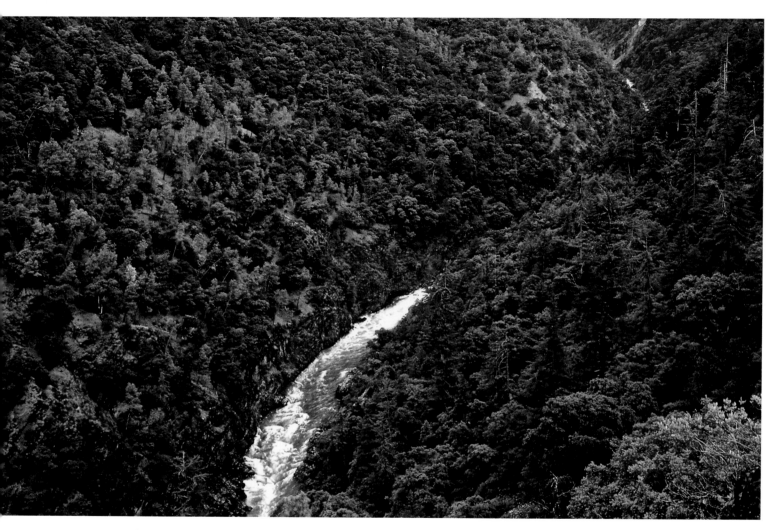

Largest Klamath tributary, the Trinity River powers through Burnt Ranch Gorge below Highway 299 in northern California. Though crucial to salmon and steelhead, the river was dammed at headwaters in 1963 and 90 percent of its flow diverted to Southern California. Legal reforms in 1992 returned 40 percent of the water, vital to four Indian tribes, sport anglers, and commercial fishermen who depend on salmon of the Klamath basin. The giant Westlands Irrigation District has repeatedly sued the government in an effort to take a larger share of the river for its corporate farms. The entire Trinity from Lewiston Dam to the mouth includes excellent boating for intermediate to expert paddlers.

The Smith is California's largest undammed river and sole remaining salmon stronghold—crown jewel of the state's North Coast. Here the Middle Fork rips through Oregon Hole Gorge along Highway 199, exposing the complex geology of the once-undersea Franciscan Formation. Great fishing, hiking trails, and fabulous whitewater boating in spring all typify this basin. The main stem riffles through ancient redwoods of Jedediah Smith State Park.

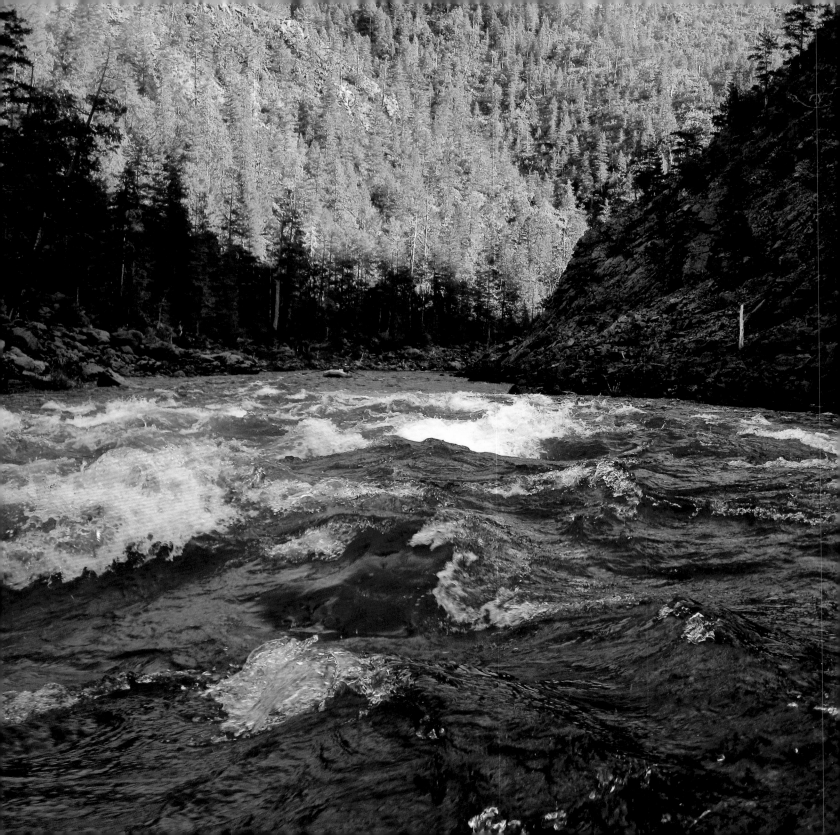

The South Fork Smith collects snowmelt from the heights of the Siskiyou Mountains and extends the high water season through springtime for great paddling on emerald water.

Opposite: The North Fork Smith careens out of Oregon and into California to meet the Middle Fork. Lucid water quality and salmon habitat mark this exceptional path through serpentine soils sprouting unusual plant life. Winter and springtime flows offer one of the liveliest whitewater runs on the West Coast.

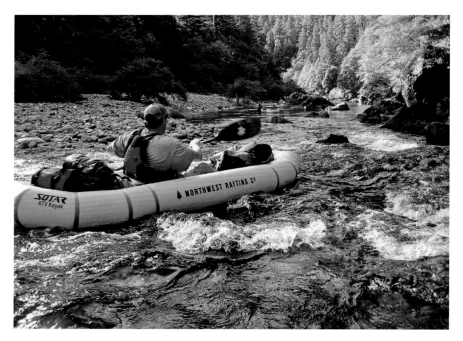

Oregon's Chetco, with no dams, roads, or development along its upper thirty miles and little below that until near sea level, is the wildest sizable river on the West Coast south of the Olympic Mountains. Upper canyons offer one of the epic wilderness river adventures in the West; hearty boaters pack inflatable kayaks ten miles over the Siskiyou Mountains and then paddle five days through boulder-riddled gorges. Drift-boating anglers fish lower reaches of this key salmon stream. Summertime swimming in the transparent water of the lower river is unsurpassed.

The Elk River's salmon habitat has been rated the finest for the river's size on the Oregon coast, though hatchery production here threatens wild fish—an issue that has remained unexplored in wild and scenic river management nationwide. Tumbling through its enchanting rain forest, this stream is reached from Elk River Road north of Port Orford. The wild and scenic North Fork, shown here, is reached by off-trail hiking upstream from Butler Bar.

The fifty-mile upper Rogue
River Trail features majestic old-
growth and sculptural volcanic
formations. Below this wintery
scene near Union Creek, the
entire stream disappears into
lava tubes at Natural Bridge and
rumbles underground for two
hundred feet.

Largest Rogue tributary, the Illinois through a lower thirty-one-mile canyon is revered for rambunctious whitewater and threatened coho salmon habitat. High flows are limited to springtime, when they can spike from 1,000 to 20,000 cfs in a day. The lower canyon can be reached at Oak Flat, east of Gold Beach.

Opposite: The upper Rogue River, seen here below Hamaker Campground in the Cascade Mountains, was designated in 1988.

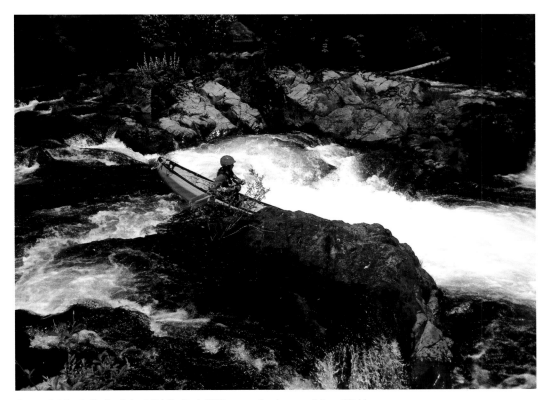

Oregon's North Fork of the Middle Fork Willamette begins at sublime Waldo Lake in the Cascade Mountains, flows through twelve miles of wilderness, then angles west with Forest Route 19 alongside. Because of waterfalls, the upper river's wild trout fishery is inaccessible to anadromous fish. Difficult whitewater below includes the Miracle Mile of Class 4 rapids followed by an easier but still challenging stretch to Westfir.

The North Umpqua may be America's most renowned river for summer steelhead fishing. Reached for most of its length by Highway 138 east of Roseburg, this may be the best road-accessible recreational river in Oregon, or anywhere: seventy-nine miles of riverfront trail for hiking and mountain biking, legendary angling, superb Class 3–4 whitewater boating, and charming campgrounds. This autumn scene lies along the upper river trail. Intensive restoration efforts strive to counteract damage inflicted with widespread clear-cutting in the 1980s.

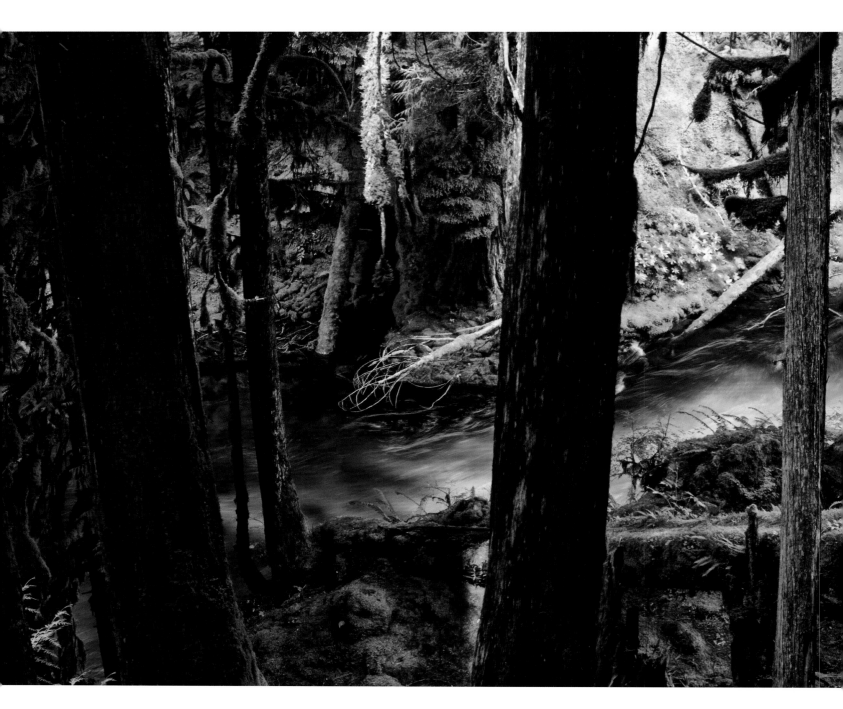

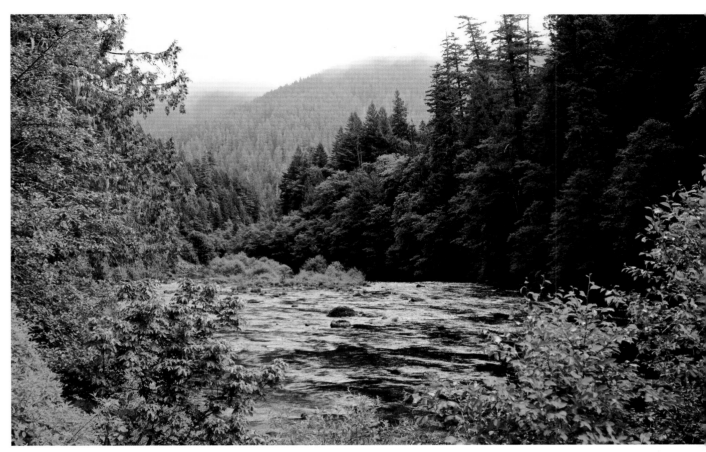

Swift water of the Clackamas is wild and scenic from its source to the uppermost of three dams. Backyard to Portland, this river has excellent hiking and paddling. Highway 224 offers this view from Indian Henry Bridge.

High in the Cascade Range of Oregon, the McKenzie River begins where a lava dam only three thousand years ago created Clear Lake, flooding trees whose snags can still be seen standing in the lakebed. One of the coldest rivers in the temperate zones of the continent, the McKenzie foams over two spectacular falls, Sahalie and Koosah, then rushes through deep forests reached by a twenty-six-mile trail. The river harbors the only native bull trout surviving on the Cascades' west slope, though populations have been reintroduced to the Middle Fork Willamette and Clackamas.

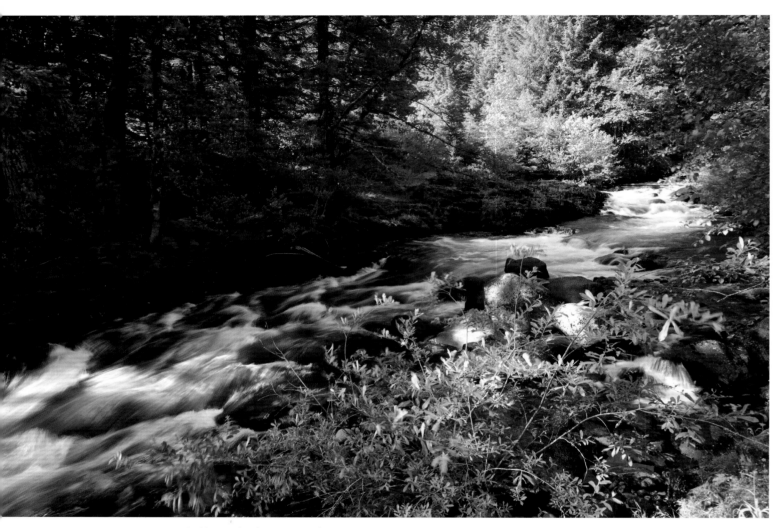

Roaring River, reached by road only at its mouth, is wild
and scenic from its source to the Clackamas.

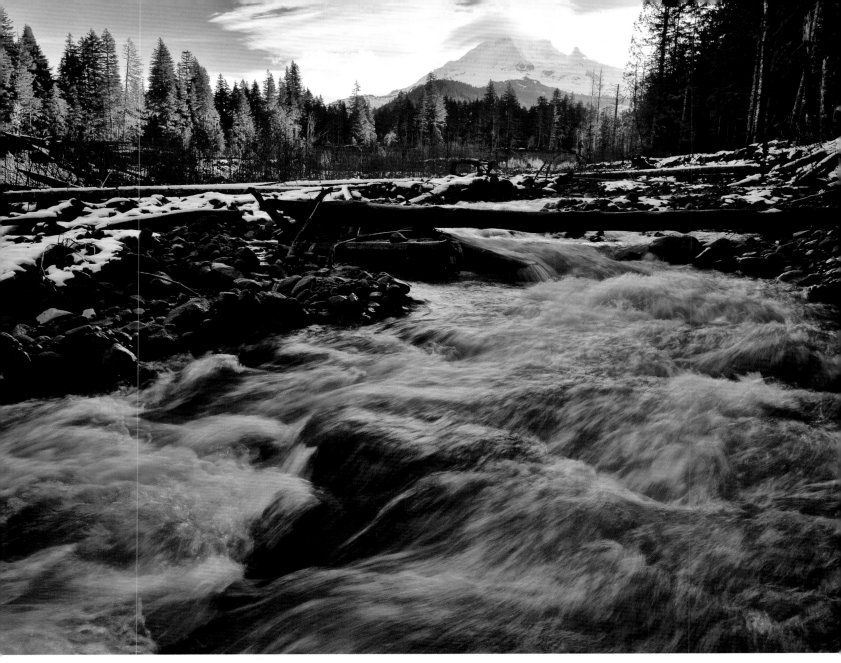

Born on the glaciated west slope of Mount Hood, the Sandy River is wild and scenic for half its fully deserving distance to the Columbia. Important to multiple runs of salmon and steelhead, the river also offers choice whitewater, then eases to gentler flows. Here Mount Hood rises above cobbled headwaters.

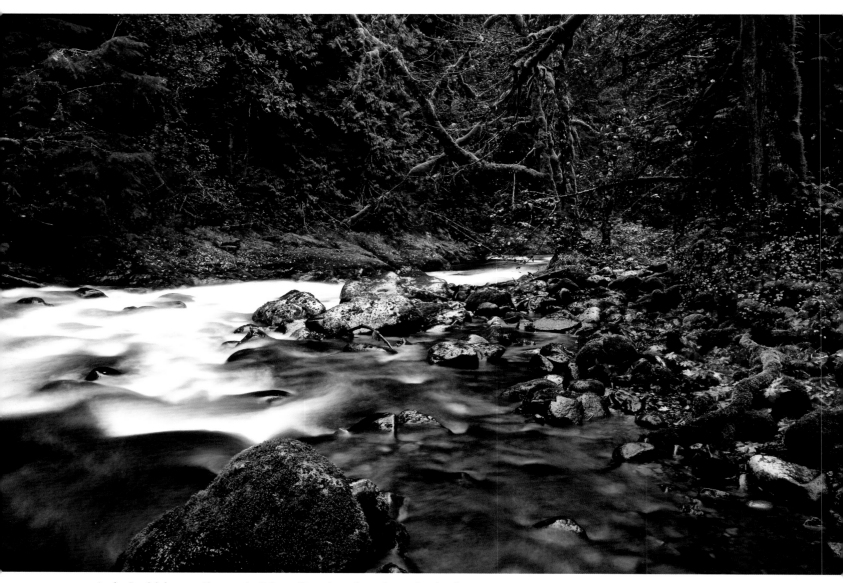

As the Sandy's largest tributary, the Salmon River drops from the south side of
Mount Hood, negotiates hidden waterfalls, then emerges at the end of the Salmon
River Road where a delightful trail follows the stream for five miles through
ancient forest. Here the first winter rains have slickened rocks and blown down the
last of November's big-leaf maple leaves.

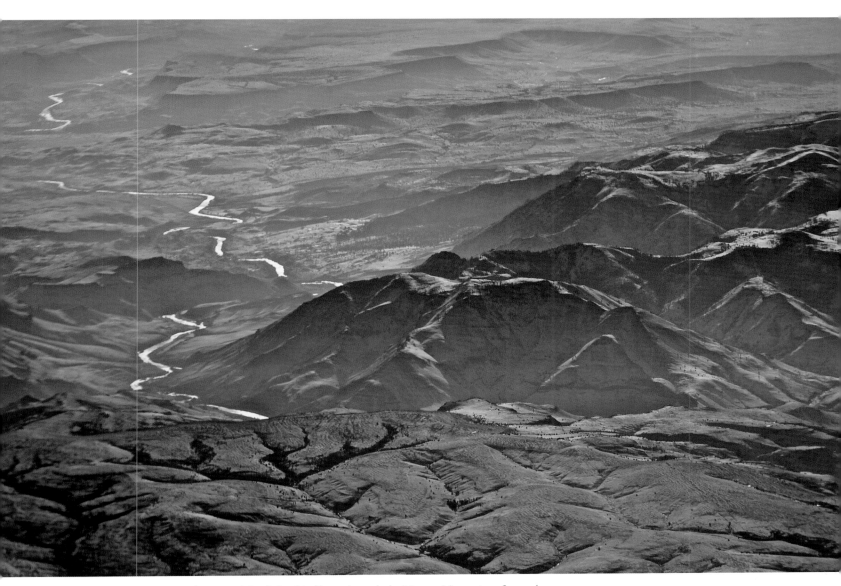

The Deschutes River snakes toward the Columbia Gorge through the Mutton Mountains of central Oregon, seen here from thirty thousand feet. In three separate sections starting on the Cascades' conifer slopes, through quiet water interrupted by astonishing falls where lava has blocked the path, and on to a remarkable desert canyon, 173 river miles are wild and scenic. The upper section is diminished by irrigation dams that invert the natural hydrograph, holding water back in winter and raising it later. The middle section is severely depleted by diversions in summer.

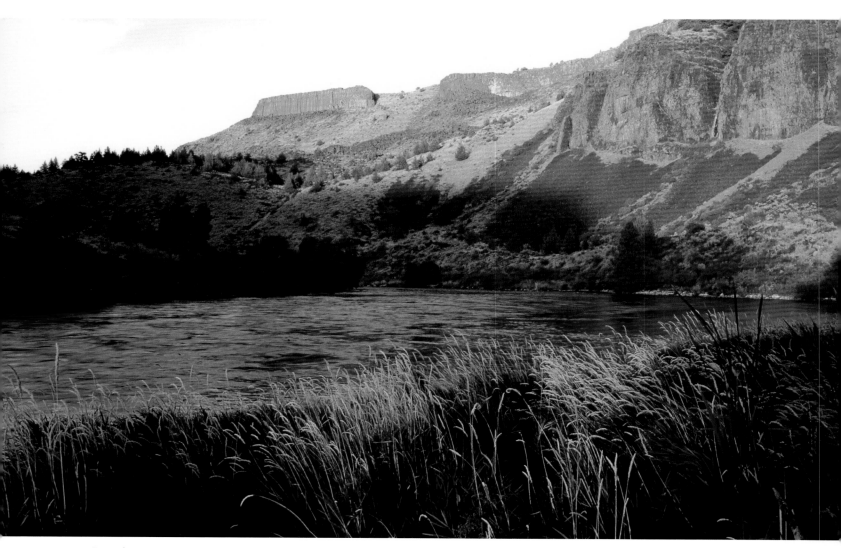

Legendary among trout anglers, the lower Deschutes is also noted for steelhead and salmon. The ninety-eight-mile canyon makes for one of the Northwest's great extended river trips, with one motorized portage around Sherar's Falls, where Indians still dip-net for salmon. Summer-long flows see heavy recreational use.

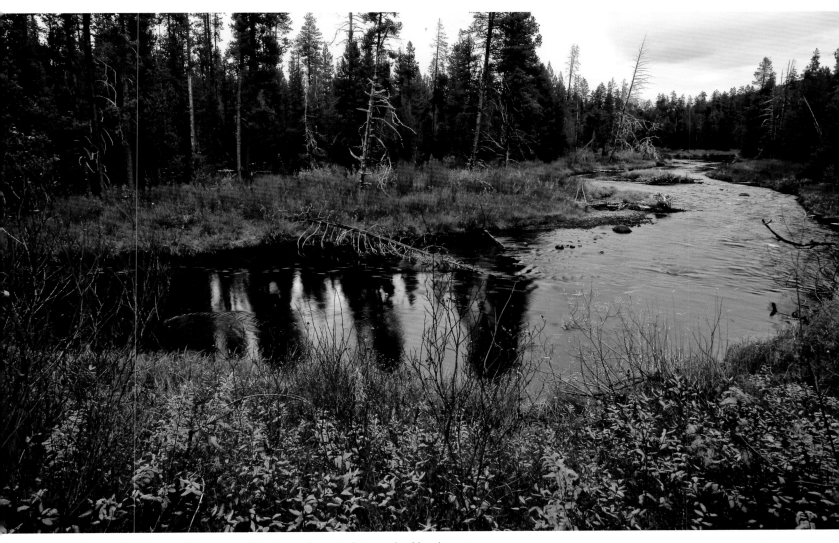

Crescent Creek is one of three upper Deschutes tributaries designated wild and scenic;
all wind from piney slopes of the eastern Cascades across uplands paved in fresh lava six
thousand years ago. With the first storms of autumn brewing, willows and spirea color the
creek's shores here west of Crescent.

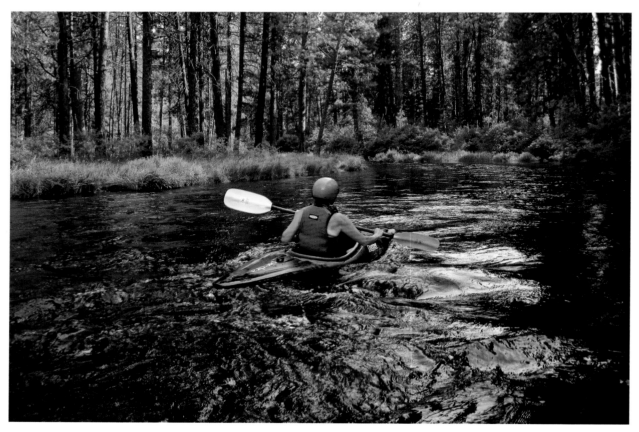

With a surface that looks like liquid glass, the Metolius River rises fully formed southeast of Mount Jefferson and ripples through ponderosa forests, meadows, and gorges near Sisters, Oregon. This is one of the country's largest spring-fed rivers. Upper reaches draw trout anglers to the slick path of clear dark water. Springs nourished by Cascade Mountain snowmelt produce one of the steadiest hydrographs known, allowing bull trout to thrive and a lush line of native vegetation to overhang the water. Leaving the road behind, the Metolius storms through an eighteen-mile gorge to the backwaters of Billy Chinook Reservoir.

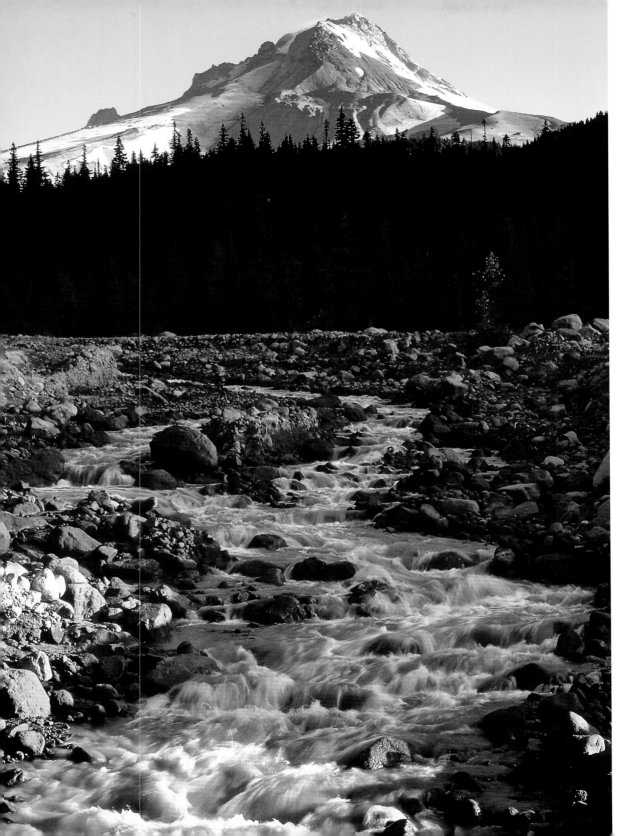

The White River takes its name from rock dust pulverized by Mount Hood's glaciers. Then it rushes through the Cascades' east-side forests of hemlock and fir, yielding to ponderosa pine in drier terrain and finally to a chain of waterfalls nearing the Deschutes. Forest Service plans for clear-cutting and a developer's scheme for hydroelectric damming were shelved with wild and scenic protections. To the west of the Highway 35 bridge, Mount Hood looms high.

171

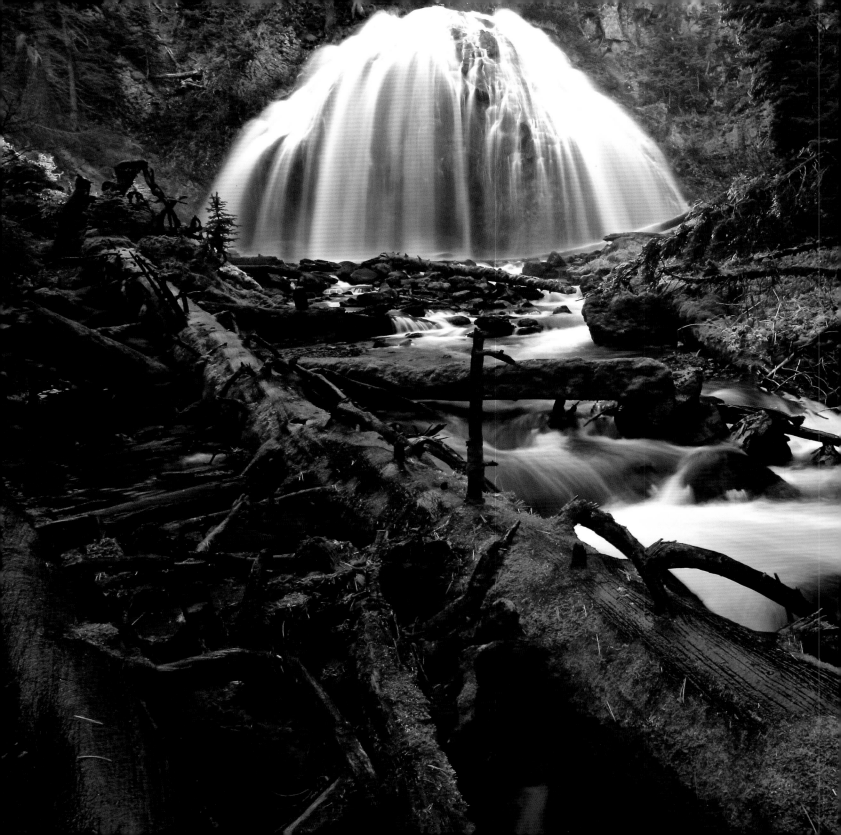

Off the beaten path, Whychus Creek rises on glacial peaks south of Sisters, Oregon, where gravel roads lead to a trail along the creek and, farther, to an upper trail and scramble ending at this stunning waterfall. With new fish passage facilities downstream at Deschutes River dams, Whychus will again become important habitat for threatened steelhead. Native redband also thrive. In an unusual approach, Whychus' North and South Forks plus Soap and Park Creeks were included within the designated river boundary, granting them wild and scenic protections though they are not named in the authorizing legislation.

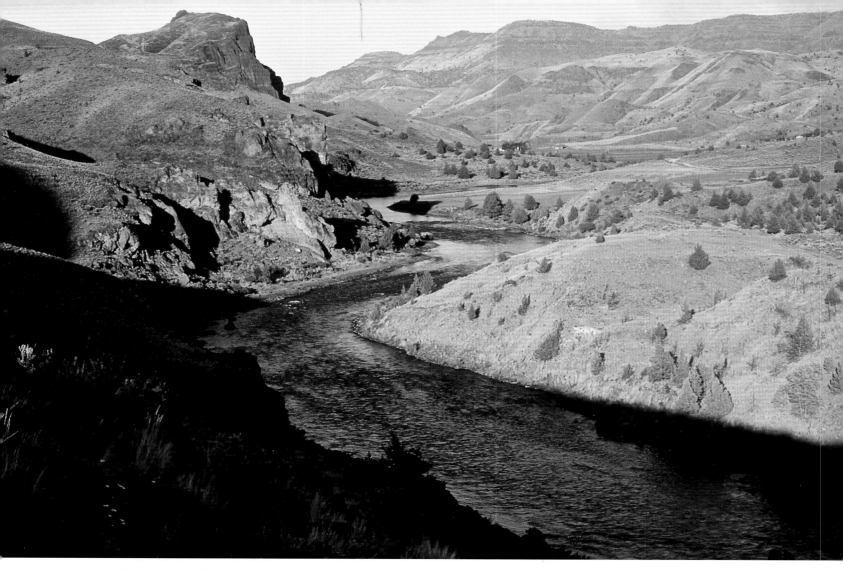

Including its North Fork headwaters, the John Day has the longest dam-free reach in the Northwest—284 miles. It also offers the longest canoe trip—225 miles with only a few large rapids. The river is a key spawning route of Chinook and summer steelhead, which encounter only two Columbia River dams downstream compared to eight that hamper anadromous fish bound for the Snake River system. The John Day traverses a mix of ranch and BLM land among golden basalt canyons. This view is below Service Creek at Dugout Canyon.

The North Fork—twice the size of the main stem where the two meet—is the true source of the John Day. Beginning in forested wilds of the Blue Mountains, it transitions to a ponderosa pine savanna. With the best surviving runs of wild Chinook and summer steelhead in the Columbia basin, the river draws catch-and-release anglers and boaters looking for mostly easy rapids.

In a class by itself, the Snake River through Hells Canyon is America's largest wild and scenic river in volume of flow, averaging nearly 32,000 cfs at its lower end (peaking at 100,000 or more). Even in late summer a gutsy 12,000 cfs are typically released from Hells Canyon Dam to the upper reach. Next to the Grand Canyon, this is the biggest whitewater in all the West, with runoff coming the whole way from Yellowstone National Park. The canyon is widely credited as America's deepest, though it does not match the forks of the Kings in California. Nonetheless, the Snake shows a staggering scale of depth, breadth, and length. Though hindered severely by eight downstream dams, wild Chinook still spawn directly in the main stem.

The Owyhee River cuts a complex path through the Columbia Plateau of southeastern Oregon. Separated by a short ranchland reach, two wild canyons of thirty-five and sixty-seven miles challenge rafters during a brief springtime window of snowmelt. Upstream in Idaho, the main stem and portions of seven tributaries have also been designated. Here canyon walls rise vertically at Iron Point, thirty-two miles downstream from Rome.

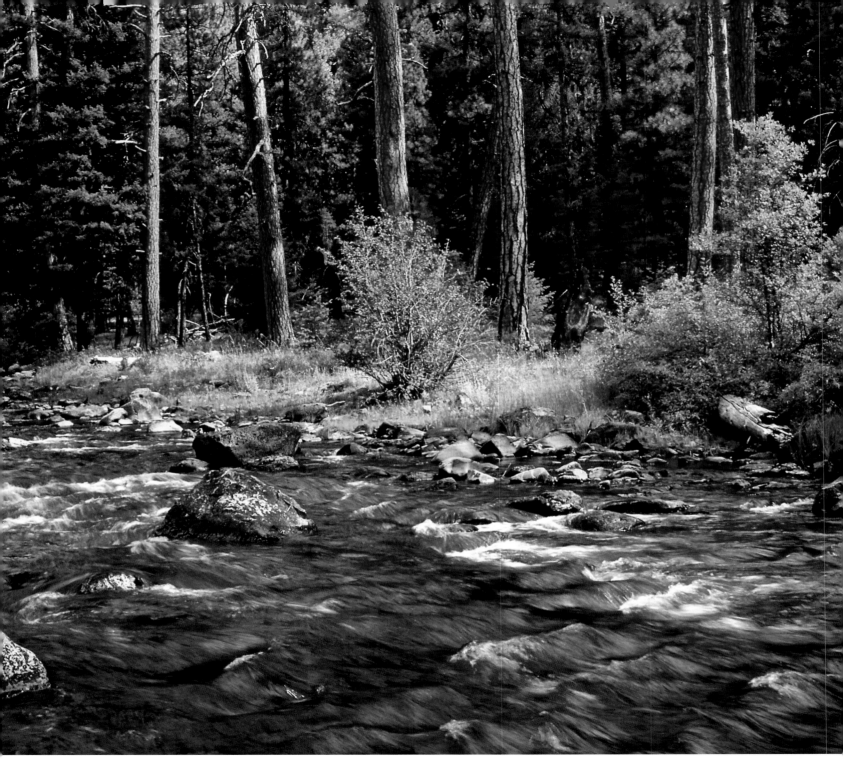

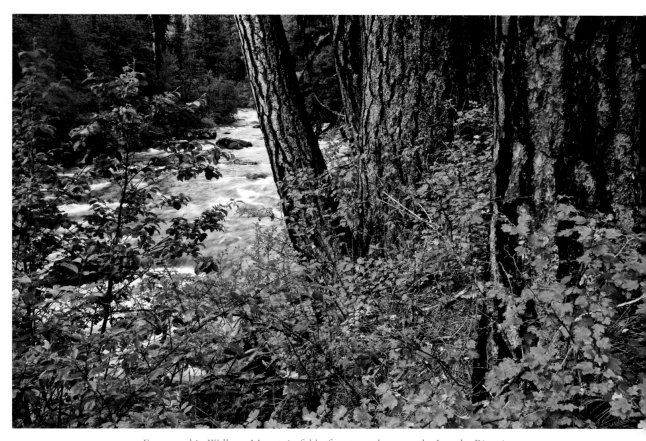

Ensconced in Wallowa Mountain folds, forests, and gorges, the Imnaha River in northeast Oregon rushes from snowdrifts to sizzling desert, dropping from eight thousand to nine hundred feet in only eighty-three miles. This source-to-mouth wild and scenic river is like an intimate, scenic, green, temperate iteration of the great Hells Canyon, into which it flows. Here is the uppermost remaining Snake River habitat for spawning salmon and steelhead. From remote roads east of Joseph, trails lead to both the headwaters and to hidden canyons at the mouth. In between lie time-forgotten ranches in deeply creased folds of dry lands.

Few people driving across eastern Oregon on Highway 20 would expect that a forest-and-canyon gem survives upstream from the depleted lower Malheur. But the headwaters and North Fork rush through glades of ponderosa and five-foot-diameter larch while floodplains alternate with canyon walls. Haunts of native redband and bull trout, these rivers can be seen from remote roads and trails southeast of John Day.

179

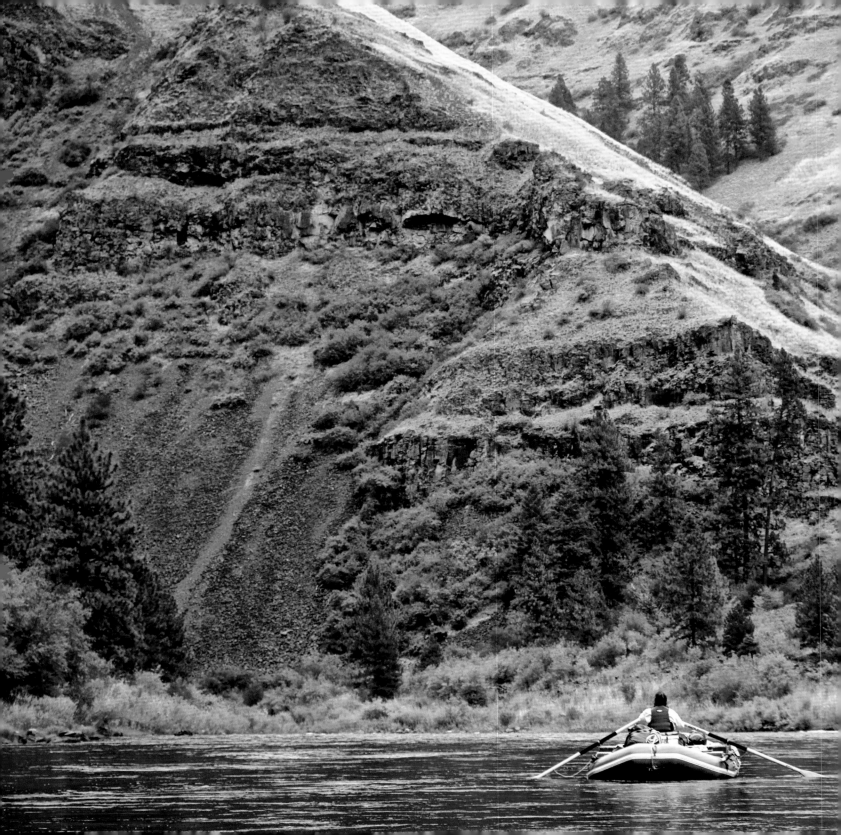

Mostly wilderness for its upper thirty-eight miles, the wild and scenic Minam is among the Wallowa Mountains' six stunning radial rivers. Though its last twelve miles pass through industrial forest, this is one of the longest completely undeveloped rivers of the Northwest. A trail follows most of the way. Haven for bull trout, this is also spawning water for Chinook and steelhead.

In northeastern Oregon the Grande Ronde's roundabout course deepens beneath plateaus and flattened cake layers of basalt. Fir forests open to pine savanna followed by a steppe of native grasses and finally rocky desert. A forty-seven-mile Class 2–3 journey, one of the West's premier easy raft trips, can be extended to the Snake River for a ninety-eight-mile voyage with a few larger rapids in lower reaches.

In the northeastern corner of Oregon, the Wenaha is the wildest and best protected full-length river in that river-rich state. Rugged trips with inflatable kayaks are possible after a rigorous hike to the put-in, though fires from 2015 will likely result in forbidding log jams.

The White Salmon River crosscuts through the deepest, tightest major tributary canyon on the Washington side of the Columbia Gorge. Once planned for a series of hydroelectric dams, the river was saved by local activists with wild and scenic designation in 1986. Downstream, the removal of Condit Dam in 2012 marked one of America's largest dam removals. A challenging Class 4–5 raft and kayak run is seen here at the put-in near BZ Corner.

Yakama Indians dip net for salmon in the lower Klickitat near its confluence with the Columbia at Lyle, Washington. Two runs of steelhead, plus Chinook and coho salmon, spawn here. Farther upriver, anglers in drift boats, kayakers, and rafters all enjoy this stream, and a bike and hiking trail follows an abandoned railroad along the shore.

Opposite: The Skagit is protected for much of its length below Seattle City Light's upper river dam complex in Washington. From above Marblemount it runs one hundred miles without major rapids to tidewater, offering one of few extended canoe journeys on the West Coast. Five species of salmon and steelhead are the healthiest of Puget Sound, and the winter population of bald eagles is the largest outside Alaska. The designation excluded an upper whitewater reach from Copper Creek to Bacon Creek due to a Seattle City Light dam proposal, and the designation also omitted a lower section where a nuclear power plant was considered. Both plans were subsequently dropped. Here Mount Baker appears downstream from the Sauk River confluence.

One of six Skagit tributaries in the wild and scenic system, the North Fork Sauk plunges down from wilderness through eight miles of rainforest. North Fork Falls is seen from a path off Forest Road 49 southeast of Darrington. These waters flow into the main stem Sauk and then the Skagit—all continuously wild and scenic for one hundred miles.

As the principal Skagit tributary, the Sauk is wild and scenic from upper reaches to mouth.
A key salmon and steelhead stream, its views to rain forest and Cascade peaks make for
superb river running in Class 2–4 whitewater. Here the Sauk encircles an island just off the
Mountain Loop Highway above Darrington.

The Cascade River is an exquisite Skagit tributary flowing from the Glacier Peak Wilderness and through emerald rain forest canyons with big whitewater, spawning habitat, and lower reaches scarred by clear-cuts on state-owned land. It is designated from source to mouth as either wilderness or wild and scenic river. This view appears along Cascade River Road just upstream from the national forest boundary.

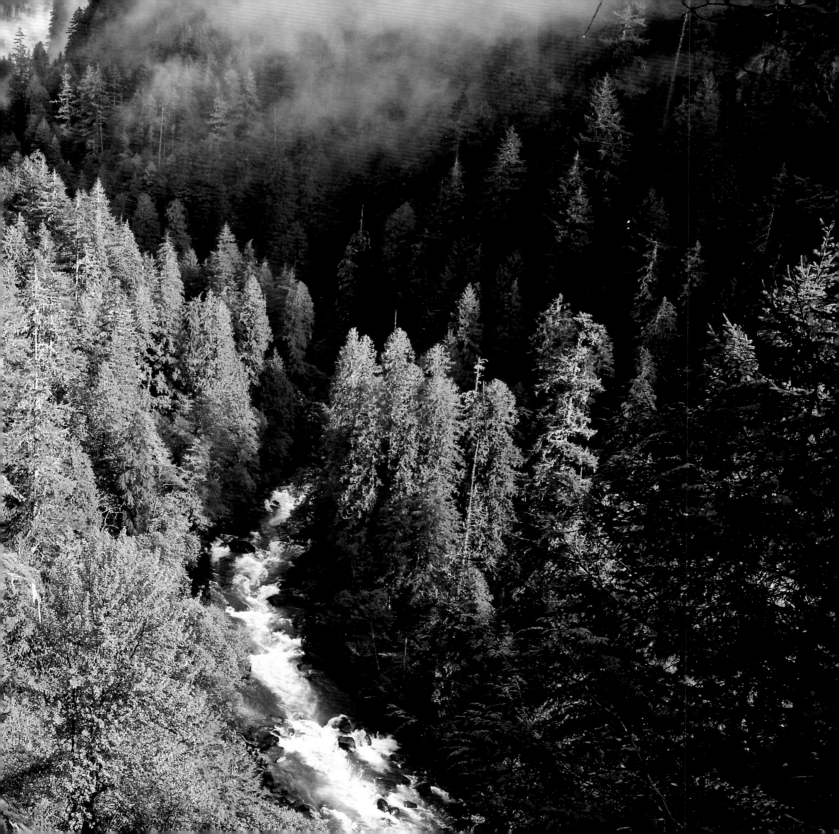

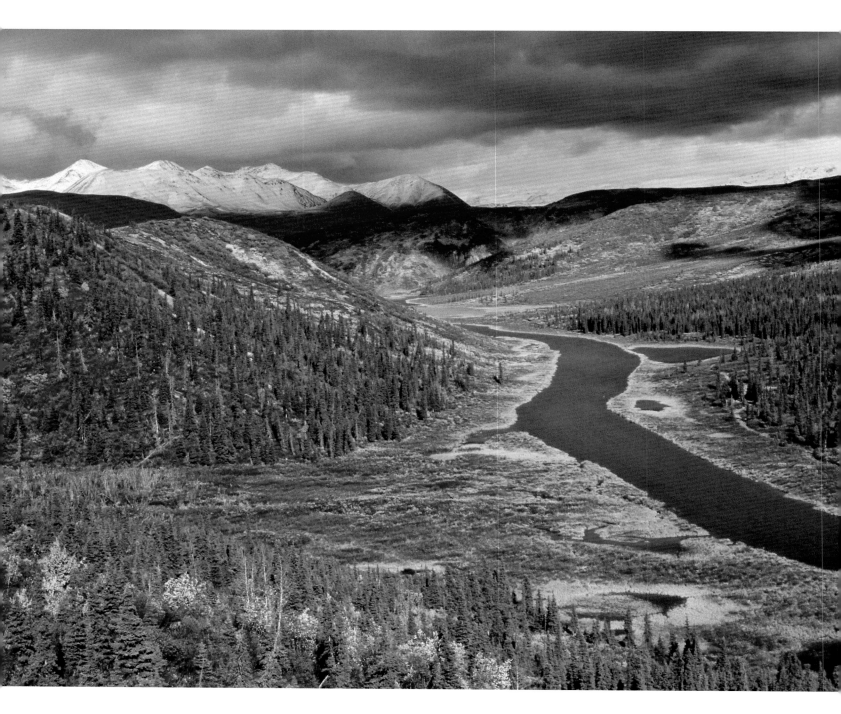

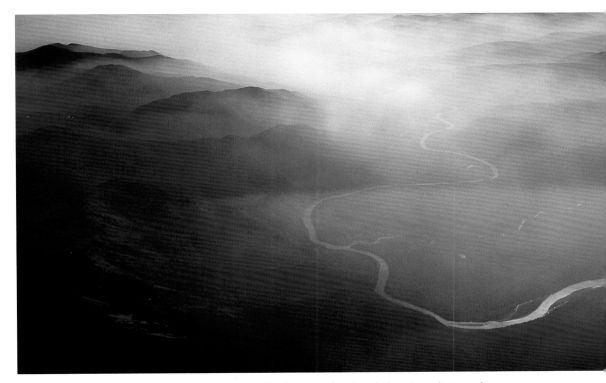

Beaver Creek is one of twelve Alaskan rivers designated wild and scenic for more than one hundred miles. Gentle currents wind through boreal forests of White Mountains National Recreation Area and Yukon Flats National Wildlife Refuge. Limestone peaks four thousand feet high backdrop the forested shores and spacious gravel bars of the "creek" that runs a total of 230 miles. In this aerial view, smoke from forest fires occludes upper reaches.

Among Alaska's thirty-three major wild and scenic rivers, the Delta is the most accessible, reachable by road at its upper and lower ends. A three-day whitewater canoe trip that includes a waterfall portage above Wildhorse Creek at the Denali Fault begins in Tangle Lakes and cuts dramatically through the Alaska Range. This blustery autumn scene awaits north of Highway 8 at Tangle Lakes.

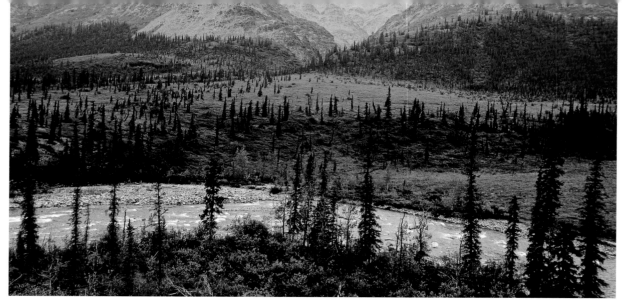

The North Fork Koyukuk flows entirely within Gates of the Arctic National Park. While many Alaskan rivers are silted from glacial runoff or bank erosion, the North Fork runs clear, its valley a migration route for Alaska's largest caribou herd. Experienced boaters fly to Redstar Lakes and paddle one hundred miles to Bettles, twenty-five miles below the North and Middle Fork confluence. (Photo by Ann Vileisis)

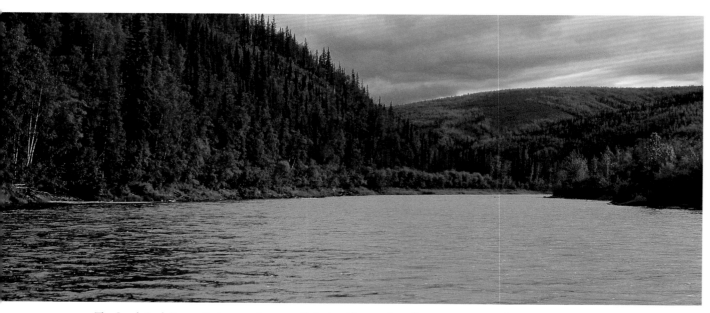

The South Fork Fortymile is part of a 407-mile basinwide complex of seventeen streams designated as the first watershed-wide grouping of wild and scenic rivers. Gold mining has threatened this otherwise pristine network of waterways. Broadening waters here lie below the Dennison and Mosquito Forks confluence near Highway 5.

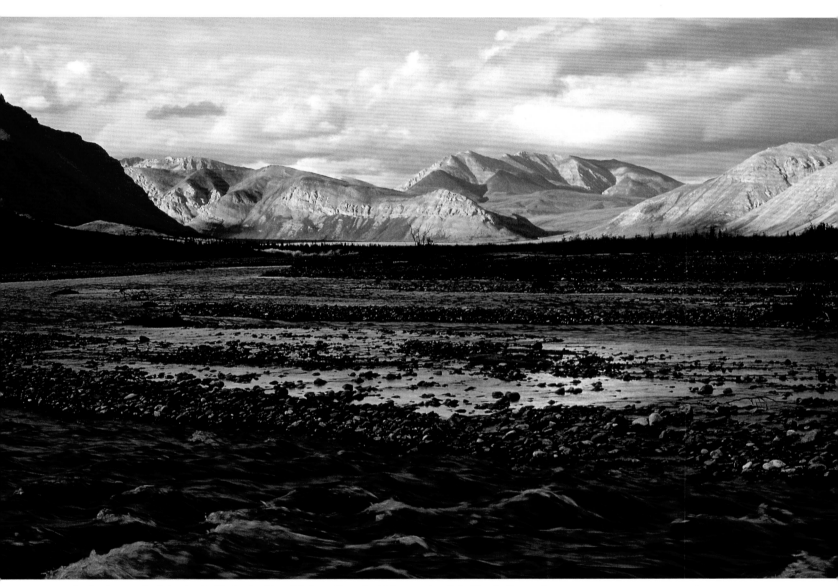

Beginning north of the Arctic Circle, the Sheenjek flows from the highest peaks of the Brooks Range. Its epic course southward offers one of the ultimate extended paddling trips of about 300 miles to the Porcupine River and Fort Yukon; 205 miles are wild and scenic. At upper reaches above Double Mountain, paddlers can fly to gravel bars, though ice covering the riverbed can interrupt downstream passage and require boat-dragging even in August. The Alaska National Interest Lands Conservation Act called for wild and scenic consideration for the rest of the river.

Reaching Further

A NATIONWIDE RIVERS INVENTORY

Efforts to add waterways to the wild and scenic rivers system described in chapters 3 and 4 have driven the work of advocates for fifty years, but the Wild and Scenic Act also called for additional measures essential to conservation nationwide.

Section 5(d)(1) of the act calls on the secretaries of Interior and Agriculture to "make specific studies and investigations" to identify "potential" rivers for future wild and scenic designation and also to require special reviews if damaging developments or resource extraction are proposed. Moreover, before any federal agency approves conflicting plans for 5d-listed rivers, wild and scenic designation must be considered.

An initial 5d list, published in the October 28, 1970, *Federal Register,* itemized forty-seven rivers (see appendix 4). These are reminiscent of the original roster of seventy-four rivers selected by Interior planners before passage of the Wild and Scenic Act, and they could be described as a wish-list relatively free of political considerations. A December 1970 memo from the interior secretary's office directed that the list be "revised" annually—work that has gone undone.

The forty-seven rivers were excellent choices and represented a fine initiative to expand protection, but as of 1980—twelve years after the act was passed—no other effort was remotely comprehensive in considering the nation's 2.9 million miles of waters. No one knew how many rivers had the qualities needed for wild and scenic status, or where they were.

Opposite: The upper Chattooga River rushes through a narrow gorge within the southern Appalachian Mountains of North Carolina.

Though early planners recommended a sampling of streams from all regions, a presumption lingered that nationally designated rivers would represent only the scenic icons—what Glenn Eugster of the Bureau of Outdoor Recreation later called the "mountains and whitewater" effect. Safeguarding just these would have been a monumental challenge. But probing further, Eugster and others realized that sensational scenery and wildness were only part of the rationale embodied in the act. "It makes sense," he explained, "to protect a selection of rivers from all the varied physiographic provinces or landscape types of the country. We shouldn't be looking for some preconceived notion of the 'very best,' but for a Noah's Ark of rivers nationwide. Two, or at least one river of every kind might be a sensible goal. Blackwater swamp streams of the Southeast are just as important as whitewater in the West."

Considering these questions more thoroughly in the mid-1970s, Bureau of Outdoor Recreation planner Bern Collins—already a river aficionado and accomplished paddling racer—had worked on a nationwide recreation inventory and saw the need to systematically inventory rivers as well. His interest was pinned to the Section 5d mandate, but it also extended Frank Craighead's original vision for river classification from twenty years before. A pilot effort was led by BOR Southeast regional director Bob Baker, with Margaret Tucker (now Margaret Collins—Bern's wife) crafting the program. This team proposed to evaluate all free-flowing streams longer than twenty-five miles (later five miles and more) nationwide, and then to identify which of these had the Wild and Scenic Act's prerequisite "outstandingly remarkable" values.

The director of the Bureau of Outdoor Recreation in the Nixon administration was James Watt—later notorious as President Reagan's outspoken secretary of the interior. Even early in his career, Watt kept no secret that he wanted to minimize conservation (he later eliminated the entire recreation bureau). In a 1991 interview with me, Bern Collins reported that Bob Eastman—in charge of the Interior's rivers program—likely pitched the inventory to Watt as "sideboards" on a program that could otherwise grow indefinitely.

However, Collins had in mind not a small list, but a large one. He and the other supporters reasoned that the list could serve as a baseline for the science of natural rivers, as a farm-club for wild and scenic additions, and maybe even more. In 1975 they launched what eventually was called the Nationwide Rivers Inventory (NRI). Staff sought rivers representing all twenty-five physiographic provinces and also eighty-five regional "sections" itemized in the classic landscape taxonomy of geographer Nevin Fenneman. The list was ultimately shaped by field personnel from BOR and other agencies.

In the DC office, Collins hustled to complete the job while Jimmy Carter was still president. Then, to make it effective, he wrote an ingenious presidential directive that he shared with American Rivers staff. Helping them, lawyer Larry Rockefeller of the Natural Resources Defense Council carried Collins' draft to the President's Council on Environmental Quality, which sent it up for Carter's signature in 1979.

Based on section 5d, the directive officially adopted the NRI and, for the streams listed, required that federal agencies "take such steps as are needed to protect and manage the river and the surrounding area in a fashion comparable to rivers already included in the Wild and Scenic Rivers System." The directive further called on agencies to consider the eligibility of *all* rivers within their jurisdictions when drawing up resource plans.

The Carter directive could have been just an administrative footnote to a one-term presidency. But in fact it teased a revolutionary concept out of the wild and scenic law: federal agencies were obligated to initially regard all worthy rivers under their jurisdiction *as if* they were designated

wild and scenic. If development proposals surfaced, they wouldn't necessarily be denied, but long-term protection would be considered instead of blithely foregone. The agencies were also instructed to "prepare legislation to designate" eligible rivers "if appropriate."

Responsible for non-federal hydropower dams, a reluctant Federal Energy Regulatory Commission (FERC) eventually considered the NRI a "comprehensive plan" in their procedures and began to recognize the directive. For all federal projects, including highways, the new check-stop resulted in discussions and conservation gains as Park Service reviewers recommended "best practices" for dredging, bridges, sewer lines, and shoreline developments. But their advice didn't have to be followed, and FERC continued to issue preliminary permits for investigation of hydroelectric plans on NRI rivers even when Park Service staff recommended against them.

To see if the directive was being followed by one of the most important agencies—the Forest Service—Kevin Coyle of American Rivers and Bob Dreher of the Sierra Club Legal Defense Fund (now Earthjustice) began to monitor the agency's land management plans. Finding that virtually none recognized the NRI, the two groups filed dozens of appeals, plan by plan. Forest Service chief Dale Robertson eventually ordered supervisors to evaluate potential wild and scenic status for 400 streams on the inventory and, furthermore, to evaluate *all rivers* within the agencies' boundaries when staff updated their plans. By 1988 the agency had studied 700 rivers and found 460 eligible as wild and scenic. Far fewer were found "suitable"—a more subjective classification that considered the amount of private land, status of local zoning, conflicting water resource plans, and political opposition. But Forest Service rivers coordinator Deen Lundeen at the time pointed out that even when rivers were not found suitable or recommended for designation, management prescriptions were often adopted to protect outstanding values. River

management staff of the Bureau of Land Management—for twenty-five years under the visionary guidance of Gary Marsh—similarly launched efforts to evaluate one hundred rivers flowing across their comparatively arid terrain. After arguing for some years that its rivers were already protected—which was mostly but not always true—the Park Service in 2006 likewise adopted a policy to evaluate rivers while crafting park plans.

Going far beyond the NRI enrollment, federal planners by 1998 had found one thousand river segments on public land eligible for wild and scenic safeguards, with more surfacing. Until further determinations found these rivers "unsuitable" for designation, safeguards applied to all of them. Shouldering the appeals task at American Rivers, Tom Cassidy noted, "This little-known initiative regarding public land planning has had a lasting effect on the nation's conservation legacy."

With the highly effective National Wetlands Inventory (created by the US Fish and Wildlife Service) as a model for even greater involvement by the federal agencies, Bern Collins promoted the improvement, expansion, and further validation of the NRI until his retirement, but with little effect in an era of tightening budgets. Staff did manage to update the inventory in 1993 and 1995 for a total of 3,431 river segments and 85,000 stream miles—2.9 percent of American stream mileage—a largely unrecognized accomplishment of enormous importance and value. The subsequent years would see growing interest in upgrading the NRI, including investigative work in 2015 sponsored by the National Park Service and American Rivers in Oregon.

BEYOND WILD AND SCENIC

Reaching beyond rivers that are designated or being considered for wild and scenic status, Section 11(b)(1) of the Wild and Scenic Act called for federal agencies to "encourage and assist" states in the establishment of river

conservation programs and to help local governments, private interests, and nonprofit organizations to establish "wild, scenic and recreational river areas." This astonishingly broad directive awaited better definition by officials in the federal agencies. "Local groups and state managers were coming to us for aid," Glenn Eugster recalled from his days at the Bureau of Outdoor Recreation in the 1970s. "We reasoned that anything we could do to help protect a river was good. It didn't have to mean wild and scenic designation—Section 11 was clear about that."

Hydropower proposals topped the list of concerns finding their way to Eugster and his colleagues. After utility-boosting legislation in 1978 proffered incentives for new private dams, thousands of proposals found welcome receptions at the FERC office. "In Maine," Eugster recalled, "the governor saw that his rivers were up for grabs wholesale, and asked for help in devising an off-limits list." Two students in graduate planning programs, Drew Parkin and David Lange, stepped forward at Eugster's call and designed the pathbreaking Maine Rivers Study of 1982, which the governor adopted. Under federal law, the state could not bar FERC-permitted dams, but by putting hydropower entrepreneurs on notice about state opposition, the list steered developers away. It also emboldened conservationists and concerned agencies to oppose unwanted dams.

Initiating similar state and local projects across a widening canvas nationwide, Eugster's popular outreach program under Section 11 of the Wild and Scenic Act expanded, and for nationwide coverage was eventually anchored in the DC office and called "Rivers, Trails, and Conservation Assistance" (RTCA) with a push from Park Service assistant director Bill Spitzer. From its beginning, the program germinated its own political base from the grass roots up and weathered repeated attacks by budget-cutting administrations. As of 2017, long-time river professional Bob Ratcliffe directed eighty-one staff nationwide in this broad-based mission of river conservation assistance.

The legacy of this obscure legislative section written by an unknown contributor to the text of the Wild and Scenic Act includes hundreds of plans for local river protection, a dozen state inventories, networks of bicycle trails, rail-to-trail conversions, public access facilities, outdoor education centers, "water trails" to encourage and facilitate river travel, floodplain regulations, and restoration initiatives from kids planting willows to state agencies blasting away unsafe dams.

SEARCHING FOR ALTERNATIVES

Through the 1990s—as we saw in chapter 4—some rivers were granted wild and scenic status, but the political resistance was increasing. Meanwhile, some observers reasoned that the program's focus on "outstandingly remarkable" values left worthy waterways out—places that River Network founder Phil Wallin fondly called "outstandingly common" rivers.

Conservation leaders considered less-ambitious paths to protection. In 1992 American Rivers proposed a National River Registry to recognize streams flowing through private land while avoiding regulatory roadblocks. Another proposal simply banned dams—limited action adopted for a few rivers such as Idaho's lower Salmon, the Snake for twenty miles below its wild and scenic reach in Hells Canyon, and Kings below its designated section. But a new *system* of dam-free rivers failed to surface.

Floating to the top of the alternatives list, the American Heritage Rivers Initiative aimed to enhance a river's status by simple recognition and infusion of federal money for waterfront revitalization as a community-building strategy. "This offered an alternative to the divisive politics accompanying stronger conservation proposals," Tom Cassidy recalled. "But, by the way, the program had no money, no regulations, and few staff." Nonetheless, "heritage" struck a strong chord in an increasingly conservative era, and

the popularity of river restoration and recreation through large towns and small was evident with 126 state and local applications to the Council on Environmental Quality. In 1998 President Clinton designated fourteen American Heritage Rivers, and some federal funds were channeled to those waterfronts.

Meanwhile, the chief alternative to national wild and scenic designation had always been state protection—encouraged in the act itself. Wisconsin, in fact, had passed the first wild and scenic rivers statute three years before the federal law. Ohio, Tennessee, and Maryland started programs in 1968—same year as the federal act.

Additional states followed. Some were bald-faced attempts to avoid federal involvement by undercutting the "need" for greater protection. Others earnestly sought to safeguard more rivers than the national program could ever do. In 1972 California designated 4,006 miles in the state's northern basins alone. Later, inattentive if not hostile state administrations reduced the mileage and neglected management plans, making it apparent that state scenic river protection was more prone to political whim than was the national program. Furthermore, all states faced the dismissive fact that courts upheld federal primacy regarding water development; FERC could permit dams wherever it wanted unless blocked by federal law—the battle for the New River was a case in point.

Peaking in 1989, state scenic river systems totaled thirty-one, with 269 waterways and 13,674 miles—comparable in size to today's national system and with significant overlap in some states. Protection varied from toothless lists to dam-free policies and incentives for zoning.

Over the following decades, many of those well-intentioned and enthusiastic efforts died as legislatures slashed resource funding, as political attacks by right-wing lawmakers intensified, and as citizen bases of support faltered. Though most programs were not roundly abolished, only a few remained active after the 1990s. The eager staff who had shepherded the programs since their inceptions had now retired, and were typically not replaced, leaving a vacuum or staff burdened with other duties and who knew little of the wild and scenic programs' legacy or requirements. Through his skills, personal dedication, and political acumen, Ed Fite managed to shepherd Oklahoma's state scenic rivers for thirty-four years, though the program's security after he retires, if not sooner, is admittedly doomed. Fite recognized, "Most state programs are gone or in total disarray. If you want to protect a river, I have to admit that federal designation is the way to go." With some hope—following several decades of neglect—Oregon designated two new rivers in 2016, but only after a vigorous campaign by state conservation groups. While history is not fate, it appears that most state river programs offer undependable paths toward permanent protection.

Reflecting on the various alternatives and on the broader canvas of conservation, Chris Brown said, "One problem has always been that people tend to compartmentalize rivers and their problems: water quality or quantity, wildlife, fisheries, recreation, dams, diversions. Only when you see the river as a complete organism does conservation of the whole river make sense. That insight is part of the beauty of the Wild and Scenic Rivers Act."

Alternatives were considered and tried, but none has replaced the National Wild and Scenic Rivers Act as the flagship program for safeguarding streams. While the twenty-first century advances, both old and new challenges await for waterways that have been safeguarded and for many more that are worthy of protection.

The View Downstream

EXPECTATIONS AND NEEDS

Fifteen years after passage of the Wild and Scenic Rivers Act, Stewart Udall said that he was "very pleased" with the results. "We really didn't know how successful the program would be." The former interior secretary remained a supporter until his death in 2010.

John Craighead agreed, "I never expected it to grow so much." In 2008, at age ninety-two, the renowned wildlife biologist remarked that his "proudest achievement" was sparking interest that led to the Wild and Scenic Rivers Act.

The program's mileage—about thirteen thousand—is impressive if one considers the goal of saving America's finest river gems. But for those who looked beyond initial expectations of setting aside a judicious selection of our greatest rivers, and onward toward a complete and representative system of streams nationwide—or perhaps even to all rivers warranting the highest form of protection—shortcomings are evident.

Taking stock here at the fiftieth anniversary of the Wild and Scenic Act, important questions come to mind. What should be the ultimate goal of this national program that was launched with no prescription for its size and distribution? How many wild and scenic rivers should there be?

First consider: How many total miles of rivers *are* there in the United States? According to analyst Al Rea of the US Geological Survey in 2015, using the latest National Hydrography Dataset, the United States has 2.9 million miles of perennial rivers and streams (earlier estimates of 3.6 million predated current data technology). Large rivers are made from many tributaries, so small streams account for most of the total mileage. In fact, fully two million miles are attributed

Opposite: The South Fork Flathead disappears into its final wild gorge before encountering the backwater of Hungry Horse Dam in Montana.

to very small streams less than five miles long. Waterways of five-mile length or more account for nine hundred thousand miles. Rivers of twenty-five miles or more—what many might instinctively call a "river"—total 6,770 and flow 417,000 miles.

Wild and scenic river protection can be granted to waterways of any length; the legislation defines "rivers" to include all sizes. And streams of any length or volume can have outstanding qualities; even intermittent ones deserve protection of some form. Yet—establishing a precedent and perhaps an expectation—the original wild and scenic rivers were all sizable, as were the twenty-seven original study rivers—each more than twenty-five miles long.

Our thirteen thousand miles of designated wild and scenic rivers account for only 0.4 percent of the total length of all perennial rivers and streams. The designated mileage is equal to 1.4 percent of the mileage of streams that run five miles or longer, and 3.1 percent of the length of streams running twenty-five miles or more. By any relative measure, the protected estate is small.

In contrast, the developed side of the ledger includes eighty thousand dams at least six feet high (no credible measurement of the length of reservoir mileage has been calculated, though 600,000 was once suggested as a rough estimate and has been widely quoted). Another 235,000 miles have been channelized, mostly small waterways through farms, and 25,000 miles on large rivers have been industrially dredged for navigation. Meanwhile, one-third of America's surveyed stream mileage is significantly polluted according to the Environmental Protection Agency. Untold additional miles—most, in fact—have been diverted or their shorelines farmed or developed.

As we saw in chapter 6, the most analytical view toward wild and scenic possibilities dates to the Nationwide Rivers Inventory, which found 2.9 percent of total stream mileage eligible. The rest was presumed to be too degrad-ed or lacked outstanding values, though further analysis by federal resource agencies has identified many more miles. Many observers now believe that the NRI would be expanded if reconsidered and upgraded, and the pilot work undertaken in Oregon in 2015 confirmed this.

The inventory, and any quick view of the nationwide map of designated wild and scenic rivers, also indicate that whole geographies remain underrepresented, most obviously, the Great Plains and South, but also parts of the Northeast. States with no wild and scenic representation are Indiana, Iowa, Kansas, Oklahoma, North Dakota, Nevada, Rhode Island, Maryland, Virginia, and Hawaii, though each has valuable rivers.

Both the lopsided ratio of developed-to-protected mileage and the map showing regions without designated rivers summon a key challenge raised in the preamble of the act: "The Congress declares that the established national policy of dam and other construction at appropriate sections of the rivers of the United States needs to be complemented by a policy that would preserve other selected rivers. . . ." Secretary Stewart Udall and others have equated "complemented" with "balanced." Having 97 percent of our total stream mileage too developed to qualify for wild and scenic status, according to the NRI, and having 0.4 percent actually designated for protection, can hardly be considered "balanced."

As another measure of success, compare the early lists of prospective or deserving wild and scenic rivers compiled by informed agency staff, to the rivers that have been designated. Only twenty-four of the seventy-four streams on the initial list compiled by Stan Young and others in 1964 gained wild and scenic status, while only eighteen of the forty-seven rivers in the 5d list of 1970 made the grade (some overlap). All are major streams that might still be rated at the top of a non-politicized list. The reasons for this disappointment are legion, but at the core involve lack of support from local people and politicians.

Taking yet another tack, compare the wild and scenic rivers system to other land protection programs. National parks were started in 1872, wildlife refuges in 1903, and wilderness areas in 1964. Parks now total 409 units covering 84 million acres or 3.7 percent of America. Larger, owing to Alaska, 586 national wildlife refuges cover 150 million acres or 6.5 percent (though some is intensively managed or farmed). Wilderness in national forests and BLM areas (other acreage of those agencies can be dedicated to multiple uses such as logging and mining) totals 45 million acres, or 2 percent of America. Counting all three, 12 percent of the nation's landscape is arguably protected. For perspective, consider that eminent ecologists Reed Noss and Allen Cooperrider, in *Saving Nature's Legacy*, argued that 50 percent of America's landmass must be protected to maintain viable ecological functions. Since its inception, the wilderness system has grown to be twelve times its initially designated acreage. Comparing favorably in this regard, the wild and scenic rivers system has grown to include sixteen times its initially designated mileage.

Of course, rivers are safeguarded in ways other than wild and scenic designation. Most streams within national parks, refuges, and wilderness areas are defended by those designations, and with 12 percent of the land being protected, one might assume that 12 percent of our stream mileage, flowing within those areas, are protected as well. Of lesser effectiveness, other river saving measures include state scenic rivers, state parks, wild trout waters under state wildlife agencies, outstanding resource waters under the Clean Water Act (forty-five years after federal law mandated these, few have been designated), restrictions on new hydropower dams under the Northwest Power and Conservation Council (44,000 miles, but only in the Northwest), and natural river inventories by states such as Maine. However, most of these classifications are weak, or specific to only one type of threat. None offer safeguards comparable to wild and scenic status.

Another way to consider the wild and scenic system's adequacy—and perhaps the most poignant—is to compare its protections to ongoing threats to rivers. Proposals for mega-dams of the past have mostly failed to resurface since the last Auburn Dam debate in California in 1998, but ubiquitous other perils have magnified, with even greater threats on the horizon, and with troubling prospects that another dam-building age could emerge. In 2016 congressional bills sought to aid hydropower developers by shortcutting the reviews of oversight agencies. Meanwhile the Department of Energy announced the brash possibility of doubling hydropower output by 2030. Part of this could occur at existing dams and canals, but conservationists braced for new conflicts at vulnerable rivers outside the wild and scenic haven, arguing that hydropower is not necessarily clean energy—rivers and all their life can be lost in the process.

The troublesome increase in demand for water, power, and land along rivers is a function of both our efficiency of resource use and our population. Though birth rates of established US citizens are relatively low, immigration rates remain high, and at current growth, the nation's population will double in about sixty-five years. As long as growth persists, the needs for more water, power, and acreage will grow as well. Efficiency improvements have spared vast amounts of water in the past three decades, but savings cannot outpace demand indefinitely, and further efficiency will come at greater cost. Ultimately, limited supplies of water cannot sustain an unlimited population. A sign of the times, the Colorado River in 2015 dipped to historic lows, triggering a region-wide crisis. In California and the West, a fifteen-year drought deepened through 2016 with apocalyptic overtones while population continued to grow. Public policies about population reach beyond the modest

scope of this book but must be addressed to realistically consider the future of our rivers.

A growing population—consuming more water, burning more fossil fuel, and eliminating carbon-rich sequestrations such as forests and rich organic soils—also aggravates the climate crisis. Extreme weather events will cause more frequent and severe flooding. Heavy runoff will come as intensified tropical storms drench the East and as the slow melt of snowfall is replaced by the flush of rain in the mountainous West. Droughts will become more severe. Global warming heats rivers beyond tolerances of native fish. It will aggravate our collective thirst for city and irrigation diversions, and will be invoked by developers as a reason for more dams.

Climate change increases the importance of protecting specific streams critical for the cold water they provide and the cool refuges they offer to fish and other life. Streams flowing from glaciers and snowfields, from north-facing slopes, from spring-fed sources, and from deeply shading forests are all examples of waterways deserving greater protection to combat the climate crisis. A map of these would illustrate a whole new agenda for river conservation, including—among many others—the White River from glacial slopes in Washington, the Gila from wilderness headwaters in New Mexico, Penn's Creek from deep and cold underground sources in central Pennsylvania, and the Peabody River from north slopes of the White Mountains in New Hampshire.

Cool tributaries are valuable not only for themselves and the life they directly support but also because they feed larger rivers having critical or degraded habitat. The unlogged, spring-fed tributaries to the beleaguered main stem Klamath River in California are one example. Others can be found in the recovering woodlands of the Appalachians such as headwaters of the Delaware, Susquehanna, and Potomac, and in the Cascade Mountain sources of

Oregon's heavily tapped Willamette. Designation of Wild and Scenic Rivers can help protect these source streams from watershed damage, diversions, and dams, and can emphasize those rivers' importance to downstream ecosystems and threatened water supplies.

Beyond the protection of specific cool-water refuges, addressing global warming will require zoning floodplains to keep development away from worsening high-water hazards, preventing new diversions, restoring depleted flows, eliminating useless dams that further warm and evaporate water, and perhaps most important, protecting and restoring riparian habitat along rivers to maximize shade and its cooling buffer-effect. This list has been the cookbook of river conservation for fifty years; global warming now means that all of it must be done more, better, and faster. By prioritizing the most important streams, Wild and Scenic River designations can advance all these protection and restoration goals.

PROTECTING THE BEST RIVERS THAT REMAIN

While traveling and photographing waterways all across America, I gained a new perspective on wild and scenic rivers. I couldn't help but wonder about the possibilities, the needs, and the opportunities for expanding and perhaps someday completing the wild and scenic rivers system. Which outstanding streams most deserve our highest level of protection? I vividly recall a few highlights from my own experience.

In the Northeast, the river-rich states of Maine, New Hampshire, Vermont, and New York are scarcely represented in the wild and scenic system but include stellar streams such as the Saint John, Machias, Kennebec, Penobscot, Saco, Lamoille, Moose, Ausable, and upper Hudson. Southern New England in recent years has had the most support for river protection through the partnership pro-

gram, which is likely to continue where residents recognize river values. The landmark arteries of the Appalachians—or even short sections of them—remain mostly unrepresented in our national cache of protected rivers: the Susquehanna, Youghiogheny, Potomac, James, Nolichucky, French Broad, and upper Clinch to name a few.

Even with its vast acreage and remarkable diversity of aquatic life, the South is the wild and scenic system's most underrepresented region. But that's not for any lack of outstanding streams. I've been amazed by the Little River in its magnificent gorge, the Cahaba and Catawba with their inflorescence of rocky shoals spider lilies at the fall line, the Black River through amber-water swamps, the Ocmulgee and Altamaha with their longest undammed mileage in the East, and the crystalline Saint Johns, Oklawaha, and similar Florida springwaters. The Midwest and Great Plains have the most uniformly degraded waters flowing through the corn belt and across increasingly dry prairies where rivers are scarcely noticed, yet possibilities for protection remain, including the upper Canadian in New Mexico. A suite of fine streams graces the lake country of Minnesota and Wisconsin, including the Flambeau, Kickapoo, upper Menominee, and Crow Wing.

While watery gems of the Rocky Mountains rank among our classic wild and scenic rivers, whole regions have been left out, including most of Colorado with its Arkansas, Gunnison, San Miguel, Elk, and Yampa Rivers. A host of Montana streams are worthy of national protection—some of them considered for designation at this writing. And across our deserts and dry lands, streams are all the more precious for their scarcity. Here the Green and a few sections of the Colorado, including the Grand Canyon, are classic arteries of the West. The Gila in New Mexico flows through the oldest protected wilderness in the national forest system and through scenic canyons below.

Thanks to the work of Friends of the River and other groups in California, the finest rivers there have been set aside more comprehensively than in any other region, but a few, such as the upper main stem Kings and North Fork Stanislaus, remain outside the wild and scenic umbrella. California's national rivers will also be a test for how already-protected streams will fare with the imperiling responses to drought, the panicked reactions to floods, and the unrelenting pressures of population growth. The threats to the Merced in 2016 indicated that the need for vigilance and defense will increase.

Oregon has many wild and scenic rivers, but they don't include the rich lowlands of the McKenzie and Santiam, the emerald Coast Range windings of the Nehalem, Nestucca, and Siuslaw, the whole splendid length of the Umpqua, and the Willamette—the West's best example of a river flowing through farmland and cities but still harboring natural values important to dozens of communities. Washington has the spectacular radial riverscape of the Olympic Mountains plus unprotected streams of the northeastern Cascades. In Alaska, hundreds of rivers remain with criterion wildness. Two of the largest have repeatedly been threatened: Susitna and Copper.

Throughout our country, I was especially drawn to the long rivers, running many miles as arteries and stitching the regions of America's landscape together. The Shenandoah mixes gentle beauties of Appalachian mountains, forests, and farmlands. The Suwannee tours a tangle of vine-clad wetlands fed by bubbling spring flows. The Little Missouri winds across hundreds of miles of grasslands, including Theodore Roosevelt National Park where buffalo graze the shores. The Green River in Utah reveals four hundred miles of exquisite red-rock canyons and habitat for endangered fish. The Yellowstone's epic descent lasts over six hundred miles from wilderness of our first National Park, through a valley aptly named Paradise, then across

the Great Plains with only a half dozen low diversion dams. These and other major waterways warrant protection, of one form or another, by a nation that values its most important, beautiful, and stately rivers.

A complete wild and scenic rivers system for America would include many of these waterways. Of course, there are political reasons why they've not been safeguarded. Gaining protection may take years for any particular river, and worthy streams will never be enrolled, but efforts for a more complete roster of waterways should explore the challenge of how all our finest and most significant rivers can be sustained.

To gain further perspective on questions of the future, and to take stock of our times, I inquired with some of the veterans who have been involved for decades. With a career in river conservation that started forty-five years ago, former American Rivers president Kevin Coyle in 2015 said, "The wild and scenic program has never really lived up to its promise. The system should be more robust and widespread. You never see these rivers marked on road maps. Most people don't know they're there. They've never been embraced like national parks, refuges, or wilderness areas."

"The rivers have taken short shrift," agreed Brock Evans, who after initiating the campaign to save Hells Canyon of the Snake River spent much of his career working for the Sierra Club and the National Audubon Society, and now leads the Endangered Species Coalition. "Conservation groups budget their work on rivers within the category of public land, and as a result, the rivers don't get the attention they deserve."

Many people engaged in the program have concluded that the wild and scenic system has not fulfilled its potential. But is the glass half empty or half full?

The protection of thirteen thousand miles has thwarted scores of unneeded dams, halted riverfront clear-cutting, stopped strip mining, leveraged acquisition of thousands of acres of riparian habitat, encouraged better local zoning of floodplains, and made these waterways more resilient to climate change. Noting these benefits, Department of the Interior Secretary Bruce Babbitt eloquently wrote in the October 1998 *River* magazine that while the Wild and Scenic Act has touched only a modest number of rivers, "It changed the way we view rivers everywhere. It is not enough to call this law an act of Congress. It was more than that. It was a turning point—the end of one era and the beginning of another. It also set into motion a swirl of ideas. It opened a window, exposed a new way of seeing the landscape. It showed us that rivers are more than scenic resources—they are ecological sentinels that mirror the health of the land around them."

Retired in 2016 from his leadership at American Rivers, the National Park Service, and the Forest Service, Chris Brown amplified Babbitt's points. "Above its immediate success in safeguarding rivers, the Wild and Scenic Act ignited a movement and shifted the balance of river development and conservation in ways that both explicitly and subtly spawned far more: the birth of American Rivers, the establishment of state wild and scenic systems, formation of watershed associations, support for water quality, and reform of planning for rivers through federal land."

After starting her conservation career studying the effects of wild and scenic designation on the Saint Croix River, Rebecca Wodder worked as Senator Gaylord Nelson's legislative aide covering river issues. She later served as president of American Rivers for sixteen years—far longer than anyone else. After then working as an advisor to Interior Secretary Ken Salazar, she remained involved in volunteer river conservation efforts in 2016, and expressed optimism along with awareness of the challenges ahead. "Wild and scenic rivers are not an idea whose time has come and gone. With growing threats, designations are now more important than ever. And now, we also have

more opportunities. Today, the number of organizations that are centered around rivers and watersheds outnumber all the rest of the conservation movement put together. Much more can be done."

As the fiftieth anniversary of the wild and scenic rivers system approached, new challenges that had scarcely been imagined in previous years became evident as the Trump administration assumed power and as both legislative houses opposed environmental protection more staunchly than any Congress in memory. For the near-term future, the need to simply maintain the gains of the past threatened to dominate the wild and scenic rivers agenda nationwide.

Throughout the fifty-year history explored in this narrative, we've learned that wild and scenic status for a river is the best way to prevent it from being dammed. It's an effective way to keep the very wildest streams wild by avoiding logging and mining where federal land lines the shores. We've learned that the involvement of people who own property along the rivers is crucial, and that with support, local planning can spare floodplains and riverbanks from damaging development. Where added management of recreational use is needed, wild and scenic designation has leveraged attention and improvements.

We've learned that safeguarding a river requires that people become engaged in the future. In 2016 American Rivers' David Moryc said, "More than ever, we need local river advocates to stand up for the health and future of their streams."

Along waterways across our country, river conservation has flourished in a new democracy of people taking responsibility for their place, and then working together for a better future. The wild and scenic rivers system reflects the best of that spirit.

The Enduring Wildness of Rivers

After fifty years of both passion and persistence, both labor and luck, the windings of our national wild and scenic rivers shine as the best remaining natural streams across our land, and their story fills an important chapter in the environmental history of America. It's a story of personal vision and activism, of genius in navigating the unknown, and of exploration through the corridors of canyons and of political intrigue. But most of all, it's a story of the rivers themselves, which are shown in the photos in this book, and of their fate in a changing world.

My first visit to Pennsylvania's Pine Creek—one of the initial twenty-seven rivers to be studied for possible addition to the wild and scenic system—was for a college assignment straight out of the Rivers Act: to illuminate the stream's values and chart a path for its protection. I did my best with those challenges, but more personally, Pine Creek went straight to my heart. I bonded with that stream and, as it turned out, with all the rivers. From just a handful championed by the founders of the wild and scenic program, our collection of nationally protected waterways has grown to several hundred.

To see the largest of these in volume of flow, last year my wife Ann and I rafted the Snake River through one of the deepest canyons on the continent. The powerful rapids and lucid pools there would have disappeared under seven hundred feet of reservoir if it weren't for the work of courageous river aficionados who embraced the vision of Frank and John Craighead and made the Snake a national wild and scenic river. The threats there are not over, as four thoroughly subsidized and unnecessary dams downstream on the lower Snake have imperiled what were once the finest runs of salmon on the continent.

Opposite: The Elk River narrows into a bedrock slot below Butler Bar Campground in southern Oregon.

Last month I toured the unlikely wild and scenic rivers of New Jersey. In traveling there to photograph scenes for this book, I realized the genius of local stewards who saw a special elegance where the Maurice and the Great Egg Harbor Rivers broaden into wetlands with marsh grass waving in the tides, all within easy reach of tens of millions of people.

Last week I visited the Elk, near my home in Oregon, where the main stem flows out of rugged coastal rain forests and where our local band of activists now works to enroll four prime tributaries for protection from clear-cutting and mining. The Elk and its forks are essential to salmon that migrate up from the ocean for spawning, and for wildlife of all kinds that depend on the refreshing flow.

Beyond the Elk, the Maurice, and the Snake, I've been privileged over the past few decades to see most of America's wild and scenic rivers, and every view was dazzling to deep blue pools or to foaming whitewater, to lush green shores shaded by cottonwoods and sycamores, and to golden canyons through wild mountains and deserts. Many of those rivers would not remain as natural, living places if it weren't for people who adopted the streams as their own and committed themselves to the future of their special place. These rivers, and all the others that deserve protection, show the best that's left in a network of waterways that are vital to all the life around them.

Quiet waters of the Musconetcong River in New Jersey reflect late-spring foliage of a silver maple.

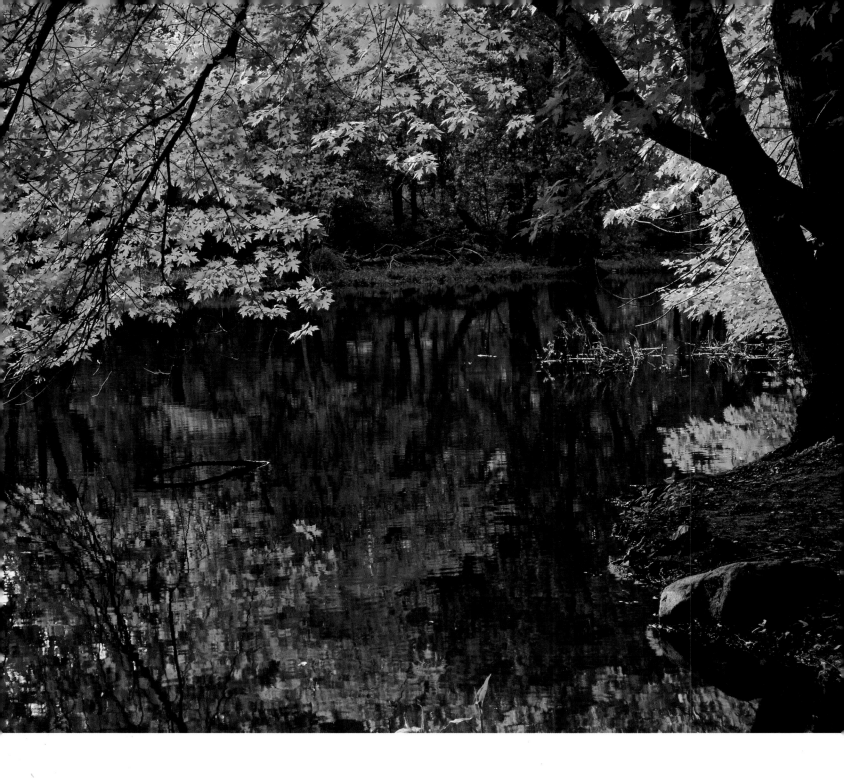

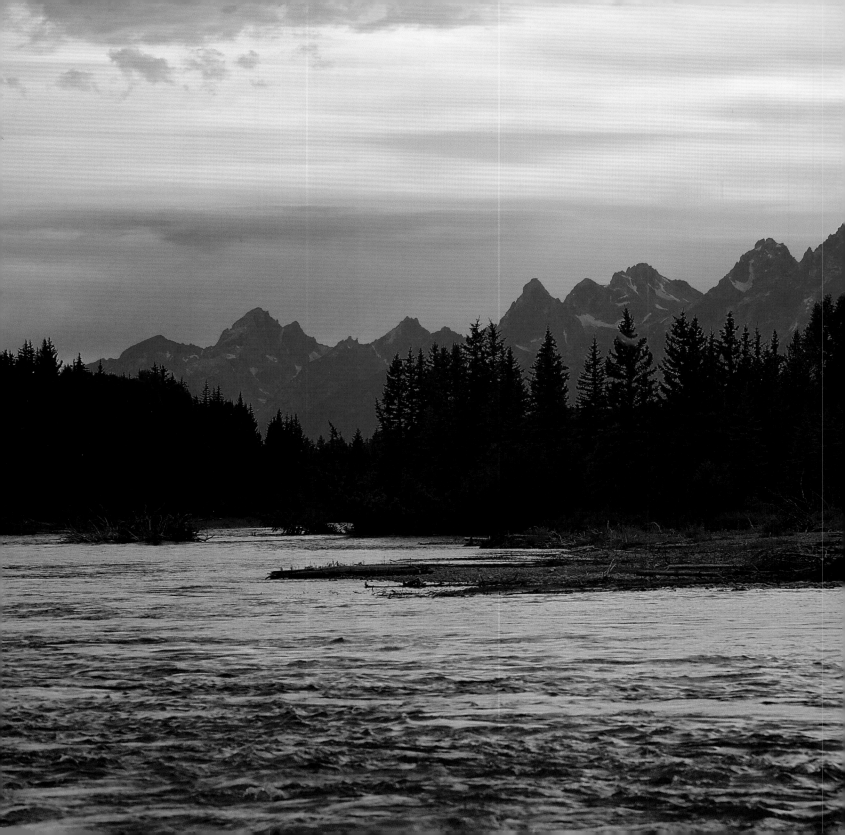

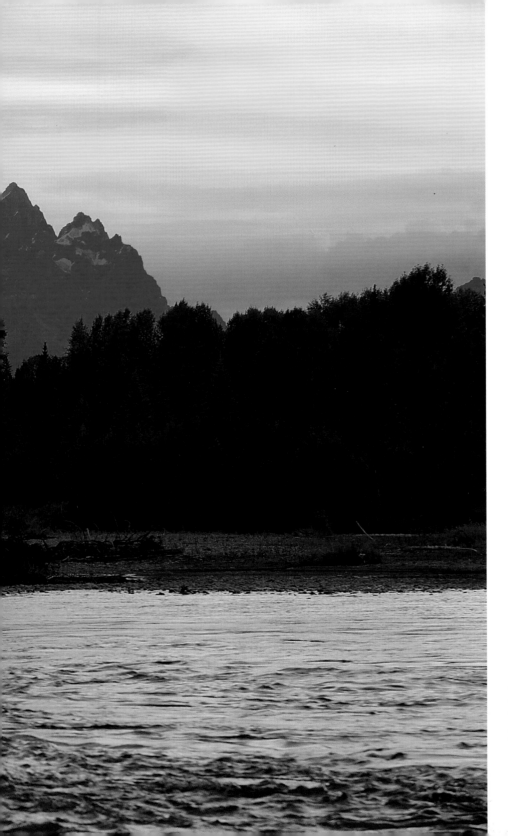

Sunset warms Wyoming's
western sky behind the Grand
Teton as the Snake River riffles
past the mouth of Buffalo Fork.

APPENDIX I National Wild and Scenic Rivers List

This is the first consolidated and published list of all America's designated wild and scenic rivers, including all tributaries named in legislation.

In column one, relatively minor tributaries are indented under their receiving stream. The column headed "mi" lists mileage, followed by a column that indicates the total mileage of the main stream plus its designated tributaries. Mileages over ten are rounded to the mile. "Agency" refers to the administrator: FS is the US Forest Service; NPS, National Park Service; BLM, Bureau of Land Management; FWS, US Fish and Wildlife Service. Administering states are indicated with state abbreviations. Though partnership rivers are managed by local commissions, NPS is the "official" manager under this federal program. "Reach" indicates

the upper and lower limits of the designation. The abbreviation "bdy" means boundary.

Mileages are derived by the Forest Service from the Geographic Information System, USGS National Hydrography Data set 1:24,000, North American Equidistant Conic. Distances differ slightly from those at rivers.gov and other sources, which were derived from legislation or agency documents and typically calculated on USGS maps by hand. The GIS data, with several corrections, is used here as the only consistent source and is presumed by many to be more accurate. However, owing to special difficulties of tributaries, NPS data was used for White Clay Creek and Wildcat Brook, and legislative data was used for Skagit tributaries and the upper Snake River with its headwaters.

River	mi	w/tribs	agency	reach
ALABAMA				
Sispey Fk, West Fork R	21	64	FS	source at Thompson & Hubbard Cr to Sandy Cr
Hubbard Cr	3.7		FS	FR 210 to mouth at Thompson Cr
Thompson Cr	8.4		FS	source to mouth at Hubbard Cr
Tedford Cr	2.1		FS	upper basin to Thompson Cr
Mattox Cr	2.7		FS	upper basin to Thompson Cr
Borden Cr	11		FS	Montgomery Cr to mouth at Sipsey Fk
Montgomery Cr	1.5		FS	upper basin to Borden Cr
Flannigan Cr	5.8		FS	upper basin to Borden Cr
Braziel Cr	5.3		FS	upper basin to Borden Cr
Hogood Cr	2.9		FS	upper basin to Braziel Cr
ALASKA				
Alagnak R	59	82	NPS	source at Kukaklek Lake to above Kvichak R
Nonvianuk R	23		NPS	source at Nonvianuk Lake to mouth at Alagnak R
Alatna R	92		NPS	source to Gates of the Arctic National Park bdy
Andreafsky R	136		FWS	source to Yukon Delta NWR
Andreafsky R, E Fk	143		FWS	source to Yukon Delta NWR

River	mi	w/tribs	agency	reach
Aniakchak R	38	80	NPS	source to mouth at Pacific Ocean
Albert Johnson Cr	9		NPS	in Aniakchak National Monument and Preserve
Hidden Cr	7		NPS	in Aniakchak National Monument and Preserve
Mystery Cr	8		NPS	in Aniakchak National Monument and Preserve
Aniakchak R, N Fk	13		NPS	source to mouth at Aniakchak R
Beaver Cr	132		BLM, FWS	Bear & Champion Cr to Victoria Cr
Birch Cr	115		BLM	Steese Hwy to Jumpoff Cr
Charley R	113	250	NPS	source to mouth
Bonanza Cr	12		NPS	source to mouth
Copper Cr	36		NPS	source to mouth
Crescent Cr	29		NPS	source to mouth
Derwent Cr	18		NPS	source to mouth
Hosford Cr	16		NPS	source to mouth
Moraine Cr	5.9		NPS	source to mouth
Orthmer & Flat Cr	21		NPS	source to mouth
Chilikadrotna R	14		NPS	in Lake Clark National Park
Delta R	58		BLM	Tangle Lakes to .5 mi n of Black Rapids
Fortymile R	41	407	BLM	source at N Fk & S Fk confluence to Canada
O'Brien Cr	28		BLM	source to mouth
Fortymile R, N Fk	59		BLM	source to mouth at S Fk (main stem)
Champion Cr	30		BLM	source to mouth at N Fk Fortymile
Hutchison Cr, N Fk	20		BLM	source to mouth at N Fk Fortymile
Fortymile R, M Fk	44		BLM	Joseph Cr to mouth at N Fk
Joseph Cr	25		BLM	source to mouth at M Fk Fortymile
Fortymile R, S Fk	29		BLM	source to mouth at N Fk (main stem)
Napoleon Cr	7.5		BLM	source to mouth at S Fk Fortymile
Franklin Cr	6.6		BLM	source to mouth at S Fk Fortymile
Uhler Cr	8.7		BLM	source to mouth at S Fk Fortymile
Mosquito Fk	38		BLM	Kechumstuk to mouth at Dennison Fk (S Fk Fortymile)
Dennison Fk	18		BLM	W Fk to mouth at Mosquito Fk (S Fk Fortymile)
Dennison Fk, W Fk	13		BLM	Logging Cabin Cr to mouth at Dennison Fk
Logging Cabin Cr	17		BLM	source to mouth at W Fk Dennison Cr
Walker Fk	12		BLM	Liberty Cr to mouth at S Fk Fortymile
Wade Cr	10		BLM	source to mouth at Walker Fk
Gulkana R	47	173	BLM	Paxson Lake to Sourdough Cr
Gulkana R, M Fk	27		BLM	source at Dickey Lake to mouth at main stem
Gulkana R, W Fk	82		BLM	source at N & S Br to mouth at main stem
Gulkana R, W Fk, S Br	17		BLM	unnamed lake to mouth at W Fk
Ivishak R	65	74	FWS	source to Flood Cr
unnamed streams	8.8		FWS	souce to mouth
John R	63		NPS	source to lower bdy Gates of the Arctic National Park
Kobuk R	125		NPS	source to lower bdy Gates of the Arctic National Park
Koyukuk R, N Fk	122		NPS	source to M Fk Koyukuk (main stem)
Mulchatna R	25		NPS	source to Lake Clark National Park bdy

River	mi	w/tribs	agency	reach
Noatak R	372		NPS	source to Kelly R confluence (33 mi above Noatak)
Nowitna R	226		FWS	Nowitna National Wildlife Refuge to mouth at Yukon R
Salmon R	79		NPS	source to mouth in Kobuk Valley National Park
Selawik R	189		FWS	source to Kugarak R in Selawik NWR
Sheenjek R	205		FWS	source to Arctic NWR s bdy with 28 mi exclusion
Tinayguk R	55		FWS	source to mouth in Gates of the Arctic National Park
Tlikakila R	57		NPS	in Lake Clark National Park
Unalakleet R	32		BLM	source to Chiroskey R
Wind R	106	124	FWS	source to mouth at Chandalar R, E Fk
unnamed tributary	18		FWS	source to mouth
ARIZONA				
Fossil Cr	17		FS	Sand Rock & Calf Pen Canyon to mouth at Verde R
Verde R	40		FS	Beasley Flats below Camp Verde to Red Cr
ARKANSAS				
Big Piney Cr	42		FS	source to Ozark National Forest bdy
Buffalo R	16		FS	source to Ozark National Forest bdy
Cassatot R	21	26	FS	Mine Cr near Hwy 4 to 4.6 mi below Hwy 4 bridge
Brushy Cr	4.2		FS	n of Hwy 246 to mouth at Cossatot R
Hurricane Cr	16		FS	source to Big Piney Cr
Little Missouri R	15		FS	source to n bdy of NW 1/4 sec 5, T5S, R27W
Mulberry R	56		FS	source to Ozark National Forest bdy
North Sylamore Cr	14		FS	Clifty Canyon Botanical Area to mouth at White R
Richland Cr	18		FS	source to n bdy of sec 32, T14N, R18W
CALIFORNIA				
Amargosa R	22		BLM	Tecopa Hot Springs area to Dumont Dunes, excepting Hot Springs and Old Spanish Trail Hwy crossing areas
American R	22		CA	Nimbus Dam to mouth at Sacramento R
American R, N Fk	37		FS, BLM	The Cedars to 1,000 feet above Colfax-Iowa Hill Bridge
Bautista Cr	11		FS	National Forest upstream bdy to downstream bdy
Big Sur R	7.5	20	FS	source at N Fk & S Fk confluence to Wilderness bdy
Big Sur R, N Fk	7.1		FS	source to mouth at S Fk (main stem)
Big Sur R, S Fk	5.2		FS	source to mouth at N Fk (main stem)
Black Butte R	20	22	FS	Mendocino Co line to mouth at M Fk Eel R
Cold Cr	2		FS	Mendocino Co line to mouth at Black Butte R
Cottonwood Cr	22		FS	source to canyon mouth (n bdy sec 5, T4S, R34E)
Eel R	151	340	CA	Van Arsdale Dam to mouth at Pacific Ocean
Eel R, M Fk	55		FS	s bdy of Yolla Bolly Wilderness to mouth at Eel R
Eel R, N Fk	34		FS	Old Gilman Ranch to mouth at Eel R
Eel R, S Fk	101		CA	Section Four Cr near Branscomb to mouth at Eel R
Feather R, M Fk	77		FS	s of Beckwourth to Oroville Reservoir
Fuller Mill Cr	3.3		FS	source to mouth at San Jacinto R N Fk
Kern R, N Fk	79		FS	source to Tulare-Kern County bdy

River	mi	w/tribs	agency	reach
Kern R, S Fk	75		FS	source to s bdy Domelands Wilderness
Kings R	6	86	FS	M Fk-S Fk confluence (source) to Converse Cr (el 1,595)
Kings R, M Fk	36		NPS	source at Lake Helen to mouth at S Fk confluence
Kings R, S Fk	44		NPS	source at Lake 11599 to mouth at M Fk confluence
Klamath R	188		FS, others	Iron Gate Dam to mouth at Pacific Ocean
Merced R	61	128	NPS, FS, BLM	source to McClure Reservoir (el 867)
Lyell Fk	7.4		NPS	source to mouth at Merced R
Triple Peak Fk	5.9		NPS	source to mouth at Merced R
Merced Peak Fk	6.3		NPS	source to mouth at Merced R
Red Peak Fk	4.1		NPS	source to mouth at Merced R
Merced R, S Fk	44		NPS, FS	source to mouth at Merced R
Owens R	.9	18	FS	above Big Springs to private land (sec 19, T2S, R28E)
Deadman Cr	11		FS	source e of San Joaquin Peak to above Big Springs
Glass Cr	5		FS	source to mouth at Deadman Cr
Palm Canyon Cr	8.2		FS	upper basin to National Forest bdy
Piru Cr	7.1		FS	.5 mi below Pyramid Dam to LA & Ventura Co line
Salmon R	19	72	FS	source at N Fk-S Fk confluence to mouth at Klamath R
Wooley Cr	7.7		FS	Marble Mountain Wilderness bdy to mouth
Salmon R, N Fk	27		FS	Marble Mountain Wilderness bdy to mouth at S Fk
Salmon R, S Fk	18		FS	Cecilville Bridge to mouth at N Fk
San Jacinto, N Fk	10		FS	source in San Jacinto St Pk to n bdy Sec 17, T5S, R2 E
Scott R	24		FS	Shackleford Cr w of Fort Jones to mouth at Klamath R
Sespe Cr	29		FS	Howard Cr confluence to end of Sec 26, T5N, R20W
Sisquoc R	34		FS	source to Los Padres National Forest bdy
Smith R, main stem	17	397	FS	M Fk & S Fk confluence to Pacific Ocean
Mill Cr	6		CA	source to mouth at Smith R
Mill Cr, W Br	4.8		CA	source to mouth at E Fk confluence (main stem Mill Cr)
Mill Cr, E Fk	6.2		CA	source to mouth at W Br (main stem Mill Cr)
Bummer Lake Cr	4.1		CA	source to mouth at E Fk Mill Cr
Little Mill Cr	3.2		CA	source to mouth at Smith R
Rowdy Cr	11		CA	OR state line to lower National Forest bdy
Savoy Cr	3.9		CA	source to mouth at Rowdy Cr
Dominie Cr	4.4		CA	source to mouth at Rowdy Cr
Smith R, M Fk	35	112	FS	source to mouth at S Fk Smith confluence (main stem)
Knopki Cr	5.3		FS	source to mouth at M Fk Smith
Griffin Cr	4		FS	source to mouth at M Fk Smith
Packsaddle Cr	4.6		FS	source to mouth at M Fk Smith
Siskiyou Fk	9		FS	source to mouth at M Fk Smith
Siskiyou Fk, S Fk	5.1		FS	source to mouth at Siskiyou Fk
Monkey Cr	7.7		FS	source to mouth at M Fk Smith
Little Jones Cr	4		FS	source to mouth at M Fk Smith
Patrick Cr	3.3		FS	source at E & W Fks to mouth at M Fk Smith
Patrick Cr, E Fk	4.6		FS	source to mough at Patrick Cr
Patrick Cr, W Fk	2.8		FS	source to mouth at Patrick Cr

River	mi	w/tribs	agency	reach
Shelly Cr	9.4		FS	source to mouth at Patrick Cr
Kelly Cr	3.8		FS	source to mouth at M Fk Smith
Hardscrabble Cr	6.7		FS	source to mouth at M Fk Smith
Myrtle Cr	6.6		FS	source to mouth at M Fk Smith
Smith R, N Fk	14.2	46	FS	OR bdy to mouth at M Fk Smith
Diamond Cr	9		FS	OR bdy to mouth at N Fk Smith
Diamond Cr, N Fk	2.1		FS	source to mouth at Diamond Cr
Bear Cr	2.5		FS	source to mouth at Diamond Cr
High Plateau Cr	3		FS	source to mouth at Diamond Cr
Still Cr	3		FS	source to mouth at N Fk Smith
Peridotite Cr	5.5		FS	source to mouth at N Fk Smith
Stony Cr	6.7		FS	source to mouth at N Fk Smith
Smith R, S Fk	40	179	FS	source to mouth at M Fk confluence (main stem)
Prescott Fk	7.4		FS	source to mouth at S Fk Smith
Harrington Cr	7.3		FS	source to mouth at S Fk Smith
Eightmile Cr	7.5		FS	source to mouth at S Fk Smith
Williams Cr	5.2		FS	source to mouth at Eightmile Cr
Quartz Cr	8.1		FS	source to mouth at S Fk Smith
Buck Cr	7.3		FS	source to mouth at S Fk Smith
Blackhawk Cr	2.3		FS	source to mouth at S Fk Smith
Canthook Cr	2.9		FS	source to mouth at S Fk Smith
Jones Cr	13		FS	source to mouth at S Fk Smith
Muzzleloader Cr	3.1		FS	source to mouth at Jones Cr
Hurdygurdy Cr	16		FS	source to mouth at S Fk Smith
Goose Cr	17		FS	source to mouth at S Fk Smith
Goose Cr, E Fk	7.3		FS	source to mouth at Goose Cr
Gordon Cr	6.8		FS	source to mouth at S Fk Smith
Rock Cr	7.5		FS	source to mouth at S Fk Smith
Coon Cr	10		FS	source to mouth at S Fk Smith
Craigs Cr	9.7		FS	source to mouth at S Fk Skith
Trinity R	109	201	FS	Lewiston Dam to mouth at Klamath R
Trinity R, N Fk	15		FS	Salmon-Trinity Wilderness to mouth at Trinity R
Trinity R, New Fk	21		FS	Salmon-Trinity Wilderness to mouth at Trinity R
Trinity R, S Fk	56		FS	Hwy 36 bridge to mouth at Trinity R
Tuolumne R	62		NPS, FS	source to New Don Pedro Reservoir, excepting Hetch Hetchy Reservoir
Dana Fk	6.7		NPS	source to Tuolumne R
Lyell Fk	14		NPS	source to Tuolumne R
Van Duzen R (Eel basin)	47		CA	Dinsmores Bridge to mouth at Eel R

COLORADO

River	mi	w/tribs	agency	reach
Cache la Poudre R	60		FS	Poudre Lake and downstream
Cache la Poudre, S Fk	21		FS	source to mouth at main stem

CONNECTICUT

River	mi	w/tribs	agency	reach
Eightmile R	11	25	NPS	Lake Hayward Brook to mouth at Connecticut R
Eightmile R, E Br	7.8		NPS	Witch Meadow Rd to mouth at Eightmile R
Harris Brook	3.8		NPS	e of Hwy 85 and Round Hill Rd to mouth at E Br
Beaver Brook	1.9		NPS	Cedar Pond Brook to mouth at Eightmile R
Falls Brook	0.7		NPS	Tisdale Brook to mouth at Eightmile R
Farmington R, W Br	14		NPS	Goodwin Dam to above takeout on Hwy 44 in Canton

DELAWARE

River	mi	w/tribs	agency	reach
White Clay Cr (see PA)				

FLORIDA

River	mi	w/tribs	agency	reach
Loxahatchee R, NW Fk	7.4		FL	Riverbend Park to Jonathan Dickinson State Park
Wekiva R	16	44	FL	Wekiva Springs to mouth at St. Johns R
Rock Springs Run	8.9		FL	source at Rock Springs to mouth at Wekiva R
Black Water Creek	19		FL	Lake Norris to mouth at Wekiva R

GEORGIA

River	mi	w/tribs	agency	reach
Chattooga R	41 (w/NC, SC)		FS	.8 mi below Cashiers Lake (NC) to Tugaloo Reservoir
Chattooga R, W Fk	7.2		FS	7.3 miles above mouth to mouth at main stem

IDAHO

River	mi	w/tribs	agency	reach
Bruneau R	39	117	BLM	lower bdy Bruneau Wilderness to W Fk Bruneau
Bruneau R, W Fk	0.3		BLM	below Jarbidge R confluence
Sheep Cr	26		BLM	upstream bdy of Bruneau Wilderness to Bruneau R
Big Jacks Cr	35		BLM	below lower bdy of Big Jacks Cr Wilderness
Little Jacks Cr	12		BLM	OX Prong Cr to lower bdy of Little Jacks Cr Wilderness
Wickahoney Cr	1.5		BLM	upper bdy of Big Jacks Cr Wilderness to Big Jacks Cr
Cottonwood Cr	2.5		BLM	upper bdy of Big Jacks Cr Wilderness to Big Jacks Cr
Duncan Cr	0.9		BLM	above mouth to Big Jacks Cr
Clearwater R, M Fk	21		FS	source at Selway/Lochsa confluence to Kooskia
Jarbidge R	29		BLM	upstream bdy of Bruneau Wilderness to W Fk Bruneau
Lochsa R	65		FS	Powell Ranger Station to mouth at M Fk Clearwater
Owhyee R (see also OR)	68	118	BLM	upper bdy Owyhee R Wilderness to ID-OR border
Battle Cr	23		BLM	upper bdy Owyhee R Wilderness to mouth (Owyhee R)
Deep Cr	13		BLM	upper bdy Owyhee R Wilderness to mouth (Owyhee R)
Dickshooter Cr	9.3		BLM	above mouth to Deep Cr
Red Canyon	4.6		BLM	upper bdy Owyhee R Wilderness to mouth (Owyhee R)
Owyhee R, N Fk	21		BLM	upper bdy N Fk Owyhee R Wilderness to ID-OR border
Owyhee R, S Fk	32		BLM	ID-NV border to mouth at Owyhee R
Rapid R	19		FS	source to fish hatchery 2 mi above mouth (Salmon R)
Rapid R, W Fk	8.8		FS	wilderness bdy to mouth at Rapid R
Saint Joe R	69		FS	source at St Joe Lake to above N Fk Saint Joe (Avery)
Salmon R	119		FS	N Fk Salmon R to Long Tom Bar (above Vinegar Cr)
Salmon R, M Fk	103		FS	source at Marsh Cr/Bear Valley Cr confluence to mouth
Selway R	97		FS	source to mouth at M Fk Clearwater R
Snake R	67		FS	Hells Canyon Dam to 4 mi above OR-WA bdy

River	mi	w/tribs	agency	reach
ILLINOIS				
Vermillion R, M Fk	16		IL	Kinny's Ford near Collison to railroad n of Hwy 150
KENTUCKY				
Red R	19		FS	Hwy 746 bridge n of Campton to School House Br, below Hwy 77 bridge
LOUISIANA				
Saline Bayou	24		FS	n bdy Kisatchie National Forest to Saline Lake
MAINE				
Allagash R	103		ME	Telos Lake Dam to W Twin Brook (5 mi above mouth)
MASSACHUSETTS				
Assabet R	6		NPS	1,000' below Damon Mill Dam (Concord) to Sudbury R
Concord R	7.9		NPS	Sudbury & Assabet confluence to Billerica (Hwy 3)
Sudbury R	16		NPS	Danforth St bridge (Framingham) to Concord R
Taunton R	37		NPS	Town & Matfield R in Bridgewater to Hwy 195 bridge
Westfield R	8.4	84	NPS	source at E Br and Swift R confluence to confluence with Drowned Land Brook in Savoy to .8 mi above Holly Brook sw of Chesterfield (8 mi); Sykes Sykes Brook n of Hwy 66 to Russell town line, .5 mi below W Branch (4.8 mi)
Westfield R, E Br	20		NPS	source at Center Brook and Drowned Lake Brook to mouth at Westfield R
Drowned Land Brook	4		NPS	upper Brook to mouth at E Br near Savoy
Center Brook	3		NPS	upper Brook to mouth at E Br near Savoy
Windsor Jambs Brook	1.6		NPS	1.6 mi above mouth to mouth at E Br
Westfield R, M Br	13		NPS	source at Trout Brook to Kinne Brook at Dayville (12.4 mi); Gross Hill Rd bridge to mouth at E Br (1 mi)
Gendale Brook	1.8		NPS	1.9 mi above M Br to mouth at M Br
Westfield R, W Br	17		NPS	source in Becket to mouth at Westfield R
Shaker Mill Brook	2.7		NPS	source to mouth at W Br Westfield in Becket
Depot Brook	6.4		NPS	source to mouth at W Br Westfield in Becket
Savery Brook	3.2		NPS	source to mouth at Shaker Mill Brook near Becket
Watson Brook	1.9		NPS	source to mouth at Shaker Mill Brook w of Becket
Center Pond Brook	1.7		NPS	Center Pond to mouth at W Br Westfield e of Becket
MICHIGAN				
Au Sable R	21		FS	1 mi below Milo Pond to 1 mi above Alcona Pond
Black R	14		FS	Ottawa National Forest bdy to mouth at L Superior
Carp R	30		FS	upper basin dto mouth at L Huron
Indian R	49		FS	Hovey Lake to Indian Lake
Manistee R	28	36	FS	below Tippy Dam to Hwy 55 bridge
Bear Cr	7.9		FS	Coates Hwy to mouth at Manistee R
Ontonagon R, Cisco Br	33		FS	source at Cisco Lake Dam to Ten-Mile Cr s of Ewen
Ontonagon R, E Br	53		FS	source at Spring Lake to Ottawa National Forest bdy
Ontonagon R, M Br	66		FS	source to n bdy of Ottawa National Forest
OntonagonR, W Br	16		FS	Cascade Falls to Victoria Reservoir
Paint R	5.6	51	FS	N & S Br confluence to Ottawa National Forest bdy
Paint R, N Br	17		FS	source at Mallard Lake to mouth at S Br Paint R
Paint R, S Br	29		FS	source at Paint R Springs to mouth at N Br Paint R

River	mi	w/tribs	agency	reach
Pere Marquette R	59		FS	N and Little S Br confluence to old Hwy 31 bridge
Pine R	24		FS	Lincoln Bridge and downstream 26 mi
Presque Isle R	23	57	FS	source at E & W Br confluence to Minnewawa Falls
Presque Isle R, E Br	14		FS	Ottawa National Forest bdy to mouth at Presque Isle R
Presque Isle R, S Br	7		FS	Ottawa National Forest bdy to mouth at Presque Isle R
Presque Isle R, W Br	13		FS	Ottawa National Forest bdy to mouth at Presque Isle R
Sturgeon R (Hiawatha NF)	40		FS	upper river to mouth at L Michigan
Sturgeon R (Ottawa NF)	27		FS	s bdy of Ottawa National Forest to n bdy
Tahquamenon R, E Br	14		FS	source to Hiawatha National Forest bdy
Whitefish R	12	36	FS	source at E & W Br confluence to mouth at L Michigan
Whitefish R, E Br	16		FS	CR 003 bridge to mouth at W Br (main stem)
Whitefish R, W Br	7.7		FS	CR 444 to mouth at E Br (main stem)
Yellow Dog R	4		FS	Bulldog Lake Dam to Ottawa National Forest bdy

MINNESOTA
 see St.Croix R, WI

MISSISSIPPI

River	mi	w/tribs	agency	reach
Black Cr	21		FS	5 mi below Brooklyn to Fairley Br Landing (Hwy 318)

MISSOURI

River	mi	w/tribs	agency	reach
Eleven Point R	44		FS	Thomasville to Hwy 142

MONTANA

River	mi	w/tribs	agency	reach
Flathead R, M Fk	94		FS	source at Trail Cr to mouth at S Fk (main stem)
Flathead R, N Fk	57		FS, NPS	Canada bdy to mouth at M Fk confluence
Flathead R, S Fk	57		FS	source at Youngs Cr to Hungry Horse Reservoir
Missouri R	146		BLM	Fort Benton to Hwy 191 (Robinson Bridge)

NEBRASKA

River	mi	w/tribs	agency	reach
Missouri R (upper)	38		NPS	Fort Randall Dam to Lewis and Clark Reservoir
Missouiri R (lower)	53		NPS	Gavis Point Dam near Yankton, SD, to Ponca State Park
Niobrara R	93	101	NPS	Borman Bridge s of Valentine to Hwy 137 bridge (76 mi); w bdy of Knox Co to mouth at Missouri R (25 mi)
Verdigre Cr	7.9		NPS	n bdy of Verdigre to mouth at Niobrara R

NEW HAMPSHIRE

River	mi	w/tribs	agency	reach
Lamprey R	22		NPS	Bunker Pond Dam in Epping to mouth at Piscassic R
Wildcat Brook	9	14.5	FS	source to Ellis R throgh town of Jackson
Bog Brook	1.6		FS	source to Wildcat Brook
Great Brook	1		FS	Hwy 16B bridge to mouth at Wildcat Brook
Little Wildcat Brook	2.8		FS	source to mouth at Wildcat Brook

NEW JERSEY
Deleware R (see PA)

River	mi	w/tribs	agency	reach
Great Egg Harbor R	46	144	NPS	rr bridge s of Albion to Spur 536 bridge (3 mi);Atlantic City Espressway s of Sicklerville to Lake Lenape (21 mi); Mill St Bridge in Mays Landing to Patcong Cr (15.5 mi)

River	mi	w/tribs	agency	reach
Squankum Br	4.3		NPS	Malaga Rd to mouth at Great Egg Harbor R
Big Bridge Br	2.6		NPS	source nw of Hammonton to mouth at Great Egg
Penny Pot Stream Br	4.3		NPS	14th St w of Hammonton to mouth at Great Egg
Deep Run	9.2		NPS	Pancoast Mill Rd n of Richland to mouth at Great Egg
Mare Run	0.7		NPS	Weymouth Ave e of Milmay to mouth at Great Egg
Babcock Cr	9		NPS	source near Cologne to mouth at Great Egg
Gravelly Run	3.1		NPS	PA rr e of Mays Landing to mouth at Great Egg
Miry Run	4.6		NPS	Asbury Rd (e of Catawba) to mouth at Great Egg
South River	13		NPS	Main Ave, Mays Landing, to mouth at Great Egg
Stephen Cr	2.5		NPS	Hwy 50 to mouth at Great Egg
Gibson Cr	6.1		NPS	First Ave to mouth at Great Egg
English Cr	4		NPS	Zion Rd to mouth at Great Egg
Lakes Cr	3.2		NPS	dam to mouth at Great Egg
Middle R	5.3		NPS	levee in Tuckahoe WMA to mouth at Great Egg
Patcong Cr	3		NPS	Garden St Parkway in Somers Point to mouth
Tuckahoe R	14		NPS	Hwy 49 bridge to mouth at Great Egg
Cedar Swamp Cr	8.6		NPS	source s of Hwy 50 to mouth at Tuckahoe R
Maurice R	19	46	NPS	s Millville to Shell Pile (Port Norris)
Menantico Cr	8.5		NPS	Menantico Lake ne of Millville to mouth at Maurice R
Manumuskin R	16		NPS	source (Hwy 557) n of Milmay to mouth at Maurice R
Muskee Cr	2.9		NPS	rr bridge e of Port Elizabeth to mouth at Maurice R
Musconetcong R	24		NPA	Saxton Falls to Hwy 46 br in Hackettstown (3.5 mi); King's Hwy Bridge s of Hackettstown to rr tunnel w of Bloomsbury (20.7 mi)

NEW MEXICO

River	mi	w/tribs	agency	reach
Jemez R, E Fk	11		FS	National Forest bdy to Rio San Antonio confluence
Pecos R	21		FS	source to Terrerro
Red R	3.9		FS	hatchery to mouth at Rio Grande
Rio Chama	25		BLM	El Vado Dam to Abiquiu Reservoir
Rio Grande (see also TX)	61		BLM	Colorado border to County Line BLM site n of Dixon

NEW YORK

Delaware R (see PA)

NORTH CAROLINA

Chattooga R (see GA)

River	mi	w/tribs	agency	reach
Horsepasture R	4.4		FS	Hwy 281 bridge to Jocassee Reservoir
Lumber R	77		NC	Hwy 1412 w of Silver City to Scotland-Robeson Co line (22 mi); Back Swamp s of Lumberton to SC bdy (59 mi)
New R	4.4		NC	N & S Fk confluence (source) to Virginia bdy
New R, S Fk	22		NC	Dog Cr near New R St Pk to mouth at N Fk (main stem)
Wilson Cr	23		FS	source to mouth at Johns River

OHIO

River	mi	w/tribs	agency	reach
Big Darby Cr	69		OH	Champaign-Union Co line w of Marysville to .9 mi above Hwy 40 (38 mi); Little Darby Cr confluence to mouth at Scioto R (32 mi)

River	mi	w/tribs	agency	reach
Little Beaver Cr	16	57	OH	source near Williamsport to mouth at Ohio R
Little Beaver Cr, M Fk	21		OH	CR 901 bridge (Elkston Rd) to W Fk near Williamsport
Little Beaver Cr, N Fk	4.3		OH	Brush Run to mouth at Fredericktown
Little Beaver Cr, W Fk	16		OH	CR 914 (Y-Camp rd) bridge to M Fk near Williamsport
Little Darby Cr	15		OH	Hwy 42 bridge to .8 mi above mouth at Big Darby Cr
Little Miami R	91	93	OH	Hwy 72 bridge at Clifton to mouth at Ohio R
Caesars Cr	2		OH	lower 2 miles to mouth at Little Miami R
OREGON				
Big Marsh Cr	17		FS	source to mouth at Crescent Cr
Chetco R	45		FS	source to lower National Forest bdy
Clackamas R	48		FS	source at Big Springs to Big Cliff
Clackamas, S Fk	4.2		FS	E Fk confluence to mouth at Clackamas R
Collawash R	19		FS	source of E Fk to Buckeye Cr (above Hot Springs Cr)
Crescent Cr	10		FS	Crescent Cr Dam to Hwy 61 bridge
Crooked R	18		BLM	below Bowman Dam (8 mi); .5 mi below Hwy 97 and downstream for 9.8 mi
Crooked R, N Fk	33		BLM	source at Williams Prairie to 1 mi above mouth
Deschutes R	170		BLM, FS	Wickiup Dam to Bend (54 mi); Oden Falls near Hwy 20 to Billy Chinook Reservoir (18 mi); Pelton Dam near Hwy 26 to mouth at Columbia R (98 mi)
Donner und Blitzen R	14	88	BLM	source to Malheur NWR upstream bdy
Little Blitzen R	14		BLM	source to mouth at Donner und Blitzen R
Donner und Blitzen, S Fk	17		BLM	source to mouth at Donner und Blitzen R
Big Indian Cr	12		BLM	source to mouth at Donner und Blitzen R
Little Indian Cr	4		BLM	source to mouth at Indian Cr
Fish Cr	14		BLM	source to mouth at Donner und Blitzen R
Mud Cr	4.9		BLM	source to mouth at Donner und Blitzen R
Ankle Cr	7.9		BLM	source to mouth at Donner und Blitzen R
Ankle Cr, S Fk	1.5		BLM	source to mouth at Ankle Cr
Eagle Cr (Mt Hood NF)	8.1		FS	source to Mt Hood National Forest bdy
Eagle Cr (Wallowa NF)	28		FS	source to National Forest bdy at Skull Cr
Elk R	17	28	FS	source at N & S Fk confluence to hatchery (Anvil Cr)
Elk R, N Fk	7		FS	source to mouth at Elk R
Elk R, S Fk	5		FS	source to mouth at Elk R
Elkhorn Cr	7.3		BLM	National Forest bdy to lower BLM bdy
Fifteenmile Cr	11		FS	source at Senecal Spring and downstream
Fish Cr	13		FS	source to mouth at Clackamas R
Grande Ronde R	42		BLM, FS	Wallowa R confluence to WA border
Hood R, E Fk	14		FS	Hwy 35 to lower National Forest bdy
Hood R, M FK	3.7		FS	source at Clear & Coe Br and downstream
Illinois R	49		FS	Siskiyou Forest bdy to mouth at Rogue R
Imnaha R	72		FS	source at N & S Fk confluence to mouth at Snake R
Imnaha R, S Fk	9		FS	source to mouth at N Fk confluence (main stem)
John Day R	143		BLM	Service Cr to Tumwater Falls, above John Day Reservoir

River	mi	w/tribs	agency	reach
John Day R, N Fk	54		FS	source to Camas Cr below Hwy 395
John Day R, S Fk	46		BLM	Malheur National Forest bdy to Smoky Cr
Joseph Cr	9.1		FS	Joseph Cr Ranch to lower National Forest bdy
Kiger Cr	4.2		BLM	source to lower bdy Steens Mountain Wilderness
Klamath R	11		BLM	Boyle Powerhouse to CA border
Little Deschutes R	13		FS	source to 1 mi above Hwy 58
Lostine R	17		FS	source to lower National Forest bdy
Malheur R	12		FS	Bosenberg Cr to lower National Forest bdy
Malheur R, N Fk	26		FS	source to lower National Forest boundary
McKenzie R	14		FS	Clear Cr to Scott Cr, except Carmen & Trail Br Dams
Metolius R	31		FS	National Forest upper bdy to Billy Chinook Reservoir
Minam R	41		FS	source at Minam Lake to lower Wilderness bdy
North Powder R	5.9		FS	source to lower National Forest bdy
North Umpqua R	32		FS	Soda Springs Powerhouse to Rock Cr e of Glide
Owyhee R (see also ID)	111	112	BLM	Three Forks to 4 mi above Rome (35 mi); 6 mi below Rome to Owhyee Reservoir (51 mi)
Crooked Cr	1		BLM	above Owyhee Reservoir
Owyhee R, N Fk	7.9		BLM	OR-ID border to mouth at Three Forks
Owyhee R, S Fk	24		BLM	OR-ID border to mouth at Three Forks
Powder R	12		BLM	Thief Valley Dam to Hwy 203 bridge
Quartzville Cr	9		BLM	National Forest bdy to Green Peter Reservoir
River Styx	0.2		NPS	underground reach in OR Caves National Monument
Roaring R	14		FS	source to mouth at Clackamas R
Roaring R, S Fk	4.8		FS	source to mouth at Roaring R
Rogue R	122		FS, BLM	Crater Lake NP bdy to Prospect (41 mi); Applegate R to Lobster Cr Bridge (81 mi)
Salmon R	34		FS	source to mouth at Sandy R
Sandy R	24		FS, BLM	source to National Forest bdy (12 mi); Dodge Park to Dabney Park (13 mi)
Smith R, N Fk (to CA)	13		FS	source to CA bdy (26.5 mi including CA reach)
Snake R (see ID)				
Sprague R, N Fk	16		FS	River Spring to lower National Forest bdy
Sycan R	61		FS	source to Coyote Bucket at lower National Forest bdy
Wallowa R	10		BLM	Minam R confluence to mouth at Grande Ronde R
Wenaha R	21		FS	source at N & S Fk to mouth at Grande Ronde R
West Little Owyhee R	57		BLM	source to mouth at Owyhee R
Whychus Cr (Squaw Cr)	15		FS	source to gauge 4 mi s of Sisters
White R	47		FS	source to mouth at Deschutes R
Wildhorse Cr	6.9	9.5	BLM	source to mouth of Wildhorse Canyon
Little Wildhorse Cr	2.6		BLM	source to mouth at Wildhorse Cr
Willamette R, N Fk of M Fk	43		FS	source at Waldo Lake to lower National Forest bdy
Zigzag R	4.7		FS	source to Mt Hood Wilderness bdy

River	mi	w/tribs	agency	reach
PENNSYLVANIA				
Allegheny R	90		FS	Kinzua Dam to Hwy 62 bridge (6 mi); Buckaloons to Oil City (51 mi); Franklin to Emlenton (33 mi)
Clarion R	52		FS	.7 mi below Ridgeway to Piney Reservoir
Delaware R	150	180	NPS	Hancock to Sparrow Bush (72 mi); Delaware Water Gap NRA (40 mi); Easton to Washington Crossing, with short exceptions (38 mi)
Tinicum Cr	6.3		NPS	sources of 2 branches to mouth at Delaware R
Beaver Cr	4.7		NPS	source to Tinicum Cr
Rapp Cr	4.8		NPS	source to Tinicum Cr
Tohickon Cr	11		NPS	Nockamixon Dam to mouth at Delaware R
Paunacussing Cr	3.6		NPS	upper creek to mouth at Delaware R
White Clay Cr (also in DE)	10	199	NPS	source at W & M Br to mouth at Christina R
Lamborn Run	1.6		NPS	source to mouth at White Clay Cr
Middle Run	6.5		NPS	to mouth at White Clay Cr
Pike Cr	16		NPS	to mouth at lower White Clay Cr
Mill Cr	39		NPS	to mouth at lower White Clay Cr
White Clay Cr, E Br	39		NPS	source to mouth at White Clay Cr
Trout Run	2.2		NPS	source to Avondale, near E Br
Broad Run	6.5		NPS	source to mouth at E Br
Walnut Run	2.1		NPS	source to mouth at Broad Run
Egypt Run & 2 tribs	7.4		NPS	source to mouth at E Br
White Clay Cr, M Br	23		NPS	source to mouth at main stem White Clay Cr
Indian Run	2		NPS	source to mouth at M Br White Clay Cr
White Clay Cr, W Br	17		NPS	source to mouth at M Br White Clay Cr
unnamed tributaries	27		NPS	source to mouth at White Clay and branches
PUERTO RICO				
Rio de la Mina	2.1		FS	source to mouth at Rio Mameyes
Rio Icacos	4.5		FS	source to lower National Forest bdy
Rio Mameyes	5.9		FS	source to lower National Forest bdy 1 mi w of Hwy 988
SOUTH CAROLINA				
Chattooga R (see GA)				
SOUTH DAKOTA				
Missouri R (see NB)				
TENNESSEE				
Emory R	1	41	NPS	Obed R confluence to Nemo Bridge
Obed R	24		NPS	w bdy Catoosa WMA to mouth at Emory R
Clear Cr	14		NPS	Morgan Co line to mouth at Obed R
Daddy's Cr	2.2		NPS	Morgan Co line to mouth at Obed R
TEXAS				
Rio Grande (see also NM)	193		NPS	top of Mariscal Canyon to Terrell-Val Verde Co line

River	mi	w/tribs	agency	reach
UTAH				
Virgin R basin (but not main stem)	163			
Virgin R, E Fk	7.5	11	NPS	e bdy of Zion National Park to w bdy of Park
Shunes Cr	3		BLM, NPS	BLM wilderness to w bdy of Zion N Pk
Virgin R, N Fk	19	70	NPS, BLM	BLM wilderness to s Ntl Pk bdy at pedestrian bridge
Kolob Cr	6.3		NPS, BLM	BLM, NPS BLM wilderness to mouth at N Fk Virgin R
Oak Cr	1		BLM	to mouth at Kolob Cr
Goose Cr	3.9		NPS, BLM	source mouth at N Fk Virgin R
Imlay Cr	2.6		NPS	source to mouth at N Fk Virgin R
Orderville Canyon	3.6		NPS	e bdy of Zion N Pk to mouth at N Fk Virgin R
Deep Cr	5.7		BLM, NPS	BLM wilderness to mouth at N Fk Virgin R
Mystery Canyon	1.5		NPS	source to mouth at N Fk Virgin R
Birch Cr	3.1		NPS	source to mouth at N Fk Virgin R
Pine Cr	3.3		NPS	source to mouth at N Fk Virgin R
Clear Cr	9.2		NPS	e bdy of Zion N Pk to mouth at Pine Cr
Oak Cr	2.4		NPS	sources of 2 forks to mouth at N Fk Virgin R
Heaps Canyon	2.9		NPS	source to mouth at N Fk Virgin R
Behunin Canyon	2.6		NPS	source to mouth at N Fk Virgin R
Echo Canyon	3.3		NPS	e bdy Zion N Pk to mouth at N Fk Virgin R
North Cr (Virgin tributary)	1.3	37.5	NPS	Left and Right Fk confluence to s bdy Zion N Pk
North Cr, Left Fk	7.2		NPS	Wildcat Canyon to mouth at North Cr
Wildcat Canyon	4.4		NPS	Zion N Pk bdy to mouth at Left Fk North Cr
Grapevine Wash	2.8		NPS	source to mouth at Left Fk North Cr
Little Cr	5.3		NPS	source to mouth at Left Fk North Cr
Russell Gulch	3		NPS	source to mouth at Left Fk North Cr
Pine Springs Wash	3.7		NPS	source to mouth at Left Fk North Cr
Wolf Springs Wash	1.5		NPS	source to mouth at Pine Springs Wash
North Cr, Right Fk	8.3		NPS	source to mouth at North Cr
LaVerkin Cr (Virgin tributary)	16	36	BLM, NPS	BLM wilderness
Willis Cr	1.9		BLM, NPS	BLM wilderness to mouth at LaVerkin Cr
Timber Cr & tributaries	8.7		NPS	sources to mouth at LaVerkin Cr
Beartrap Canyon & trib	3.8		BLM, NPS	BLM wilderness to mouth at LaVerkin Cr
Current Cr	1.4		NPS	source to mouth at LaVerkin Cr
Cane Cr	0.3		NPS	source to mouth at LaVerkin Cr
Hop Valley Cr	2.9		NPS	in Zion N Pk to mouth at LaVerkin Cr
Smith Cr	1.2		NPS	source to mouth at LaVerkin Cr
Taylor Cr (Virgin tributary)	1.8	8.8	NPS	source at N & S Fks to lower bdy Zion N Pk
Taylor Cr, N Fk	2.1		NPS	source to mouth at Taylor Cr
Taylor Cr, M Fk	3.3		BLM, NPS	source to mouth at Taylor Cr
Taylor Cr, S Fk	1.6		NPS	source to mouth at Taylor Cr
VERMONT				
Missisquoi R	34	45	NPS	Westfield s bdy (3 mi n of Lowell) to Canada, excepting Troy hydro dams (20 mi); then after a reach in Canada, Canada bdy at Richford to Samsonville (15 mi)

River	mi	w/tribs	agency	reach
Trout R	11		NPS	Jay & Wade Brooks to mouth at Missisquoi R
WASHINGTON				
Cascade R	20		FS	source at N & S Fk confluence to mouth at Skagit R
Cascade R, N Fk	1		FS	lower bdy North Cascades National Park to mouth
Illabot Cr	14		FS	source to 2 mi above mouth (Skagit R)
Klickitat R	11		FS	Wheeler Cr near Pitt to mouth at Columbia R
Pratt R	9.8		FS	source to mouth at M Fk Snoqualmie R
Sauk R	43		FS	Elliott Cr to mouth at Skagit R
Sauk R, N Fk	8		FS	Glacier Peak Wilderness to mouth at Sauk R
Skagit R	56		FS	Bacon Cr above Marblemount to Sedro-Woolley
Snoqualmie R, M Fk	25		FS	source and downstream to bdy of Sec 11, T23N, R9E
Suiattle R	28		FS	Glacier Peak Wilderness to mouth at Sauk R
White Salmon R	21	29	FS	source to National Forest lower bdy
Cascade Cr	7.7		FS	source to mouth at White Salmon R
WEST VIRGINIA				
Bluestone R	13		NPS	2 mi above Summers-Mercer Co line to Bluestone Reservoir
WISCONSIN				
Namekagon R	98		NPS	Lake Namekagon Dam near source to mouth
Saint Croix R	152 (with MN)		NPS	Gordon Dam to mouth, excepting Taylors Falls Dam
Wolf R	24		NPS	Langlade-Menominee Co line to Keshena Falls (Menominee Indian Reservation)
WYOMING				
Bailey Cr	6.9		FS	source to mouth at Snake R
Blackrock Cr	22		FS	source to mouth at Buffalo Fk
Buffalo Fk of Snake R	22		FS, NPS	source at N & S Fk confluence to mouth at Snake R
Buffalo Fk, N Fk	32		FS	source to mouth at Buffalo main stem
Buffalo Fk, S Fk	28		FS	source to mouth at Buffalo main stem
Buffalo Fk, Soda Fk	10		FS	source to mouth at N Fk Buffalo
Clark's Fork R (Yellowstone)	21		FS	1 mi below Hwy 296 bridge to mouth of canyon
Crystal Cr	19		FS	source to mouth at Gros Ventre R
Granite Cr	22		FS	source to 1 mi above mouth at Hoback R
Gros Ventre R	59		FS, NPS	source to near Hwy 89, excepting Lower Slide Lake
Hoback R	11		FS	2 mi below Granite Cr to mouth at Snake R
Lewis R	15		NPS	Shoshone Lake to mouth at Snake R
Pacific Cr	34		FS, NPS	source to mouth at Snake R
Shoal Cr	8.5		FS	source to Sublette Co line
Snake R	100		NPS, FS	source to Jackson Reservoir (47 mi); 1 mi below Jackson Dam to 1 mi below Moose (30 mi); Hoback R to 1 mi above Hwy 89 bridge (23 mi)
Willow Cr	16		FS	source to mouth at Hoback R
Wolf Cr	7		FS	source to mouth at Snake R

APPENDIX 2 Enumerating Methods

The official number and mileage of national wild and scenic rivers is maintained by the Interagency Wild and Scenic Rivers Coordinating Council. Details appear on www.rivers.gov. As of January 2015, 208 rivers were reported. This is based on the language of the Wild and Scenic Act and its amendments, which have often combined several rivers under one name. For example, the original act designated the Middle Fork Clearwater as one river, but it includes the Middle Fork Clearwater of 21 miles plus two separate rivers that join to form it: the Selway (97 miles) and the Lochsa (65 miles). The Andreafsky of 136 miles is listed as one river, but it includes a separate river, the East Fork, which, at 143 miles, is longer than the main stem and one of the longer rivers in the wild and scenic system. The Skagit is listed as one river, though it includes three major tributaries, the Sauk, Suiattle, and Cascade—each of which would have been a major wild and scenic addition if designated by themselves. The Smith of California is one "river" including a main stem of 17 miles plus 3 forks and 49 named tributaries totaling 397 miles. Sizable branches of many other rivers are not separately listed, though they are indeed separate rivers. In other cases, separate branches or tributaries *are* counted—it depends entirely on the legislated language. Rivers as small as 0.4 miles, and "creeks" as minor as Duncan, 0.9 miles, are counted as separate "rivers." Typically, if tributaries of a river are designated with it, they are not counted, whereas the designation of an individual stream—no matter how small—is counted as a separate river. But, in other cases, such as the Owhyee and Bruneau, minor tributaries *are* counted as separate rivers. The legal numeration is—figuratively speaking—all over the map.

Focusing on geography rather than legislative language, and seeking to convey the actual numbers of rivers in the program, my numeration of designated rivers follows several guidelines. "Major rivers" here includes all "rivers," plus all "forks" or "branches" longer than five miles. Branches or forks of forks, as well as "creeks" are counted as separate rivers only when they're designated as stand-alone streams (Little Beaver Creek and White Clay Creek, for example), but not when they are listed as tributaries to a designated main stem. But, my "total rivers and tributaries" includes *all* streams of any length that are explicitly designated in wild and scenic legislation (the Smith River's 49 tributaries are all counted).

Following this protocol, as of February 2017 the wild and scenic system had 289 major rivers and a total of 495 named rivers and tributaries.

APPENDIX 3 Chronology of Designations

Note: Where no comma follows the first river name, only the listed fork is included (Clearwater M Fk means the Middle Fork Clearwater). Where a comma follows the first river name, both the main stem and the following fork are included (Saint Croix, Namekagon). Small tributaries do not appear in this list but were almost always designated at the same time. After the initial designation, additional mileage was added to some rivers; they will again appear under the later date. NF indicates National Forest.

1968	Clearwater M Fk, Selway, Lochsa, ID
	Eleven Point, MO
	Feather M Fk, CA
	Rio Grande, Red, NM
	Rogue, OR
	Saint Croix, Namekagon, WI, MN
	Salmon M Fk, ID
	Wolf, WI
1970	Allagash, ME
1972	Saint Croix, WI, MN
1973	Little Miami, OH
1974	Chattooga, GA, NC, SC
1975	Little Beaver, OH
	Snake, ID, OR
	Rapid, ID
1976	New, NC
	Missouri, MT
	Flathead NF, MF, SF, MT
	Obed, Emory, TN
	Saint Croix, WI, MN
1978	Pere Marquette, MI
	Skagit, Sauk, Sauk N Fk, Suiattle, WA
	Delaware, PA, NY, NJ
	American N Fk, CA
	Saint Joe, ID
	Rio Grande, TX
	Missouri, NE, SD

1980	Alagnak, AK
	Alatna, AK
	Aniakchak, AK
	Charley, AK
	Chilikadrotna, AK
	John, AK
	Kobuk, AK
	Koyukuk N Fk, AK
	Mulchatna, AK
	Noatak, AK
	Salmon, AK
	Tinayguk, AK
	Tlikakila, AK
	Andreafsky, AK
	Ivishak, AK
	Nowitna, AK
	Selawik, AK
	Sheenjek, AK
	Wind, AK
	Beaver Creek, AK
	Birch Creek, AK
	Delta, AK
	Fortymile, AK
	Gulkana, AK
	Unalakleet, AK
	Little Miami, OH

1981	American, CA
	Klamath, Salmon, Scott, CA
	Trinity, N Fk, S Fk, New, CA
	Eel, M Fk, S Fk, N Fk, Van Duzen, CA
	Smith, M Fk, N Fk, S Fk, CA
1984	Verde, AZ
	Tuolumne, CA
	Au Sable, MI
	Owyhee, OR
	Illinois, OR
1985	Loxahatchee, FL
1986	Horsepasture, NC
	Cache la Poudre, CO
	Black Creek, MS
	Saline Bayou, LA
	Klickitat, WA
	White Salmon, WA
1987	Merced, S Fk, CA
	Kings, M Fk, S Fk, CA
	Kern N Fk, CA
1988	Bluestone, WV
	Wildcat, NH
	Sipsey Fk of West Fork River, AL
	Big Marsh Creek, OR
	Chetco, OR
	Clackamas, OR
	Crescent Creek, OR
	Crooked, OR

Deschutes, OR
Donner und Blitzen, OR
Eagle Creek (Wallowa NF), OR
Elk, OR
Grande Ronde, OR
Imnaha, OR
John Day, N Fk, S Fk, OR
Joseph Creek, OR
Little Deschutes, OR
Lostine, OR
Malheur, N Fk, OR
McKenzie, OR
Metolius, OR
Minam, OR
Crooked, N Fk, OR
Willamette N Fk of M Fk, OR
Owyhee N Fk, OR
Smith N Fk, OR
Sprague N Fk, OR
North Powder, OR
North Umpqua, OR
Powder, OR
Quartzville Creek, OR
Roaring, OR
Salmon, OR
Whychus (Squaw) Creek, OR
Sycan, OR
Rogue, upper, OR
Wenaha, OR
West Little Owyhee, OR
White, OR
Rio Chama, NM

1989 Vermilion M Fk, IL
1990 Jemez E Fk, NM
Pecos, NM
Clarks Fork Yellowstone, WY
Niobrara, NE
1991 Missouri, NE, SD
1992 Bear Creek, MI
Black, MI
Carp, MI
Indian, MI
Manistee, MI
Ontonagon Cisco Br, E, M, & W Br, MI
Paint, MI
Pine, MI

Presque Isle, MI
Sturgeon (Hiawatha NF), MI
Sturgeon (Ottawa NF), MI
Tahquamenon E Br, MI
Whitefish, MI
Yellow Dog, MI
Allegheny, PA
Big Piney Creek, AR
Buffalo, AR
Cossatot, AR
Hurricane Creek, AR
Little Missouri, AR
Mulberry, AR
North Sylamore Creek, AR
Richland Creek, AR
Merced, CA
Sespe Creek, CA
Sisquoc, CA
Big Sur, CA
Great Egg Harbor, NJ
1993 Westfield, MA
Maurice, NJ
Red, KY
1994 Rio Grande, NM
Cossatot, AR
Big Darby, OH
Little Darby, OH
Farmington W Br, CT
1996 Wallowa, OR
Elkhorn Creek, OR
Clarion, PA
Lamprey, NH
1998 Lumber, NC
1999 Concord, Sudbury, Assabet, MA
2000 Wilson Creek, NC
Wekiva, FL
White Clay Creek, PA, DE
Wildhorse Creek, OR
Kiger Creek, OR
Lamprey, NH
Donner und Blitzen, OR
Delaware lower, PA, NJ
2002 Rio Mameyes, PR
Rio de la Mina, PR
Rio Icacos, PR
2004 Westfield, MA

2005 White Salmon, WA
2006 Black Butte, CA
Musconetcong, NJ
2008 Eightmile, CT
2009 Clackamas S Fk, OR
Eagle Creek (Mt Hood NF), OR
Hood E Fk, M Fk, OR
Roaring S Fk, OR
Zigzag, OR
Fifteenmile Creek, OR
Collawash, OR
Fish Creek, OR
Elk N Fk, S Fk, OR
Battle Creek, ID
Big Jacks Creek, ID
Bruneau, W Fk, ID
Cottonwood Creek, ID
Deep Creek, ID
Dickshooter Creek, ID
Duncan Creek, ID
Jarbidge, ID
Little Jacks Creek, ID
Owyhee, N Fk,, S Fk, ID
Red Canyon, ID
Sheep Creek, ID
Wickahoney Creek, ID
Armargosa, CA
Owens, CA
Cottonwood Creek, CA
Piru Creek, CA
San Jacinto N Fk, CA
Fuller Mill Creek, CA
Palm Canyon Creek, CA
Bautista Creek, CA
Virgin N Fk, UT
Fossil Creek, AZ
Snake River, Headwaters, WY
Taunton, MA
2014 River Styx (Cave Creek), OR
Snoqualmie M Fk, WA
Pratt, WA
Illabot Creek, WA
Missisquoi, Trout, VT
White Clay Creek, PA, DE

APPENDIX 4 Rivers Listed under Section 5d of the Wild and Scenic Rivers Act, October 28, 1970

Au Sable, MI
Beaverkill, entire river, NY
Big Fork, MN
Birch Creek, AK
Blackfoot, MT
Cacapon, entire river, WV
Chatanika, AK
Chitina, entire river, AK
Columbia, above Pasco, WA
Delta, AK
Deschutes, OR
Escalante, above Lake Powell, UT
Flambeau, South Fork, WI
Fortymile, entire river, with tributaries, AK
Grande Ronde, Wenaha, Wallowa, Minam, OR
Green, source to Horse Creek, WY
Gros Ventre, entire river, WY
Guadalupe, TX
Gulkana, entire river, with forks, AK
Henrys Fork, ID
Hudson, source to Luzerne, NY
John Day, below N Fk confluence, plus N Fk, OR
Kern, North Fork, entire river, CA
Klamath, Iron Gate Dam to mouth, CA

Little Missouri, ND
Madison, MT
Manistee, with Pine River, MI
Mullica, entire river, with Wading & Bass Rivers, NJ
Niobrara, NE
North Fork White, MO
Pine, entire river, with Popple River, MI
Pocomoke, entire river, MD
Rappahannock, with Rapidan River, VA
Russian, California
Sacramento, upper, with Keswick Dam to Sacramento, CA
Shenandoah, entire river, VA
Smith, entire river, with forks, CA
Snake, Hells Canyon, with Imnaha, ID, OR, WA
Snake, source to Palisades Reservoir, WY
Tangipahoa, LA
Tuolumne, CA
Wacissa, entire river, FL
Wapsipinicon, IO
Wenatchee, entire river, with Chiwawa, White, WA
Wind, WY
Wolf, WI
Yellowstone, National Park to Pompey's Pillar, MT

APPENDIX 5 Longest and Largest Wild and Scenic Rivers

Longest in continuous mileage

1. Noatak, 372 miles
2. Nowitna, 226
3. Sheenjek, 205
4. Namekagon-Saint Croix, 200
5. Rio Grande, 193
6. Selawik, 189
7. Klamath, 188
8. Eel, 151
9. Missouri, 146
10. John Day, 143

Long designations in multiple sections

Rio Grande, 254 miles
Missouri, 237
John Day, 197
Deschutes, 170

Largest in volume of flow (mean or average flow in cubic feet per second)

1. Snake, Hells Canyon, 19,970 at Hells Canyon Dam, 32,200 at Anatone.
2. Missouri, 30,900 cfs at Sioux City
3. Klamath, 20,520 at mouth.
4. Allegheny, 19,750 at Emlenton
5. Noatak, 16,600 in lower river
6. Delaware, 13,000 at Lambertville (New Hope)

Longest total designated stream mileage in single watersheds
NOTE: *rivers larger than 7th order streams are not tabulated here*

1. Klamath, 573 miles (CA, OR)
2. Snake River Headwaters, 414 (WY only)
3. Fortymile, 407
4. Smith, 397
5. Eel, 387 (including Van Duzen)
6. Noatak, 372
7. Owyhee, 372 (ID and OR)
8. Deschutes, 354
9. Andreafsky, 279
10. Salmon, 256 (ID)
11. Saint Croix, Namekagon, 252
12. Charley, 250
13. John Day, 243
14. Nowitna, 226
15. Flathead, 208
16. Sheenjek, 205
17. White Clay Creek, 199
18. Selawik, 189
19. Delaware, 180
20. Gulkana, 173
21. Rogue, 171
22. Skagit, 170

Selected Sources

Albert, Richard C. *Damming the Delaware.* 1987.

American Rivers. *The American Rivers Guide to Wild and Scenic River Designation.* Kevin J. Coyle. 1988.

_____. *The Nationwide Rivers Inventory: Evaluation of a River Conservation Tool.* White paper. 2000.

_____. *Two Decades of River Protection; A Report on the National Wild and Scenic Rivers System.* Anne Watanabe. November 18, 1988.

Bennett, Dean B. *The Wilderness from Chamberlain farm.* 2002.

Craighead, John. "Wild River." *Montana Wildlife.* June 1957.

_____ "Wild River." *Naturalist.* Vol. 16, # 3, autumn 1965.

Craighead, John J., Frank C. Craighead. "River Systems: Recreational Classification, Inventory and Evaluation. *Naturalist.* Vol. 13, # 2, 1962.

Fosburgh, Jamie, Joe DiBello, Fred Akers. "Partnership Wild and Scenic Rivers." *The George Wright Forum.* Vol. 25, No. 8, 2008.

Friends of the River. *National Wild & Scenic Rivers in California; A Status Report.* Brochure. 1998.

Idaho Rivers United. *National Wild & Scenic Rivers in Idaho.* Brochure. 1998.

Interagency Wild and Scenic Rivers Coordinating Council. See the *Wild and Scenic Rivers Act, Abridged,* plus lists of the designated rivers, river-by-river narratives, and various white papers regarding administration and policy, all at www.rivers.gov.

_____. *Evolution of the Wild and Scenic Rivers Act: A History of Substantive Amendments 1968-2013.* Cassie Thomas. www.rivers.gov. 2014.

_____ *Wild and Scenic Rivers Act; 30th Anniversary Forum— Moving to Action, Final Meeting Report.* Edwin E. Krumpe, William J. McLaughlin. 1998.

Meral, Gerald. "Do We Need a Coalition on American Rivers?" *American Whitewater.* Spring 1973.

Noss, Reed, Allen Cooperrider. *Saving Nature's Legacy.* 1994.

Olson, W. Kent. *River of Broken Promises: A Report on State Management of the Allagash Wilderness Waterway under the National Wild and Scenic Rivers Act of 1968.* Allagash Partners. 2001.

Pacific Rivers Council. *Entering the Watershed.* Bob Doppelt, Mary Scurlock, Chris Frissell, James Karr. 1993.

Palmer, Tim. "A Time for Rivers: The System at Midstream." *Wilderness.* Fall 1984.

_____. *Endangered Rivers and the Conservation Movement.* 2nd edition 2004.

_____. *Lifelines: The Case for River Conservation.* 2nd edition 2004.

_____. *Stanislaus: The Struggle for a River.* 1982.

_____. *The Wild and Scenic Rivers of America.* 1993.

Tarlock, A. Dan."Preservation of Scenic Rivers." *Kentucky Law Journal.* Vol. 55, 1967.

US Council on Environmental Quality. *Interagency Consultation to Avoid or Mitigate Adverse Effects on Rivers in the Nationwide Inventory.* President's Directive, August 10, 1980.

US Department of the Interior and Department of Agriculture. *National Wild and Scenic Rivers System: Final Revised Guidelines for Eligibility, Classification and Management of River Areas.* Federal Register, Sept. 7, 1982.

_____. *Wild Rivers.* May 1965. Booklet.

US Department of the Interior, National Park Service. *Nationwide Rivers Inventory. http://www.nps.gov/ncrc/programs/rtca/nri/index.html.* List of inventoried rivers.

_____. *The Nationwide Rivers Inventory.* White paper. January 1982.

US Heritage, Conservation and Recreation Service. *Urban, Cultural, Recreational Rivers: A Survey of State River Conservation Interests in the Northeast.* J. Glenn Eugster. March 1979.

US House of Representatives. *Providing for a National Scenic Rivers System, and for Other Purposes.* Report 1623. July 3, 1968.

US Senate. *National Wild and Scenic Rivers System.* Report 491. August 4, 1967.

Wild and Scenic Rivers Task Force, National Leadership Council. *Wild and Scenic Rivers: Charting the Course Navigating the Next 40 Years of the Wild and Scenic Rivers Act.* April 2007.

Interviews and special information sources, 2015

NPS indicates National Park Service; FS, US Forest Service; BLM, Bureau of Land Management; AR, American Rivers

Akers, Fred, Great Egg Harbor River, NJ

Bell, Julie, NPS, White Clay Creek

Blackwelder, Brent, Environmental Policy Center, retired

Bosse, Scott, AR, Northern Rockies

Brown, Chris, AR President, NPS RTCA director, and FS Rivers Coordinator, retired

Chaudet, Mollie, Deschutes National Forest, retired

Collins, Bern, Bureau of Outdoor Recreation and NPS, retired

Coyle, Kevin, BOR and former AR President

DiBello, Joe, NPS, Philadelphia

Diedrich, Jackie, FS regional & national rivers program manager, retired

Eisenhauer, Steve, Maurice River, NJ

Eugster, Glenn, Bureau of Outdoor Recreation & NPS, retired

Fahlund, Andrew, former AR conservation director

Fite, Ed, Oklahoma State Scenic Rivers Commission director

Fosburgh, Jamie, NPS Partnership Rivers, Boston

Frankel, Zach, Utah Rivers Council, director

Fremont, Mike, Rivers Unlimited, Ohio

Haas, Dan, Fish and Wildlife Service, formerly NPS

Halbert, John, NPS rivers program director, retired

Harn, Joan, NPS, rivers program manager

Harris, Steve, Far Flung Outfitters, Taos, NM

Irvin, Bob, AR President

Kauffman, Gerald, White Clay Cr, Univ. of Delaware

Kenny, Paul, NPS, Philadelphia

Kober, Amy, AR communications director

Marsh, Gary, BLM Wild and Scenic River program manager, retired

Meral, Jerry, Planning and Conservation League, CA, retired

McCartney, Jim, NPS Partnership rivers, Boston

McDonald, Kristen, former AR staff

Moryc, David, AR River Protection Director

Nelson, Kezia, Zion National Park

O'Keefe, Tom, American Whitewater

Olson, Ken, AR President, retired

Ratcliffe, Bob, National Park Service, Program Chief, Conservation and Outdoor Recreation

Rea, Al, U.S. Geological Survey

Reed, Jennifer, Arctic National Wildlife Refuge

Rutledge, Colleen, Illahe Lodge, Rogue River

Sedivy, Bill, former Idaho Rivers United director

Stewart Deeds, Shana, Missisquoi River, Vermont

Terry, Claude, outfitter and conservationist, Atlanta

Thede, Steve, NPS, Superintendent, Niobrara Wild and Scenic River

Thomas, Cassie, NPS, Anchorage, formerly Boston Partnership program

Wallin, Phil, River Network founder, Western Rivers Conservancy, retired

Welsh, Randy, FS Wild and Scenic Rivers coordinator, retired

Werschkull, Grant, Smith River Alliance

Wodder, Rebecca, AR President, retired

Woodward, Doug, river conservationist, Georgia

Regarding early history of the wild and scenic rivers program, see many additional sources and seventy-two interviews listed in *The Wild and Scenic Rivers of America*, 1993. From that book I've excerpted or used interviews with the following:

Brandborg, Stewart, Wilderness Society

Brown, Howard, AR President

Church, Bethine, wife of Senator Frank Church

Conrad, David, AR staff

Craighead, Frank, wildlife biologist

Craighead, John, wildlife biologist

Dowling, Paul Bruce, America the Beautiful Fund

Edgar, Bob, congressman, PA

Evans, Brock, Sierra Club and National Audubon Society

Kauffmann, John, NPS

McCloskey, Michael, Sierra Club

Munoz, Pat, AR staff

Nelson, Gaylord, US senator and The Wilderness Society

Painter, Bill, AR president

Saylor, John, congressman, PA

Schad, Ted, Senate Select Committee on Water Resources

Swem, Ted, NPS

Udall, Stewart, former secretary of the interior

Young, Stan, Bureau of Outdoor Recreation

Acknowledgments

Scores of people contributed to this book with their insights, memories, and encouragement. See Sources for a list of interviews, plus an older cast drawn from my earlier book, *The Wild and Scenic Rivers of America* (1993).

Special thanks to Glenn Eugster for sharing a trove of archival letters and paperwork, plus a keen memory from his many years of dedicated service. Also in a class by themselves, Chris Brown, Kevin Coyle, Ken Olson, and Rebecca Wodder shared their views and reflections from illustrious careers attached to the wild and scenic rivers program. Dan Haas plays a vital role as the diligent and talented keeper of information at rivers.gov and has posted hundreds of my photos of rivers there for agency and NGO use. Helpful papers at rivers.gov were thoughtfully and carefully authored by Jackie Diedrich, Cassie Thomas, and others through the Interagency Wild and Scenic Rivers Coordinating Council. Their work is essential to anyone wanting to fully understand the wild and scenic rivers program and its nuances of policy.

Steve Gordon of Cartagram expertly and artfully crafted the map you see in the opening pages. After including other maps by Steve in five of my previous books, I can scarcely think of publishing one without his help. Steve patiently worked from my drafts and the official Interagency Wild and Scenic Rivers Coordinating Council's beautiful wall map of 2009 (soon to be updated), which benefits from a much larger scale. Steve Chesterton of the Forest Service was generous in reviewing a draft of my necessarily consolidated map.

For fact checking, quote confirmation, further review, or just plain bedtime reading, I sent full copies of the manuscript to Brent Blackwelder, Scott Bosse, Chris Brown, Tom Cassidy, Kevin Coyle, Jackie Diedrich, Andrew Fahlund, Dan Haas, Joan Harn, John Haubert, Bob Irvin, Amy Kober, David Moryc, Ken Olson, Denielle Parry, Bob Ratcliffe, Risa Shimoda, Cassie Thomas, and Rebecca Wodder. Heartfelt thanks to all for their time, and especially to Jackie, John, and Cassie for exceptional care. Also to Bern Collins, Maggie Collins, Steve Evans, Mike Fremont, Bill Painter, Bill Sedivy, and others who checked specific sections of text. Andrew Keske of the Forest Service did the GIS analysis for wild and scenic mileage. Joan Harn of the National Park Service was helpful in various networking ways. Special thanks to Bob Irvin of American Rivers for his eloquent forward to the book.

Teachers can be the most influential people in our lives; from deep in the past, my first involvement with wild and scenic rivers owes to the insight, initiative, and influence of a revered Penn State forestry professor, Peter W. Fletcher.

Working with Mary Elizabeth Braun, Tom Booth, Micki Reaman, and Marty Brown and designer Erin Kirk New at Oregon State University Press was an unqualified pleasure. Their commitment to good books and their interest in river conservation benefits all of us, not just in Oregon but across America.

Bert Kerstetter provided funding assistance to cover some of my costs in authoring this book.

Generously answering my request, Alan Rea of the US Geological Survey calculated the numbers of US rivers and their length using the most recent and detailed GIS techniques and data available. In this book, those numbers (see chapter 7) replace others that for years have been in widespread use.

Saving the best until last, my wife, author Ann Vileisis, constantly supported this project with enthusiasm and her own overflowing love of rivers. She was with me from beginning to end, including some remarkable photo expeditions by raft, kayak, and canoe, and also through our shared deliberations into her own field of writing—environmental history. Not only a consummate and award-winning writer and historian, but a fine editor, Ann read the full manuscript with a sharp eye and a mastery of language that improved every page.

About the Author and Photographer

Tim Palmer has written twenty-six books about rivers, conservation, and adventure travel. He has spent a lifetime canoeing, rafting, hiking, exploring, and photographing along streams, and his passion has been to write and speak on behalf of river conservation. He has paddled on more than 350 rivers nationwide, including over 100 designated as national wild and scenic rivers, and has been involved with the wild and scenic rivers system in a variety of roles almost since its inception. He was highly engaged in wild and scenic campaigns to protect the Kings, South Yuba, Clarion, Stanislaus, Chetco, Elk, Pine Creek, and other rivers, plus a pilot project aimed at upgrading the Nationwide Rivers Inventory.

Recognizing his contributions in writing, photography, and activism, American Rivers gave Tim its first Lifetime Achievement Award in 1988, and Perception Inc. honored him as America's River Conservationist of the Year in 2000. California's Friends of the River recognized him with both its highest honors, the Peter Behr Award and the Mark Dubois Award. *Paddler* magazine named Tim one of the "ten greatest river conservationists of our time," and in 2000 included him as one of the "100 greatest paddlers of the century." In 2005 Tim received the Distinguished Alumni Award from the College of Arts and Architecture at Pennsylvania State University. Topping these honors, he received the National Conservation Achievement Award ("Connie") for communications given by the National Wildlife Federation in 2011.

Tim's *Rivers of America* was published by Harry N. Abrams and features two hundred color photos of streams nationwide. He also photographed and wrote *Rivers of California* and *Rivers of Oregon*. *The Columbia* won the National Outdoor Book Award in 1998. *California Wild* received the Benjamin Franklin Award as the best book on nature and the environment in 2004, and *Pacific High: Adventures in the Coast Ranges from Baja to Alaska* was a finalist for that award in 2003. The *Heart of America: Our Landscape, Our Future* won the Independent Publisher's Book Award as the best essay and travel book in 2000. In 2015 Tim's *Field Guide to Oregon Rivers* was the winner of the National Outdoor Book Award and also a finalist for Foreword Review's Adventure Book of the Year and for the Oregon Book Award.

Tim lives in Port Orford, Oregon. Before becoming a full-time writer, photographer, and conservation activist, he worked for eight years as a land-use planner in Pennsylvania. He has a bachelor of science degree in landscape architecture, and is a Visiting Scholar with the Department of Geography at Portland State University and an Associate of the Riparia Center in the Department of Geography at Pennsylvania State University. He frequently speaks and gives slide shows for universities, conservation groups, and conferences nationwide. See his work at www.timpalmer.org.

About the Photographs

For many years I used a Canon A-1 camera with 17-200 mm FD lenses, but most of the photos here were taken with a Canon 5D digital camera with 17-200 L series zoom lenses and a 50 mm L series lens. I also use a Canon underwater Powershot. For backpacking and other adventures when a small kit is needed, I carry a Fujifilm digital X-E2 with its 18-55 and 55-200 XF zoom lenses.

With the goal of showing nature accurately and realistically, I limit myself to minor post-photo adjustments for contrast and color under Apple's very basic iPhoto program. I use no artificial light or filters and do nothing to alter the content of the photos.

I don't dress my photos up, but I do search for the most beautiful scenes I can find. Most pictures were taken in early morning or evening with nature's elegant low light that's full of color, shading, and shadows. Using a tripod, I take long exposures to keep my ISO low and to maximize depth of field, which also gives flowing water the streamed effect of motion. I vary perspectives from high-to-low, shoot from the canoe and raft, wade shallow or deep, climb trees and mountains, and slip underwater now and then. The overriding principle of my work is to share with others the beauty that I've been privileged to see in the natural world.

Index